Being an Artist

Being an Artist
Artist Interviews with Art21

Dedicated to Susan Sollins

ISBN 978-0-692-09673-4

Contents

Acknowledgments 7
Foreword 10

Becoming an Artist
Ida Applebroog 16
John Baldessari 20
Mark Bradford 25
Nick Cave 30
Vija Celmins 34
LaToya Ruby Frazier 38
Katharina Grosse 42
Rashid Johnson 46
William Kentridge 51
Kimsooja 55
Catherine Opie 60
Lari Pittman 66
Kiki Smith 70
James Turrell 76
Ursula von Rydingsvard 84
Kara Walker 88
Carrie Mae Weems 94

The Power of the Public
Mark Bradford 100
Cai Guo-Qiang 104
Theaster Gates 109
Jenny Holzer 113
Barbara Kruger 117
Maya Lin 120
Ursula von Rydingsvard 125

The Role of the Artist

Tania Bruguera 132
Theaster Gates 136
Mike Kelley 142
Jeff Koons 148
Glenn Ligon 153
Kerry James Marshall 159
Zanele Muholi 163
Raymond Pettibon 168
Pedro Reyes 173
Doris Salcedo 178
Stephanie Syjuco 183
Sarah Sze 188

On Process

Diana Al-Hadid 194
El Anatsui 199
Cai Guo-Qiang 204
Vija Celmins 211
Ellen Gallagher 216
Trenton Doyle Hancock 220
Joan Jonas 224
Mike Kelley 228
Liz Magor 233
Kerry James Marshall 237
Julie Mehretu 241
Bruce Nauman 248
Robert Ryman 252
Jack Whitten 258

Biographies of the Artists 262
Index 278

Acknowledgments

A cornerstone of Art21's accomplishments over the course of twenty-one years is a library of more than fifty hours of film, documenting the works and words of today's foremost visual artists. This achievement would not be possible without the steadfast commitment and innovation of Art21's staff and board of trustees, to whom I am tremendously grateful. At the helm of the organization for seventeen years was our pioneering founder and my predecessor, Susan Sollins, who passed away in 2014. Susan left the world with the special gift of Art21 and its mission to inspire a more creative world through the dissemination of the artist's voice. With her series co-creator Susan Dowling, Sollins gave birth to the centerpiece of Art21's programming, *Art in the Twenty-First Century*. Now in its ninth season, this Peabody-award-winning film series sits comfortably alongside two other series spawned from new approaches to digital storytelling: *Extended Play* and *New York Close Up*. All of these ingenious films are overseen by our masterful production team, helmed by the ever-creative, humorous, and indefatigable Nick Ravich, our director of video programming and production, and finessed and made sophisticated by the handiwork and grace of Ian Forster, our producer. I would also like to note the commitment of Eve Moros Ortega, our former executive producer, for her years of service toward realizing Art21's hopes and dreams, alongside Sollins. In addition, Wesley Miller, our former curator, was a steady hand conducting curatorial research for early seasons overseen by Sollins, working closely with many of the voices compiled in this volume.

While the interviews included here were predominantly conducted by our founder, we embrace new partners in the production of our films, as we grow as an organization and tell more stories. I thank Ravich, Forster, and Miller for their roles as thoughtful interviewers on several of the interviews. Additionally, I would like to extend my appreciation to Deborah Dickson, Stanley Nelson, Christine Turner, and Pamela Mason Wagner; these directors' insights and keen investigations with select artists in the Art21 family helped to seed our work. Early on in Art21's development, consulting directors Catherine Tatge and Charles Atlas provided critical and artistic insight.

The dream to put a compilation like this one together was readily embraced by the astute and all-seeing eye, hand, and pen of Danielle Brock, our curatorial assistant. Without her, this book would not see the light of day. Art21's digital staff, headed by the tech-savvy Jonathan Munar, our digital director, and supported by Lindsey Davis, our former digital-content editor, continues to give new online recognition and interpretation to the individual stories of artists. These stories become alive in the engaging classrooms of Art21 Educators led by the buoyant Joe Fusaro, our senior

education advisor. The necessary financial support that enables us to do all of this work with ease is available thanks to the talented members of the Art21 development team: Lolita Fierro, associate director of individual giving; Esther Knuth, development coordinator; and Maggie Albert, former associate director. Our curatorial intern, Sunny Leerasanthanah, took on this project as her own during her time with us, and for that we are thankful.

This compilation is a timely way to mark the occasion of Art21's twenty-first anniversary, and it was made possible by the foresight of the Art21 staff. Alongside producing films, Art21 has had a long-standing commitment to publishing written material, extracted from challenging and sometimes laborious interviews conducted under cameras and lights. During the first six seasons of *Art in the Twenty-First Century*, books were published to complement the broadcast syndications and DVD releases. Carefully edited fragments from interviews featured in those six seasons can be found in that set of books; a few reappear in this volume in fuller form. Those books were thoughtfully edited by Marybeth Sollins, who poured her skills into the work for each of those seasons. In 2001, Art21 began to publish excerpts from interviews online, sharing them with PBS and its website. When Art21 launched a blog on its website in 2008, new print interviews were published, overseen by Susan Sollins and edited by Nicole Caruth. We continue to publish supplementary interviews in the online Art21 Magazine and other sections within the Art21 website. This anthology is the first time we have collected such a diverse group of artists into a single volume. I would like to send my gratitude to the book's copy editor, Deanna Lee, and its designer, Adam Squires from CHIPS, for their creative input on this project.

Our work is supported by a devoted board of trustees, many of who helped Sollins in innumerable ways to build Art21 to be the beacon of arts education that it is today. Special thanks go to the board's president emerita, Migs Wright, and the board's chairman, David Howe, for their thoughtful contributions and oversight over the years of Art21's growth. This moment to reflect on Art21's history is made possible by the generous support of the Juliet Lea Hillman Simonds Foundation. Thank you, Lea, for our mutual love of books.

All the current funders of Art21's films and educational initiatives are to thank in ways big and small. Neither book, television series, nor website would exist without the extremely generous support of the philanthropic community: the National Endowment for the Arts; The Anna-Maria and Stephen Kellen Foundation; Agnes Gund; PBS; the Lambent Foundation Fund of the Tides Foundation; the Rockefeller Brothers Fund; The Andy Warhol Foundation for the Visual Arts; The Horace W. Goldsmith Foundation; the Ford Foundation; Brenda Potter; Toby Devan Lewis; the New York City Department of Cultural Affairs; the New York State Council on the Arts; and the Art21 Contemporary Council.

Art21's approach to education positions artists as role models for creative and critical thinking, supporting a belief that art is an essential right across disciplines and outside of established pedagogical silos. While this collection serves as an essential primer on a group of artists who have made an undeniable mark on art history, it reveals insights into the specific lives and works of artists. And so, the ultimate appreciation goes to the artists themselves, for offering Art21 a window into their most intimate moments and for affording us the space of collaboration. Because they allow Art21 into their lives, our work is made possible. We thank them for their help in collectively telling the story of contemporary art in the first two decades of the twenty-first century. With artists at our side, our future looks bright.

—Tina Kukielski
 Executive Director and Chief Curator, Art21

Editor's note: The conversations published in this volume have been edited and condensed for clarity. Wherever possible, the sequence of the discussions has been preserved.

Foreword

As a cultural producer, having spent many years as a curator in museums before finding my way to the directorship of Art21, I thought I knew what it means to be an artist. I had worked with artists, helped them build projects, and wrestled with their ideas. But nothing prepared me for the deeper level of understanding that I would find when I joined Art21, a team devoted to telling the stories of artists.

Since coming to Art21, I have gleaned two things about what being an artist means. The first is that, sometimes, somebody calls you an *artist* and the moniker sticks, as in Richard Serra's revelation in the inaugural interview with Art21's founder, Susan Sollins. In that original 1999 shoot, Serra comfortably confides how he became an artist: "I have a Jewish mother. She used to introduce me to everybody as, 'This is my son, Richard Serra, the artist.' Now, if your mother is telling you all that—even if you don't believe that it's true—you kind of grow up with the definition of yourself as being 'Richard Serra, the artist.'" No doubt Serra showed early signs of a creative proclivity, inciting his mother to bestow the title. In any case, it was undoubtedly in those early days that the fate of Serra, now a titan of sculpture, was sealed.

The second thing I have learned is that being an artist is tantamount to naming oneself such. Otherwise said, it can be an honor self-anointed, despite others' best interests for you and your livelihood. In the collection of interviews that provided the model for this compendium, the critic Jeanne Siegel speaks with the Pop artist, Allan D'Arcangelo, who, in a panel discussion about art and social protest, quotes his fellow panelist and provocateur, Ad Reinhardt: "We all name ourselves. We call ourselves *artists*. Nobody asks us. Nobody says you are or you aren't." D'Arcangelo points out that the inchoate impulse comes from a place rather fundamental; it stems from the "condition of being alive."[1] Whatever truth one ascribes to this explanation, being an artist might not be an easy path, yet it is distinctly human to be one.

Being an artist is a bedrock decision. John Baldessari argues in this volume's first section, "Becoming an Artist," that "art making is essentially about making a choice." And once one makes that choice, there is little going back. As LaToya Ruby Frazier reminds us, in her interview, "It's a 24/7 job." Art21 is similarly unceasing in its purpose: to give audiences the permission to be artists. Hearing directly from artists about their choices allows others to make such choices, too. At Art21, we celebrate that choice.

1. Jeanne Siegel, *Artwords: Discourse on the 60s and 70s*, (Ann Arbor, MI: Da Capo, 1985), 113–114.

A frequent misconception in our culture is that artists are outsiders: privileged hermits at a remove from society at large or downright crazy. Another misconception is that art is unintelligible: its ideas are reserved for the few and are not open to the masses. For these reasons, artists can become easy scapegoats. Beyond the perils to artists themselves, today we are inundated with dubious information, fake news, and unreliable narrators, much of which is aimed at creating a debilitating culture of conformity to reactionary views. There are emergent and recurring threats against art and culture, across the globe as well as in our own backyard—as signaled by the potential dismantling of the National Endowment for the Arts and similarly, some would say, in the attempts to weaken the democratic nature of the Internet. The work of Art21—educating audiences about the purpose and validity of art—feels more necessary than ever.

Art21 is committed to supporting arts education and creating tools available for teachers, and this book is designed to be helpful to those invested in curriculum building. For non-teachers, the content is compiled to be inspiring and useful to any art enthusiast. The book is arranged into four sections that organize the collection of voices that Art21 has assembled over the years.

The opening subject of this compendium is a recurring question, perhaps the most obvious, that we ask any artist we work with: how did you become an artist? In the interviews in "Becoming an Artist," artists see through lines from early childhood influences to later careers, like Rashid Johnson's decision to use shea butter, a substance originally brought by his mother from West Africa when he was a child, or Kimsooja's musings on the trappings of female identity as they play out in her homeland of South Korea. For William Kentridge, the only Art21 artist to be the subject of an Art21-produced feature film, becoming an artist was an act of deep investigation. Sollins spent hours with Kentridge, and at one point he shares: "There was a part of me that knew I only existed if I made some kind of external representation of [myself] on a sheet of paper... [being an artist] has to be about you not being enough." While early creative sparks are a common theme for some artists, others contend with roadblocks that affect their choices at surprising stages in their career. For instance, Ida Applebroog courageously defied critics who believed in the 1970s that, as she recounted, "women don't have the physicality or eroticism to be painters."

While much has changed during the fifty years since that bogus comment, Art21 as a cultural agent, one with an increasingly resounding public voice, has doubled down on its belief in public trust and responsibility. We are now bound within an attention economy driven by the Internet, but we acknowledge that the places where people access Art21, the Internet and television, are inherently public realms. As cultural commentators, we must question the value of these spaces and who owns them. Today, public space is being fought over, as demonstrated by the conversations about net neutrality and by the

scrutiny of public monuments sparking intense debates in cities worldwide. People are fighting to hold their ground through public demonstrations, online activism, and grassroots organizing. As ever, artists are part of these conversations, providing us with new and illuminating ways of thinking about issues of public space, power, and ownership—and what to do about them. As Mark Bradford states in the section, "The Power of the Public," public space has "the potential to be inclusive." Yet artists, perhaps more than the rest of us, must navigate power as it is both leveraged and exchanged in a public arena.

Conversations about cultural equity live deep within Art21's identity as an organization. They inform our curatorial point of view, and, being cognizant of the broadcast medium, we consider questions of inclusion and exclusion as we decide who and what to feature in our films. Art, for us, is a human right, and access to culture has been proven to strongly affect people's health, education, and general well being. But what does it mean when one doesn't have access, when social determinants preclude the availability of resources, information, and knowledge? Many artists seek to answer that underlying question as they identify with their role in a broader cultural sphere. As such, they make choices about what to say or do in that role. Tania Bruguera addresses this in her interview in the section, "The Role of the Artist," when she talks about "how one can use all the tools of art to change reality." Similarly for Pedro Reyes, the role of the artist is to drive reinvention—of institutions, relationships, materials, or forms—and yet a commitment over time is critical because the "opus" is how the artist will be seen.

It would not be an Art21 effort if we neglected to give voice to the artistic process. Much can be learned from simply watching our films and observing the way artists work: how they paint, make molds, use power tools, or work with assistants to achieve large-scale projects. Many of our interviews document artists describing their processes as they are living it, day-to-day in the studio. These interviews can be exacting and illuminating; the parts tend to stand in for a greater whole. In the section, "On Process," we learn how Mike Kelley envisioned his epic film and mixed-media installation, *Day is Done*, as a fusion of personal and cultural memory, formed predominantly from high school yearbooks and his faulty recollections. Liz Magor shares her experiences as a purveyor of found objects, drawing from the flotsam of other people's lives. This section of the book also reveals why and how Kerry James Marshall transformed the image of Blackness in painting into an "emblem of power"—a compelling example of art's influence on today's conversations about cultural representation.

The people who watch Art21's programs represent a panoply of artistic individuals. Educators, curators, students, collectors, art enthusiasts, and artists themselves are Art21's power users, but Art21's ability to demystify contemporary art by presenting it in vernacular terms that anyone can experience provides the art novice with a platform to reach a deeper

connection to art and cultural understanding. Based on feedback from educators, critics, supporters, and fans of Art21 programs, it is clear that Art21 films leave a lasting impression on audiences. An Art21 film or interview becomes a transformational moment for a viewer when it helps to incite discussion and inspire reflection on universal issues that deeply affect people across economic, social, and political boundaries.

Through the distribution channel of public television, Art21 has built an audience that is diverse and at times amorphous. Contemporary art, frequently seen as exclusionary, has a complicated relationship to the populist mediums of film and TV. When the subject of contemporary art shows up in films or TV shows, whether fiction or documentary, it typically concerns the sensational price of certain artworks and the myths or vicissitudes of the market or, worse, the vapidity of certain artworks and ideas. Yet video is proven to be an effective tool for cross-cultural understanding.

I am reminded of David Joselit's astute analysis of video's principles, which is specific to video as an art form, but it is relevant nonetheless. In discussing video practice, he speaks of the intersubjectivity of the medium: "It is on the one hand a privatized exploration of the self and on the other a remapping of the discursive formations of mass media."[2] It echoes Rosalind Krauss's conclusion that video is a medium that situates the viewer within a psychology. This is, I believe, why Sarah Sze can state, "a studio visit can be more interesting than a museum show," and, "an Art21 interview can be more interesting than an [exhibition] catalogue." Art21's accumulated insights, gathered through countless hours of filming and conversation, bring forth the most illuminating picture of contemporary art. Working for twenty-one years to present the truths about artists, we are proud to offer this compilation of some of their voices.

—Tina Kukielski

2. David Joselit, "Film and Video Installation in the Biennale of Sydney," unpublished paper (1996), quoted in Lynne Cooke, "Tony Oursler: *ALTERS*," *Parkett* 47 (1996): 38.

Becoming an Artist

Ida Applebroog
John Baldessari
Mark Bradford
Nick Cave
Vija Celmins
LaToya Ruby Frazier
Katharina Grosse
Rashid Johnson
William Kentridge
Kimsooja
Catherine Opie
Lari Pittman
Kiki Smith
James Turrell
Ursula von Rydingsvard
Kara Walker
Carrie Mae Weems

Ida Applebroog in her SoHo studio, New York, 2004. Production still from the *Art in the Twenty-First Century* Season 3 episode, "Power." © Art21, Inc. 2005.

Power and Feminism

Ida Applebroog shares her experiences starting out as an artist in the 1970s and the ramifications of power and tokenism in art.

Interview by Susan Sollins at the artist's studio in New York City on October 12, 2004.

Art21—Can you talk about first making art when you moved back to New York in the 1970s?

Applebroog—As I said before, now I consider myself a generic artist. When I started out, I came to New York in about '74. At that time I didn't know anyone. I was a New Yorker, but I'd been away for a long time. So, I came back and I really didn't know how to enter the art world again. I was in the art world, so I shouldn't say *again*, but what happened was that I started to go back to my roots, just doing drawings, and for me it was like instant coffee—I can just draw and draw forever.

From these drawings I started making books. Being in New York and not knowing anybody, I had access to a printing press and would mail them to people I did not know: artists whose work I really liked, people writing who I thought were interesting. I think I sent out mailings—one every few months—and suddenly I was, I guess, a nuisance. Next, I went into doing videos—narratives and videos. Then I worked on three-dimensional vellum paper sculptures. I'd fold them in such a way that they became stagings. And working with the vellum, I used to put layers of Rhoplex on. At one point, they took Rhoplex off the market because it was supposed to be carcinogenic and I thought, "No, I'm not going to use that," so I tried to simulate that stroke in paint. And then people liked to call me a painter.

I still feel I'm not really a painter. When I work with canvases, I work with three-dimensional structures. It's about structures. It's about stagings. It's still—it's always about stagings. No matter what would happen to my hands or the rest of my body, I'd still have my mouth, and I can still plant a pencil in my mouth and work. It's like anybody who creates: they're going to find a way to create and it doesn't matter how. Now that I've given you that sermon...

The word power: does it resonate for your work?

I like the idea, the power part. And it's the kind of thing where, every time someone asks me what my work is about, I always say, "It's hard to say what your work is about." Nobody really wants to say it, or they make up something that they have stuck in their heads that would sound right. But for me, it's really about how power works. And I learned that at

a very early age. I come from a very rigid, religious background. And it's the idea of how power works—male over female, parents over children, governments over people, doctors over patients—that operates continuously. So, it's not as though I set out to say, "Well, let's see what the power balance is between this piece in my painting and that piece in my painting." This is the part we're talking about: that you never really know what you're doing until at the end you realize, "Ah, that's what I'm doing; that's what I've done."

When you look back at the work, how do you think about being a female artist during a time dominated by primarily male artists?

Coming out of the '50s, women were pretty invisible. Women had a certain role in life. No matter what school you went to, you had to make certain recipes, make sure that you got married, had children. The war was over, and Rosie the Riveter was over. The working women were gone, and the men came back from war. I mean, I was a child, but I still lived through all of that. And it never occurred to me that anything was wrong; that's just the way things were.

When I went back to school, I was in my thirties, about thirty-five. I went to the Art Institute of Chicago. I used to be flattered when a teacher would say to me, "Oh, your work is so interesting and good, it looks just like a man's." And I was very flattered—"My work is good; it looks like a man had done it!" It took me a long time to resent this and realize what Betty Friedan had said: Women have a condition that has no name. I realized at a certain point, "Yeah, I know what

that problem is, and I don't know what the name is, but I have it." And coming out of the '50s and going into the '60s, it was an incredible time for me to understand how power worked or how power can work. A number of years back, a piece was published in *The Village Voice*. It was by a male critic, and he said biology is destiny: women don't have the physicality or eroticism to be painters. It was a long time ago, the '90s. I hope by now he's been somewhat radicalized. In those days, we had a lot of very strong women painters around—Susan Rothenberg, Elizabeth Murray—so to have read that was incredible!

Did the feminist movement change the work?

I want to tell you something: I have a real problem with feminism and art. This is something that I've always objected to. I never liked the all-women shows. It really does label us, ghettoize us. There are many women around who say, "Don't call me a *feminist*; that's a dirty word; let's not discuss feminism." And a lot of the younger artists—not that they say that, but they feel: "It has nothing to do with us anymore. We're able to do all this; we're able to go out there; we're accepted; we are the gallery system."

I remember when Pace had a full-page photograph of its gallery artists on the cover of the *New York Times Magazine*. It was all male, but I think there was one woman at Pace at that time. I don't remember who it was...

Agnes Martin?

Oh, Agnes Martin, of course! The '80s were a very interesting time because of what happened to the art market, what happened to women.

All the things that they worked towards in the '70s—feminism, minimalism, conceptualism, and performance art—it was very exciting. And then came the '80s, and it became very market driven. I think we lost a lot. Now I hope we've reclaimed some of that.

What about feminism and you?

No, I don't want to be placed in that crack. I don't want to have to give anyone that kind of a handle, to place us in such a way that it ghettoizes the entire way of thinking about who's making art, how art is made. You can make art from today until doomsday, and if they only place you in a show that is about women artists, if that's the only thing that happens, the only place that they put the women, we're in trouble. It feels like tokenism again. And it really distresses me.

Would you consider yourself a political person?

I don't even like the word *political*! I don't like any words. No, I really hate being labeled. I do a lot of work on violence all the time, you know. I've also had that come back at me: "Why are you so obsessed with violence?" And you know my answer? I look at them and I think, "Why do you say I'm obsessed with violence? I live in this world; this is what's going on around me. I can't change that."

So, when I'm doing the work, it's like I'm in the studio and I have all this stuff on my back. I have all this baggage, and I try desperately to start working. I'm carrying in how the postman looked at me that morning, what happened in my personal life, what did my dealer say to me, what did my friend say on the telephone— all the different things that go on in your mind: What do I have to do? What appointments do I have?

And then how do you get to do the actual marks on the canvas, where that [baggage] disappears? It takes a long time. And then this is not really what you're doing, but in a way it's like peeling off the layers. And finally you're not conscious any more of anything being there, and you're free and you're working and you don't know that time has gone by—and it's hours and hours and hours. But then you have to go back into the real world. And the real world is the world that the six o'clock news is about, and your own personal life is involved in that, also. ■

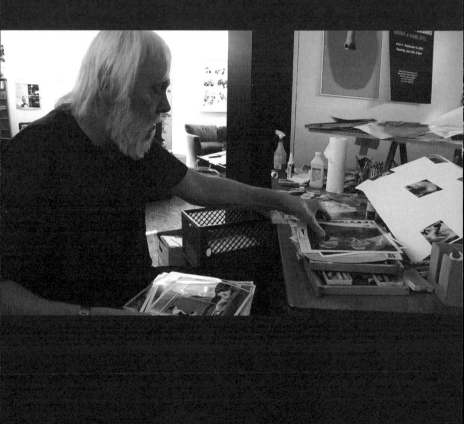

John Baldessari at work in his studio, Los
Angeles, 2008. Production still from the
Art in the Twenty-First Century Season 5
episode, "Systems." © Art21, Inc. 2009.

Just an Artist
John Baldessari discusses language and communication and how many years of teaching influenced his work in the studio.

Interview by Susan Sollins at the artist's studio in Los Angeles on July 15 and 16, 2008.

Art21—I'm curious about your longtime interest in language. Were you always fascinated by words?

Baldessari—The idea, which wasn't unique to me, that language could also be art might have begun back when I was painting. I never quite understood categories. Words and images are ways we communicate, and I couldn't figure out why they had to be in different baskets. I was getting tired of hearing the complaints: "My kid could do this," and "We don't get it. What's modern art?" I wondered what would happen if you gave people what they wanted, that is, something they always look at. They look at magazines and newspapers, so why not give them photographs or text? That was the motivation, and when I moved in that direction, thinking about language—and I don't know exactly how this happened—it seemed to me that a word could be an image, or an image could be a word. They could be interchangeable. I couldn't, in my mind, prioritize one over the other. For a lot of early works, I would have files of photographs that I would take from TV, and I would have an assistant attach on the back of the image a word that she thought could be its surrogate. And then I played: I would make a sentence out of the words, and then, for that sentence, I would use the images instead of the actual words, kind of flip-flopping. In my multiple-image pieces, I had the idea that there were words behind them, and I was building blocks or frames. I don't do this so much anymore, but some parts of my work are multiple frames like a writer or poet builds with words. That's a description that seems to make me feel comfortable. And I still have the idea that an image and a word could be interchangeable.

How do you feel about people applying the term *conceptualism* to your work?

I think "isms"—impressionism and so on—are useful for writers when something seems to be brewing and they want to give it some generic title. I think with conceptual or minimal art or the period when I began to emerge as an artist, I just got put in that basket—that I was labeled a conceptual artist because I used words and photos. But as time goes on, one can see an artist more distinctly and realize that the labels don't really apply. And I

think if you asked any artist who you might think of as conceptual now, if he or she would use that term, the answer would be, "No, I'm not a conceptual artist." Once, I said to Claes Oldenberg, "You're a Pop artist." He said, "No, I'm not; I'm an artist." And Roy Lichtenstein said the same. I have the same feeling. *Conceptualism* doesn't really describe what I do. If somebody wants to use that term, it's fine, but I'd prefer a word that's broader and better. I'm really just an artist.

Tell me about growing up in a small town and moving back there after college.

I was going to the Otis Art Institute, and I got tired of that after two years of living in Los Angeles. I needed a job, so I started teaching in the San Diego public schools. That put me back in National City, where I was born. At the time I felt pretty isolated, but looking back on it, it was a valuable time. Originally I had the idea that I would just lead a normal life in National City: you know, I'd get married and have kids, paint on weekends, teach high school, and that would be it. But my life began to change after I moved back. I thought no one was looking or listening to me at that point, so I decided to use text and never touch a canvas. I hired a sign painter to paint the text for me, and I'd say, "I don't want it to look decorative in any way but more like 'keep out' or 'no trespassing' signs." I don't think I could have gotten away with it in Los Angeles because I'd be aware of all of the art around me, and I probably would have been laughed at. In fact, when I tried to show my work around galleries in Los Angeles, that was pretty much the result.

I'm glad I stayed in National City because I was able to find out what was the bedrock for me about art.

So what was the bedrock?

That art making is essentially about making a choice. I felt that was fundamental.

What are some misconceptions about your work?

People think I'm trying to be funny, but my work is just the way I can understand the world. It's a way for me to make sense of it. If I were trying to be funny, it would be a different kind of work. I think a great example is the art teacher's story that I heard, about a painting instructor who tried to throw his students off a little bit, so that they would think differently. And this is back in painting classes with canvases on easels. So, he asks that when they work at their easels, if they could just stand on one foot. This would give them a sense of asymmetry or disharmony or whatever. It sounds really funny, but it made perfect sense to him. Do you see what I'm getting at? I think that explains it.

I spell things backward because I get tired of spelling them the right away. I said: What would happen if I spelled it backward? What would it be? What kind of word would that be? I think it's about having a restless mind and taking things apart, putting them back together again, taking them apart, and putting them back together again. It's a kind of boredom.

Tinkering and making things comes from boredom?

Well, that's exactly what kids do all the time. They make-believe airplanes or whatever out of stuff they find around.

The artist as a scientist...

Art is play. It should be about play. If I can't sleep, I make up word games in my mind instead of counting sheep. I'll take a word ending in, for example, i-n-g, and I'll go through the whole alphabet. Okay, "A" doesn't work, but "B," being, "C," seeing ... I see how many words I can get out of each letter. Finally, I fall asleep. I made a whole series of works called "Blasted Allegories" that are all about word-image games: I make up a game, and then I play it, and that's the piece.

got a job teaching in the San Diego public high schools. And then I taught at the La Jolla Museum for preschoolers, a program that was funded by Ted Geisel, [known as] Dr. Seuss. Then I taught junior high in a ghetto district. And I taught juvenile delinquents for the California Youth Authority. I taught adult school and community college prior to teaching at the University of California, San Diego. Then I was asked to teach at CalArts. In the mid-1980s, I got a Guggenheim grant and left for a

My guess is that when you were a teacher, you provoked students to think and to look. What age groups did you work with?

I've taught every level imaginable. I got my B.A. degree at San Diego State University, and I began teaching right away because one of my instructors got ill and asked me to take over his classes. My second experience was teaching a Saturday life-drawing class at the San Diego Fine Arts Gallery. Then I

while. I started to miss teaching, so I called up friends at the University of California, Los Angeles, and started teaching there half-time. I quit from working there about four years ago.

Obviously you love teaching. Why do you love teaching so much?

I got my degree in art, and my sister said, "How are you going to support yourself?" So, I got a teaching credential. But I get bored easily, and to make teaching not boring, I decided to approach it like art, and

that of course means invention. Teaching at CalArts was really helpful because we had no grades, no curriculum. Students came to a class because they wanted to; there was no reason they had to. We actually let some instructors go because they didn't have any students. Teachers had to be inventive.

I think of ways to make my time in the classroom like I'm making art, in some way. A vital lesson for me was learning that teaching is about communication. Lecturing doesn't do it. You have to see the light in the student's eyes; you have to see that they get it. If you don't see the light, then you try another approach and then another. I realized that this attitude—that you have to communicate was filtering into my art. Teaching and art began to cross-pollinate, and one affected the other. I realized that art was about communication. I was learning how to communicate by teaching. In effect, I was saying: the art I do is what I'm talking about in the classroom and vice versa, and they're interchangeable.

I think I wanted to be a social worker. My father was Catholic, and my mother was Lutheran. We went to a local Methodist church, and I certainly got a love of literature reading the King James version of the Bible. I developed a strong sense of moral obligation, and I think that's why I was a late starter in art. From what I could see, art didn't seem to do anybody any good. It didn't heal bones; it didn't help people find shelter. Teaching juvenile delinquents was a real eye-opener for me because they had a stronger need for art than I did. And they were criminals. We had no other shared values, but they cared more about art than I did. It dawned on me that art must provide some sort of spiritual nourishment.

What have students taught you?

That's really a good question. I wish I could remember the different stages of teaching: I remember the first one is that you think you know everything, and the last one is that the students are teaching you, but I forget the stages in between. You can probably figure them out. I can't think of anything specific, but I think I learn a lot. I think one good thing about teaching is that students are less kind than your peers. If they don't like something, they'll tell you, whereas your peers are more cautious. That's valuable. And a lot of the times, they are right on. ∎

Politics, Process, and Postmodernism

Mark Bradford reveals his personal evolution as an artist, from making signage for his mother's hair salon as a child to the additive and subtractive processes evident in his current work.

Interview by Susan Sollins at the artist's studio in Los Angeles on June 17, 2006.

Art21—Do you think of your work as political?

Bradford—An artist has a choice to be as political or apolitical as anyone else who's making choices. So, I don't think an artist is necessarily apolitical if he or she doesn't make overtly political work. But so much of contemporary art is engaged in the ideas that are circulating in the atmosphere, in the press and the media, and oftentimes we're influenced by that. So, it seems comfortable to me to have that bleed into my work. For me, the subtext is always political. You look at a sign and you realize it belongs to popular culture. But on another level, the sheer density of advertising creates a psychic mass, an overlay that can sometimes be very tense or aggressive. The colors shift; the palette becomes very violent. If there's a twenty-foot wall with one advertisement for a movie about war, then you have the repetition of the same image over and over: war, violence, explosions, things being blown apart. As a citizen, you have to participate in that every day. You have to walk by until it's changed.

Your mixed-media collages, like *Ridin' Dirty*, incorporate bits of found signage and advertising. Do you know other artists working in a similar way?

Immediately my thoughts go to Robert Rauschenberg's combines. What he was gathering was found. But it's interesting because he found a lot of furniture, cans, and boxes—domestic throwaways. I think if you fast-forward to now, you would see less domestic and more media throwaways. I think if Rauschenberg were pulling from the streets now, he and I would be fighting for the billboards.

Is your process with the collages more additive or subtractive?

My practice is décollage and collage at the same time. Décollage: I take it away; collage: I immediately add it right back. It's almost like a rhythm. I'm a builder and a demolisher. I put up so I can tear down. I'm a speculator and a developer. In archaeological terms,

I excavate and I build at the same time. As a child I wanted to be an archaeologist, so I would dig in my backyard. When I was six, I was convinced that I could probably find a dinosaur bone there, but after about a week I realized that it was only in particular places that you find dinosaur bones. It was not like my mother stopped me. She was very good about allowing me to do, as she called them, "projects."

Can you say more about these childhood projects and the influence your family had on your development as an artist?

My art practice goes back to my childhood, but it's not an art background. It's a making background. I've always been a creator. My mother was a creator; my grandmother was a creator. They were seamstresses. There were always scraps of everything around. There were always two or three or four projects going on at the same time. We just never had an art word for it. But I would go to the museum as a child, and I was bored. They would tell me about art, and I would look around and say, "This is art." Then I'd get on the bus and go home. It never touched me. But the projects at home touched me. For instance, making the signs for the prices at my mother's hair salon: I was in charge of that, so I taught myself calligraphy. So, my very early work used signage and text, but it was not perfect. It always got a little slimmer at the end because I wouldn't measure it properly. But it worked out. My mother always said, "When I raise the prices, you'll have another chance."

When was the shift, from being a maker to being an artist?

There wasn't really a light-bulb moment at the shift from the idea of just making to the idea of being an artist. At CalArts, there was no shock, no "Oh, wow!" There was no "uh-huh" moment. But there were bodies of ideas, writings by people who were basically writing how I was born. I felt like I'd discovered friends in these books and writers, these revolutionary people. It was like a coming home to language, to people who were critiquing, questioning, remixing larger bodies of ideas. It was the reading, the writing, the written word—not so much visual art, photography, painting, sculpture. But the written word can be poured into any vessel. I do it now. It's poured into video, into a painting, into a public-domain practice. It's the idea that holds it together for me.

I never knew what the postmodern condition was before I went to art school. I never knew about Michel Foucault, bell hooks, Cornel West, or Henry Louis Gates, Jr. But even though I had never read those types of writings, I lived with people who were living those types of lives. I remember coming home and telling my mother, "You know, you're postmodern." She'd say, "Oh, that's sweet."

What did learning about these things, such as the postmodern condition, mean to you at the time?

When I started thinking and reading about the postmodern condition—or fluidity—I saw it as taking independence. It was revolutionary for me that you could

This page and previous: Mark Bradford at work in his studio, Los Angeles, 2006. Production still from the *Art in the Twenty-First Century* Season 4 episode, "Paradox." © Art21, Inc. 2007.

put things together based on your desire for them to be together. Not because they were politically correct, not because they are culturally comfortable or sociologically safe, but because you decide they're together. If you decide those tennis shoes and those polka-dot socks are together, they're together because you say so. I had always done that, but I was aware that it wasn't always the "right" thing to do—not because I didn't feel it was right, but because I was made aware by some people (in society, say, or in school) that that behavior was not correct. So, my mother and I would go to the store, and I'd get a G.I. Joe and a Barbie, and I'd bring them to school when we had Show and Tell. "So, which one is yours?" said the teacher. "Both," I said. "Well, that's not going to work," she said. "Why not?" I asked. And she answered, "Well, what does your mother think

about this?" I was always supported in the domestic realm, and I was always strong about standing up for myself, but there were still struggles in my life. Reading about these kinds of conditions made me realize it was about independence, about doing your own thing. And that's a state of mind. It's not an artwork or a book. It's a state of mind. Fluidity, juxtapositions, cultural borrowing—they've all been going on for centuries. The only authenticity there is what I put together.

I take comfort in histories and knowing that something came before me and something will come after me and that I'm just part of it. Sometimes students will say, "Well, it's all been done." But I think, "Who cares? What does that have to do with anything?" I wouldn't be painting if I cared about that. Okay, it's all been done—so what? You have to figure out how to do it for you. ■

Childhood

Nick Cave recalls the impact of the community in which he was raised and how that encouraged him to pursue his creative interests.

Interview by Stanley Nelson at the artist's studio in Chicago on December 15, 2015.

Art21—How and where did you grow up?

Cave—I grew up in Fulton, Missouri—one of seven boys. We lived in a small community with a sense of trust and infrastructure that raised us and really kept us together. I'm very close to my brothers. We were built on this unconditional love, where we are connected and take care of and love each other. It's been extraordinary.

I grew up around other families and kids. It was the sort of network where other parents were responsible for the wellbeing of each and every one of us. If at six o'clock I was supposed to be in the house, but I'm walking down the street, a neighbor would say, "What are you doing outside? Does your mother know that you're out here?" There was a sense that these guardians were around me at all times.

Your family wasn't rich, but did art play a role in your family?

Every night my mother would prepare dinners for us and for this other family that didn't have food. As kids, we would take turns bringing food to their house. I didn't know that I grew up without wealth but I grew up unaware of a division between us and them. Growing up with this sense of care and compassion really changed my perspective. I grew up with things you can't buy. You can't buy affection; you can't buy an unconditional connection. You can't buy trust.

As a kid, I was one of two creative individuals in the family. I have a brother, Jack, who's also an artist. We grew up learning, being immersed in making things out of nothing. Because we were not privileged, I was making stuff out of whatever was around. When we didn't win first or second place in art shows, my mother talked us through it, the whole process—that we were still special, still lovely. This amazing infrastructure really cushioned us.

Once, when I was probably twelve, we were going to the grocery store and my grandmother said to me, "You have Papa's soul," and she put her hand on my forehead. There was a sense of exchange, a sense of me receiving something. For some reason, I knew that was going to be my guarding, the protection that I needed; I think it has allowed me to move accordingly with my life.

Were you an artistic kid? Was art a big part of your childhood?

It was and wasn't, at the same time. I was struggling amid six siblings with only sports in their heads. I wasn't quite interested in sports, but I was trying to find my interests and my way yet still stay connected and be part of this community, in terms of what kids do.

But art has always been part of exercising my interests. I didn't have access to materials. But I was able to create things based on what was accessible, like surplus or whatever was within my surroundings. It was really about hands-on building things.

My brother Jack and I, in high school, would have these competitive moments, to see who could more quickly paint a watercolor still life or who could better finish an oil painting. I think that energy conditioned me to understand how to handle oneself in a creative situation.

You went to Cranbrook Academy of Art for graduate school, right? What was that like?

It was a bit shocking at the beginning because I was the only minority student there, in 1988. It was difficult because it was the first time that I was confronted with my identity as a Black male. Prior to arriving at Cranbrook, it never entered my mind or my existence, and I never thought that I would be the only minority student there. I tried to understand what that meant, by making a series of drawings about my identity. It was a lot to work through, but it gave me something to respond to, right away. At Cranbrook, students have to design their own pathways, and addressing my identity gave me something to talk about, which was a great initiative to jumpstart my process.

It also seems like that experience gave you focus.

I wanted to address and express in my work the awkwardness, the discomfort, and how the experience made me feel. I started to make work that was about the isolation of my upbringing and my separation from that: Why does it feel uncomfortable to be the only minority at this school? Am I uncomfortable with myself as a Black man?

Tell me about the first *Soundsuit*.

The first *Soundsuit* was made in 1992, in response to the Rodney King incident, the L.A. riots. I was following the story; it made me think about what it feels like to be discarded, dismissed, and profiled. It affected me psychologically: I thought, the moment I step outside of the privacy of my home, I could be profiled. I'm an artist and a professor, yet I could be in a situation in which my career has no effect on what I look like and how I'm perceived.

I was reflecting on that while sitting in the park one day, and I looked down and saw a twig on the ground, as something discarded. Then I proceeded to collect the twigs in the park. That became the catalyst for the first *Soundsuit*.

I brought the twigs back to the studio and started to build a sculpture. I wasn't even thinking about the fact that this could physically be worn. When it was done, I realized that I could put it on, which put everything in perspective.

Number one: I was building a sort of second skin, which operated as a suit of armor, something that could shield me from society and the world. Number two: it was scary and familiar. It made me think about when I cross the street and hear car doors locking.

Then I realized that when I moved, it made sounds. I thought about the role of protest: in order to be heard, you have to speak louder. And I thought of the outrage of the community that came together, of people who were emotionally charged and disturbed by that incident. Out of all that came a performance-sculpture that changed the direction of my art process. I'm lucky that I had art as a vehicle to express my emotions because I don't know what I would have done without it, how I would have handled what I was feeling about that incident.

The impetus for the *Soundsuits* originally came from a scary place. But it's also kind of fun, which makes your work interesting.

I don't ever see the *Soundsuits* as fun because they really are coming from a very dark place, but I devise strategies to get viewers onboard, to pull them in. And once they're in, then there are deeper and more radical meanings. I'm interested in bringing viewers on this journey, but I've got to find a way to make it somewhat comforting, accessible, and not difficult because people tend to shy away from difficulties. Once viewers are in, they decide whether to explore what is confronting them or to turn back and head in the other direction.

If work is hard, we tend to not want to respond. I choose to seduce you with beauty; once I have your attention, then we can

Nick Cave at work in his studio, Chicago, 2015. Production still from the *Art in the Twenty-First Century* Season 8 episode, "Chicago." © Art21, Inc. 2016.

　　　　Nick Cave

have a discussion. It's about how one chooses to enter the work. For me, it's very dark. The surface may not be dark, but what's behind the work is very political.

I meant *fun* as a positive term. It's part of what makes the work so engaging.

I think a lot of the work is fun because it stems from nostalgia. A lot of my materials are things that we're familiar with, things we grew up with. It's about the excessive abundance of stuff; I am negotiating its roles, in the way I build the work and change the value of these things.

I think about my grandparents and the values they placed within the family structure. They were makers and builders, and I'm celebrating that along with ideas that are associated with craft. I've always been interested in sitting on the fence [in answering the question]: Is it art or is it craft? With my work, I like to create spaces where the conversation opens up these issues, so we're able to talk about them.

Talk a little about the juxtaposition of images in your work. How do you go about assembling a new sculpture?

I don't like to think about it a lot; I look at the objects and I know. A conversation starts to build. What that is and where one may take that is up to the individual. I see partnerships and relationships when I'm searching for materials. I'm taking A and putting it with W, and the chemistry between them dictates the spirit and the energy around the piece. I just make that happen and then let it exist in the world. I want to keep the process loose and organic,

and allow everybody to develop their own narratives in relation to the work.

One thing will provoke an idea. I take a found object and move it around the body until I find where I want it to exist. My process is really off-the-cuff. I'm not creating from a sketch. I'm making decisions along the way about construction, about how to bring one element to the next element: what is the fusing, the mortar, that's holding these things together? I'm always thinking about new ways to approach that.

Your work has an amazing intricacy.

Based on principles of construction and how things are built, one can manipulate and advance materials while creating the work. It creates a different vocabulary. It broadens and secures it. It has solidity because the material becomes part of the building of the work. ∎

Earliest Influences, Early Works
Vija Celmins discusses learning to look at paintings and her early attempts to make her own.

Interview by Susan Sollins at the artist's studio in New York City on March 27, 2003, and the artist's studio in Sag Harbor, New York, on April 24, 2003.

Art21—I'm curious about this old painting you have in the studio. Have you been thinking about its qualities, in terms of what you're working on now?

Celmins—Well, I did this painting about 1965. I was going to do a show, so I had it out, and somebody was writing something. I actually took it out about a month ago, to show this person from London an early work. I think I painted this in the middle of the Vietnam War. I was sort of remembering the planes when I was in Europe myself, in 1944, just a small child. I remembered the airplanes. I'd never seen one, of course, but I heard them. They were this sound. There was something thrilling about it—I always liked airplanes—and then, of course, frightening. I'd seen them in World War II, and I painted this during the Vietnam War. We have another war now. It's sort of like an image of a war machine. It's quite beautiful, in some ways, and kind of a dramatic image. It came out of me painting objects—single objects on the still life—and then I sort of shifted, like I tend to do every now and then. I shifted to painting objects that were found in photographs that were no longer objects now but machines. Mostly airplanes. I think of them as sort of still lifes.

What's kind of amazing about this painting right here, now, is that my recent work is more intellectually mangled. There's something more intellectual, in a way, with more of a pressure of the mind on them. They're so flat, and this painting has such an illusionistic space in it. I think I remembered kind of feeling the joy of being able to paint anything. At that time I painted a lot of different objects, things that turned on, like my hotplate and the lamps. Things that I had—pretty much everything I had in the studio. Then I started painting images of little clippings, and this is one of them. So, I liked the painting. I'm trying to see whether it can hold up to my having had maybe thirty-five years of painting after it. I still like it... I don't know... maybe I like it. It still seems like a pretty strong painting.

I'm interested in the fact that you held onto it for so long, that you didn't let anyone snatch it away.

Well, I saw that some people were beginning to buy these works—and thank goodness nobody wanted this one by the time I came around to valuing it myself a little bit. I had

a habit of painting and throwing work away because I thought that the painting part was where I learned and went through things, and I didn't pay that much attention to the painting afterwards, sometimes. I would throw away a lot of work, and I kept this one, so that's nice. What can I say? I mean one of the things that it has is that strange quality of being kind of flat and also illusionistic. Of course, it's more illusionistic than the work I do now.

They seem to have a complete stillness.

One of the things that I guess is sort of interesting is that the airplane is moving, of course, and is up in the air, and yet it has this certain very still quality. Of course, I think stillness is one of the pleasures of painting—that it's a surface that doesn't move and that is still.

What about time? Your work seems to have something about time or timelessness.

I don't know. I really can't tell you about that. I don't try for things like this. Sometimes, now that I've reflected back on my work, I see some of that in it, but it's a quality that seems to be (maybe) because the paintings are so thoroughly realized. That's not something that I ever think about.

The making of the paintings— the kind of brushes, the kind of concentration and the amount of time it takes, and the sanding—to me, it all has a quality of meditation. Is there something about that that you like?

Well, I think I like the reality of preparing the canvas. I like to make that reality really real. I like the image

coming and going. I like to sand the image off and have it come again. I guess it's a kind of a futile attempt to put something in there that is sort of dense. Maybe you could say there was time. It's certainly a record of time spent on one small surface, sort of shaping it over and over in slightly different ways, different days. In a way, it's a kind of composing without composing. That's what I can think of saying about it.

Do you think having the airplane painting in the studio influences what you're doing now? You made art as a child...

I did a lot of drawing, of course. We all did drawing; that's how it started. You know, you're little; you start drawing, just keep drawing. It sort of makes a certain kind of life. I used to read and draw a lot. I made a sort of world.

Did your parents encourage you?

No, they did not. I did it in spite of my parents. They were busy working. They worked very hard, and they didn't pay any attention to me. I mean, they didn't say, "Stop drawing"; they didn't say, "Start drawing." They left me alone; it was the old-fashioned way. They didn't pay any attention to it. I must have just gravitated that way.

I remember once, though, of asking my mother to draw a flower for me when I was maybe about seven, in the kitchen. This was in Germany. What was so wonderful is that I thought that she could do something that was really magical. And she drew this little pansy, which I've now planted around. I sort of like the pansy; it makes me

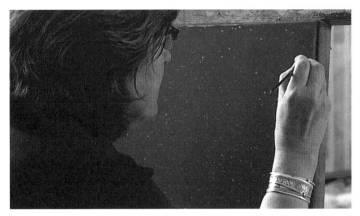

Vija Celmins at work in her studio, New York, 2003. Production still from the *Art in the Twenty-First Century* Season 2 episode, "Time." © Art21, Inc. 2003.

remember my mother. And she was not a draftsman, but she drew this little pansy—two little ears and one down and then a little face. Like pansies have a little face! I thought it was the greatest thing I'd ever seen; I loved it. I mean, who knows—maybe somehow I thought to myself, "I'm going to be able to do this sometime." But I didn't want to do it; I wanted her to do it. And my sister, I think, also drew. And my father also drew. We just did whatever. He drew plans for houses, and he built houses and did all that stuff. Nobody ever talked about anything like that, and we just left each other alone.

Were there people along the way who encouraged you?

Oh, yeah, when I went to school in the United States, I really couldn't speak English. And I couldn't speak German either. But I didn't go to German school; I went to Latvian school. I started drawing in Latvian school, but I don't think they really encouraged drawing. I think they encouraged drawing and creativity much more in the States. They have a lot of rules about what children should do in Europe, if I remember correctly. I used to have to stay after school all the time. I was testing those rules. I sometimes used to stay 'til the night classes came in. And they'd say, "What are you doing there?" You had to face the wall, you know. And I had done something, like—who knows what I did—throw things.

In America, I used to draw all the time because I couldn't really understand what they were talking about. So, I used to draw things, and then teachers were always encouraging me. But I guess that was something. I think teachers encouraged me to draw and paint, and I suppose that was something because we didn't have the habit of doing that in our house, encouraging

each other to do things like that.

And art school?

Yeah, and then going to art school. It turned out that maybe I had some gifts in that area, so I had a lot of encouragement. But I was also very rebellious and inward. I don't know how to talk about it. Something, I suppose, that many artists felt—sort of outside of society a little bit. Then when you go to art school, you feel like maybe you've found some place where you can feel a little better.

When you could speak English?

I came when I was nine, so probably a couple of years later. I mean, I don't express myself well; I never judged myself that way. I think I could speak English; I played with kids. When I came, they put me in the fourth grade. I think by the sixth grade, I was trucking right along.

Are there visual things that inspired you early on?

I think I remember there was a picture of the opera house, in my house in Latvia. And when I was about twelve, I had a photograph of it on the wall, and I did a copy of it.

Is there an early painting that affected you?

No. I was sort of awed and scared of museums. It takes a long time to learn how to look at paintings. I didn't know how to look at paintings. And it took a long time to learn how to sort of figure out what it was about and to see them. I don't remember one painting that really, totally knocked me over until I went to Europe and I saw the Giotto chapel in Padua. That really knocked me over—maybe all that glorious blue or something, and those little compartments

with extraordinary scenes in them. It was really a great work. I got turned on by a lot of art then.

Before that, early in art school, what did I draw? I drew things that girls draw, you know. I used to draw movie-star pictures out of movie magazines. I used to draw horses, heads, and faces. I tried the really amateur, dopey kind of stuff that children do. I guess a lot of kids now draw comics; I never really drew comics. I don't know why—I love comics. I think I learned English from looking at comics. I used to look at *Nancy*. She didn't speak much, did she? Was it Tubby and Nancy? Or Lucy? Lucy had the head like a bean, remember? And Nancy had the hair, the round head with the little spikes in it. ■

Intergenerational

LaToya Ruby Frazier describes the external factors at play in her work and the rapidly changing socio-economic landscape of her hometown of Braddock, Pennsylvania.

Interview by Nick Ravich aboard New Jersey Transit on December 8, 2010, and by Wesley Miller at The 1896 Studio in Brooklyn, New York, on March 7, 2011.

Art21—Was art part of your childhood?

Frazier Art has been in my life from the beginning. I started drawing and painting and thinking about art when I was about six years old, in kindergarten. The school district that I attended was very big on the arts. The arts were almost equal in importance to the football team. The art department had its own section [of the high school]. Students were in a lot of art competitions in Pittsburgh.

What is your relationship to Pittsburgh?

I was born and raised in Braddock, Pennsylvania. One side of my family has been there since the 1700s; the other side migrated there in the 1800s. My family has witnessed and lived in drastically different socioeconomic climates in Braddock.

My grandmother grew up there when it was prosperous, in the 1930s. My mother grew up there in the '50s, when the steel plants started to close, and she was around during segregation and the White flight to the suburbs. I grew up there in the '80s, when the government unleashed crack into our community to finish us off. Through the twentieth century and into the twenty-first, we've internalized the history of what American capitalism can do to people. So, I started making work there. For the past ten years, I've been making photographs there. I began with analyzing and dealing with the domestic, interior spaces of our family within the home and how the outside socioeconomic factors dictate the roles of family members and how we relate to each other.

My mother became an active participant; she became an artist herself. Her voice and her images are incorporated in the work. We started making videos together. My grandmother was always a collaborator as well, making images. The works are self-portraits. But I view the three of us as one entity that exists in the vortex of Braddock's history.

How singular is Braddock?

In making the work about Braddock, I'm talking about the parts of American history and the impact of the industrial

LaToya Ruby Frazier performing in a costume of Levi's jeans in front of the Levi's Photo Workshop, SoHo, New York, 2010. Production still from the *New York Close Up* film, *LaToya Ruby Frazier Takes on Levi's*. © Art21, Inc. 2011.

Previous: LaToya Ruby Frazier, *Momme Portrait Series (Heads)* (2008). Installation view at the Studio Museum in Harlem, New York, 2011. Production still from the *New York Close Up* film, *LaToya Ruby Frazier Makes Moving Pictures*. © Art21, Inc. 2012.

revolution—the part that people won't tell. People are always proud of America being the creator of steel, but they don't highlight the flipside of it or what happened once those steel mills left the country and closed. I see Braddock in line with what happened in Detroit, in particular, and in Cleveland, and also globally. When industries close, the infrastructure that's left behind becomes toxic and hazardous. It's never removed or cleaned up. The industries let it fall apart.

How do interiors and private spaces relate to this?

It's my belief that one should not separate the public and the private because what happens in the private home, in the domestic sphere, is affected by things that are going on in the community, things that are connected to economic status and to a place that's vibrant and flourishing. I noticed the psychological differences in the way that my mother and my grandmother and I viewed ourselves as women from this community: the way that we look at ourselves, the way that we have a familial gaze with one another or an intergenerational psyche connection based on coming from this specific place.

Through my work, I talk about my experience being a postmodern subject from a post-industrial place that is still in the process of becoming de-industrialized. It's about being this de-centered self, coming from this distinctive historic American period of the steel industry. The connection of the outside world to the family portraits demonstrates that one's environment has an impact

on the body: it shapes the body, it shapes the way you stand, it shapes the way that you think and how you present yourself to the public.

Do you still spend a lot of time in Braddock?

Yeah, I'm there every other week, continuing the documentary work that I've been doing for the past ten years. Each time I go back, there are significant changes. I'm very concerned about how we, the residents, and the history of our community are being erased. Sometimes I have anxiety because the gentrification is happening so aggressively and rapidly that I feel like there's not enough time to catch it.

I'm committed to making my work in Braddock. Even though my gallery and I are in New York, it is important for me make the public understand that my work is made in a specific geographic location.

For the past three years, I've been the curator at Rutgers University, at the Mason Gross School of Art, where I've curated a number of shows. So, I've worked with a lot of artists, both national and international, and have taken on some pretty intense installations, like the ones for Simone Leigh and Chitra Ganesh. I also teach in the photography department. I'll teach whatever they need, from intro classes to black-and-white, to color, to digital photography. So, I go back and forth about ten to twelve times a week, and all my money goes to New Jersey Transit, unfortunately.

In addition, I'm a working artist. Whenever I'm not teaching and not curating, I'm usually at a residency program. I'm currently in the Whitney Independent Study Program. I prefer to be in a program so I can stay connected to other artists and be a part of that community because, coming from Pittsburgh, it was really hard to understand how to maneuver in New York City's art scene. But now that I've been here for three years, I've been able to build respect from my peers and develop collaborations and ideas.

Your schedule seems pretty busy.

I don't get much sleep. On average, I might get three to five hours of sleep. I'm usually up by 7:30 am. By the time I get through my whole schedule, I might get home about 2:00 am, try to do a couple of things for myself, and go to sleep so I can get back up at 7:30 and do it all over again. I don't get the weekends off, either. When you're an artist, it's a 24/7 job. ∎

Contending with the History of Painting

Katharina Grosse shares how artistic theory and conceptual art challenged her understanding of painting as a medium.

Interview by Susan Sollins at the artist's studio in Berlin on December 1, 2013, and at Hamburger Bahnhof in Berlin on December 2, 2013.

Art21—What makes the role of being an artist so exciting?

Grosse—I find it fascinating that as an artist, especially as a painter, I do something that is not being processed through the media or through a machine but that is directly traceable to me as the author. I have the responsibility of what is seen and can make decisions based on that responsibility.

How do you understand this responsibility? There are many artists who are involved with social and political actions...

I've become dubious about the idea that art might only have relevance if it touches upon the political impact that we have, as individuals, on society. I find that art is often misused. There are so many ways that we interact, which might have more than political impact. I believe there are many reasons why we are here that may be of a spiritual nature. I just like to see something totally amazing in painting; that's why I do this.

When did you begin to paint?

I was painting as a little kid, early on. It was natural to paint things. But I wasn't the kind of kid who would get an oil-paint kit from her grandmother and all of a sudden paint self-portraits. I just loved to make things. I remember we would go into the woods, close to our house, and do stuff there. I would come up with ideas, like constructing a hammock and pretending that I knew how it worked. I didn't, but I orchestrated all the kids in peeling off bark from trees, and we would interweave the bark, hoist it up on trees, and make these land-art things from it.

The rural area where I grew up has a history of the Informel [art movement]. One figure I already knew about when I was a little kid was Emil Schumacher, who made huge gestural Informel paintings. My teacher for my first lessons in painting came from that tradition.

Which teachers or artists really interested you, during your studies?

I spent a long time studying. I began to study in a small art school in Münster, which is in northern Germany and is known for the Münster Sculpture Project.

42

I was very inspired by my teacher Norbert Tadeusz, who was a colorful figurative and narrative painter and used raw colors, like yellows and blues and reds. I always have had a fascination with the unmixed palette.

Tadeusz introduced me to Renaissance painting, and I began to look at originals in the big museums in Europe and wall paintings in Rome and Naples. He would not teach me anything about conceptual art, so I would only think about the work while making it. Later, I came to find this a deficit, but it didn't occur to me as a student that there could be something else than making the work.

Why did you feel that this approach had a deficit?

I think the teaching of theory in the German art schools was neglected in those days. Compared to English or American schools, German schools did not implement theoretical training and thinking as strongly.

I began to understand this when I was studying at the Düsseldorf Art Academy. I grew up in an era when painting came back [in fashion], just before photography became so strong with the school of Bernd and Hilla Becher. There was a wave of figurative paintings, labeled "wild new painting," that was clearly a movement against the minimalist theories of the 1960s and '70s. The idea was to be in the medium and to not reflect on it, in the sense that one reads, talks, and thinks about theory. The Courbet quote, "silly as a painter," is taken out of context—I later understood that Courbet was a very conceptual person—but my teachers always confronted me with that saying. I couldn't make sense of it because I felt that I had so many talents that I couldn't use when doing my work. That's when I started to develop a different take on my system and on how to make my work.

You mentioned that Courbet was a very conceptual person. What do you mean by the term *conceptual*?

That's a very good question. The faculty at my first art school included a German conceptual artist, Reiner Ruthenbeck. He was one of the first people to point to the big step that artists took after the war: You can make a concept—like a cross with this kind of red and that kind of blue, painted on the wall this big—and you can send it to the United States, and Leo Castelli can have this piece executed on the gallery wall. You don't have to make the work, yourself; you can think about and design it, write it down, and have it made by somebody else. In those days, that was an unusual thought in Germany, and not many people would start to think that way.

But the term *concept* also has another notion, of course, which means that you project a strategy that could make you act. That activity, then, allows you to explore the strategy and maybe make it produce something that has visually nothing to do with strategic thinking but that internally follows the strategic thinking.

Is that why you moved away from doing works that were flat and began moving into space and working with three-dimensional forms?

Yeah, that is exactly why I

started to use other surfaces than just the canvas and its relationship with a wall. I asked myself: How could a painting be shown in a space, and why do paintings always follow the given walls? Could painting be shown in a different way, other than affirming or reaffirming the functions that walls have in a space? Could painting behave differently in the given space? And it dawned upon me that the painting could sit anywhere. It could sit up in a corner. It is as fluid as a film, as something that can sit everywhere and that has no site.

What do you mean by *site*? Traditionally, paintings are not site-related unless they were commissioned for a specific space.

A painting could always be transported to other places, but the surface of the painting or the canvas itself had to fit the wall. Somehow, the space that was given to me to show my work was always confirmed by the surface of the painting, and I thought that was wrong.

A number of Abstract Expressionist painters were involved in gesture. Were you interested in them?

There was a time when I was very interested in the gestural painting of the Abstract Expressionists. However, I always saw them in relationship to the history of European paintings. For example, I found the vast expansive flower paintings by Monet are very related to [paintings by] Pollock.

When I began to study art, I saw a huge Pollock show in Paris. There were many paintings I had never seen in the flesh. On the same trip, I also saw Bonnards and the early Matisses in person for the first time. I realized that I loved them all and saw them on the same level: the early Matisse paintings, with the thick orange and red and little blue dots, were just like the Pollock paintings that show the canvas and the drips.

I was inspired by the Abstract Expressionist [paintings] less for their gesture and more for the questions [they raise]: How does the color or the paint sit on the canvas? And what kind of information does it give to you? ∎

Katharina Grosse at work in her studio, Berlin, 2013. Production still from the *Art in the Twenty-First Century* Season 7 episode, "Fiction." © Art21, Inc. 2014.

Becoming An Artist

Rashid Johnson reviews the early experiences that led to the materials he uses in his work.

Interview by Nick Ravich at The 1896 Studio in Brooklyn, New York, on March 5, 2011.

Art21—To you, what are ideal contexts for seeing art?

Johnson—It's always great to visit the studios of my peers and see the bones and the inner workings of what they do and how their work is brought to life. In that environment, I begin to witness a practice.

Is an artist's studio the best context for the art?

The question becomes: what are the intentions? What are we trying to get from this environment, this person, this experience, this opportunity, and this access? In the case of having the opportunity and access to an artist's studio, to look at their practice or talk with them —on Tuesday I'd tell you a different thing than I did on Wednesday.

Does one need to be there on both days to get a full picture? Or can we just paint Tuesday's picture? Contradiction is a big part of what most artists go through every day in their studios. If, after visiting an artist's studio multiple times, you sense a natural fluidity, then you probably missed the right days. You should be hearing something completely different one day than what you hear on the next day, whether it's enthusiasm or absolute self-pity over a project.

I think most artists have spent a lot of time with that roller-coaster experience. I think the best artists are loaded with contradictions and complexities that are difficult to capture.

Can we come up with a narrative about it?

Probably. If there's a simple anecdote that seems to describe what this person does, there are two options: one, that this person is not making interesting things; two, that you simplified what is probably a far more complex process.

How did you get started in art?

When I was 17, I got a job as an assistant to a wedding photographer in the Chicago suburbs, Larry Stern, and he was a really engaging character. He was doing portraits at the time. I was interested in the way that he interacted with people as he photographed them. I responded positively to the idea of making portraits, of taking these still moments and having the opportunity to engage with someone, one-on-one. I guess I was as interested in the conversation that would result as I was in the final document of that relationship. That led me to go to Columbia College in Chicago for photography, with an interest in trying to also do something in film.

Was he the first artist-photographer you knew of?

No. I got a camera after I started working for him, and I realized that I was not interested in photographing people at all, like I thought I would be. I started photographing clouds. I talked to a few people after I developed my photographs, and I was introduced to the work of Alfred Stieglitz. I started looking at Stieglitz's *Equivalents* photographs. Stieglitz was the first artist-photographer who I understood as being an artist more than a picture maker or a person with a camera.

You wanted to make beautiful photographs.

Absolutely. I am an aesthete, at heart. I wanted to make beautiful photographs, something interesting to look at, something that would open up the opportunity to have a bigger conversation. I've always been interested in attractive things. I think that I've never shied away from that.

You quickly became a working artist.

Yeah, it happened fairly quickly for me. I was maybe 19, a sophomore or junior, and I was making a body of work that I thought was interesting. I'd overheard a couple of my professors talk about an exhibition at a gallery run by Martha Schneider, who showed mostly photography and a little bit of sculpture. The title of the exhibition was "New Artists, Old Processes." At the time, I was working with nineteenth-century photographic processes. So, I decided to take my portfolio to the gallery. When I got to the gallery, I was told that they didn't take submissions, and they weren't interested in looking at the work of artists coming off the street. But after I pleaded a bit, Martha looked at my portfolio, and the next week she gave me a solo show. From that show, a few works were bought by the Art Institute of Chicago and the Whitney Museum and then a few other places.

You were pretty courageous.

Well, I think it was naiveté. I think I was an idiot. I wouldn't make that decision today. Now, I would not go into a gallery or go into MoMA with a portfolio and say, "Hey, I'm here with my things; you should look at them." But then, I felt that I really fit in; I had done my research. It's something that I still think is important: how you put your work into the world.

I didn't walk into a random gallery; I went into a gallery that was doing a show that fit the context of what I was making. It was calculated. Obviously, just walking in was probably more informed by naiveté or foolish pride.

Did you have expectations?

I don't know if I had any expectations. I didn't know whether I was supposed to have work in a museum or not. I had a little celebration, like, "This is great; the museum is going to have my work." But at that time, I wasn't sure. The goal for most photographers coming out of Columbia College, as I understood it, was to produce a book and then maybe get a teaching job, to teach other people how to make photographs.

I had never considered that I would have a career of exhibiting my work. I think that changed the way that I produced my art: I was thinking less about how they'd be reproduced and more about

my art as things, as objects to put into a gallery space or to look at. I think it led me to sculpture.

Tell me more about that.

Working with nineteenth-century photographic processes means physically applying the photosensitive chemicals, and I became very interested in paper, materials, and the additive process.

interested in and engaged with the materiality of art to thinking about what the materials symbolize and how they functioned as signifiers.

What did the materials mean to you?

Shea butter, for instance, has been an interesting material for me because it has played different roles in my life. When I was young,

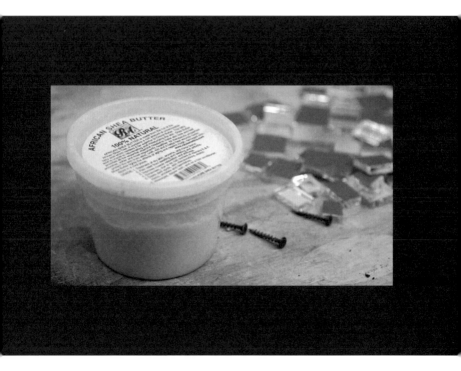

Photography is more often seen as a subtractive process: taking pictures means subtracting an image. I was more interested in the addition of materials and how they were applied and how I was physically participating in the process. It led me to apply other materials, which later led me to melt black soap and wax and pour it. I think it was a natural progression, from being

my mom would bring it back from West Africa, and we'd have it in the house. At the time, I wasn't thinking about the application of an African product to one's body, but over time I started thinking, "We're putting Africa on ourselves, right?" We were essentially coating ourselves with African product.

And shea butter is a healing material; it has been used over the

course of history by people who've been burned. I was interested in this healing property: a material on an art object can have the ability to heal whoever is applying it. That's how I came to use shea butter.

I wanted to take ownership of a few different materials, of some things that I hadn't seen employed in art objects, that I could essentially take as my own, and I developed what I thought was an extensive collection of materials that I could call my own. I think it was also about the opportunity to have another conversation, whether it was about healing materials, about my relationship to them, or about my first trip to West Africa, when I was seeing all these trees with shea nuts on them. These things I hadn't seen employed in art objects in the past, I think they function as autobiographical things or this opportunity to bring something to light that was new or different.

Your works are like specific cultural objects.

While I was making the pieces that resemble shelves, I learned of a book by Lawrence Weiner called *Something To Put Something On*, with characters talking about tables: "I have something for you," "What is it?" "It's on the table," "What's a table?" "A table is something you put something on." I was interested in this idea, of something to put something on.

So, I started making something to put something on. Then I thought: what do I put on the thing that I made to put something on? From there, I started using the things that were around me, whether they were the books that I was reading, the records that I was listening to, or the substances I was applying to my body, like black soap that I showered with or shea butter that I put on my cooking burns. All of those materials began to gel together to form what I thought was my conversation. ∎

Waiting To See What I Would Become

Sharing stories of growing up in South Africa, **William Kentridge** reveals how early experiences influenced his drawing style and describes similarities and differences between South African and North American histories.

Interview by Susan Sollins at James Cohan Gallery in New York City on November 9, 2009.

Art21—What is your earliest memory of making things?

Kentridge—I started off drawing, the way all children draw, which is not unusual. But there were a couple of early experiences that I think were not so usual. One was that I made a really beautiful, bright, colorful painting when I was five, using gouache. It was a splatter painting—like a five-year-old doing Jackson Pollock. A lot of fuss was made over that painting. I don't know what I knew about color then, but I certainly don't know it now.

The other experience was that, very early on, I was taken to an elderly friend of my grandparents, a Welsh artist named Matthew Whitman, who was painting in Johannesburg. I think I showed him some of my drawings, and he gave me a drawing list, explaining how to draw the veranda of his house and where to put the shadows. I was happy to be watching him looking.

While in university, I realized my grandfather's advice that painting should just be a hobby didn't hold much water. But I thought I would do drawing while I wait for the revolution. After the revolution, then I'll see what is needed. Will I be the people's commissar for beautiful objects? What will I become; what will be my role? I couldn't imagine, for example, that the legal system would be the same after the transition as before, which was incredibly stupid. I was drawing while waiting to see what I would become.

I went from drawing into theater school because I was acting at the same time. When that was a disaster, I started working in the South African film and television industry, as a props person and then as a production designer.

Then you started working as an artist?

After working in the film and television industry for a couple of years, I got back in the studio, making drawings, thinking I'd do it for a while and then do something else and eventually discover what I

should be doing. At a certain point, a friend of mine, to whom I'd always complained about what job I should get and what I should do, said to me in no uncertain terms, "You're now 25 or 28, whatever age you are; you've never had a job; you are unemployable. Stop talking about someone giving you a job. No one will give you a job. Do what you're doing and make a success or a failure of it, but stop imagining that there's going to be a different trajectory for you." I said, "Okay, I'll make drawings, fine." I ended up as an artist. It wasn't a decision I made; it wasn't a choice. It was what I was reduced to.

When did you know you were an artist?

When I was about 15, people wanted me to say what I thought I was going to study, what I thought I was going to be when I became an adult—like a lawyer, engineer, deep-sea diver, marine biologist. In one survey, I wrote that I wanted to be a conductor. Somebody said you have to be able to read music to be a conductor, so I changed that one.

Was art always there, in you?

In retrospect, it was always there. It was not something I suddenly started in my late twenties. It had started very early on, even though I'd stopped for a couple of years. Part of me knew I only existed if I made some kind of external representation on a sheet of paper. I think there has to be some psychic need like that for anyone to spend their life making drawings. It has to be about you not being enough. It's about knowing you exist only through other people's responses to work that you have done. I think it's why artists are so bad at dealing with critics because a criticism of the work is not just someone thinking the work is bad. It's an annihilation because, as an artist, one of the ways I know I exist is in making this and showing it. If people don't want to look at it, it doesn't exist; you may think you've done something, but there's nothing there. It's more than someone saying you're wearing ugly trousers today. It's someone saying there's a fundamental way in which you cease to exist.

Did you have artistic family members?

My mother was a lawyer. She says, as in reverse genetic engineering, she became an artist after I was an artist. She spent the past many years painting and drawing with a lot of passion. If one does it well, it becomes an intense kind of looking in a difficult exercise.

What was your family's political history?

On my father's side, my grandfather was a politician; he was a member of parliament for forty years. He began as a socialist, standing for the Labor Party, and after the revolution was berated as a sympathizer of the new Soviet government. Obviously, South Africa had a Whites-only parliament then. In the 1922 strike by White miners, protesting the danger of Black miners taking their jobs, the logo or one of the slogans of the strike—which tells a lot about South African history—was, "Workers of the world unite and fight for a White South Africa."

My family was involved with the legal battles against apartheid, including the Sharpeville massacre and the treason trials in the 1950s and early '60s, which my father was

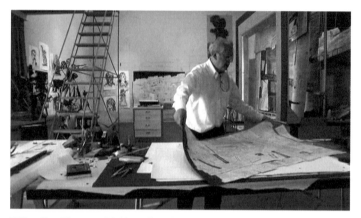

William Kentridge at work in his studio, Johannesburg, South Africa, 2009. Production still from the *Extended Play* film, *William Kentridge: Meaning*. © Art21, Inc. 2012.

a part of, and later, with the Legal Resources Center that my mother founded. Ours was a house in which one was aware of South Africa being an anomaly. Other boys in my classes assumed Whites had the rights and Black people didn't have the rights, and that was the way nature and the world was.

My family was not at the forefront of the liberation movement in South Africa, but I grew up very aware of the distortions of the society and of the unnaturalness of the world I was in. Of course, all White South Africans benefited from the privileges that were their birthright, which is very different than what's happened in the past sixteen years, when there has been a remarkable transformation.

It sometimes strikes me that, in terms of understanding or getting a historical perspective on how things connect to each other, American audiences have been much less attuned than audiences outside the United States. Perhaps it's because American history fills up the heads of a lot of Americans, leaving no space for anything outside of it, or it's a different sensibility. For example, in New York there have been recent museum exhibitions of the work of Gabriel Orozco, Tino Sehgal, Marina Abramović, and me. None of the four of us are from North America; we have a different sensibility, which is not obvious or necessarily straightforward. It seemed to me a lot of people have understood the connections.

There are probably a million people who do not know what you're talking about.

In South Africa, there was always anticipation that there'd be this violent upheaval and

transformation from the apartheid state to a different state, which would be a socialist state, of one form or another. The Communist Party was very strong in the underground movement in South Africa and still is part of the coalition of the government in power now. The ideas of Marxism, socialism, and radical transformation, of understanding a long history of transforming society—they didn't start with the civil-rights movement in the 1960s but predated it by a hundred years. That comes from a different strain, from Eastern Europe and into southern Africa. This fundamental way of understanding the world was clear in Johannesburg.

I'm aware of some similarities between South African history and North American history. A lot of Black South Africans have taken courage from the civil-rights movements in North America, in the United States. But I'm more aware of huge differences between traditions and trajectories that operate in the two places. It's possible for South Africans to understand the context of American transformation and radical movements. The hope is that people in the United States can make the imaginative leap to understand the different context in South Africa as something that is not identical to what Americans have.

Getting back to your art: working in film opened the door for you.

Yes, because it gave me a sense that it was possible to work without a plan in advance and to make it without first writing a script. If you work conscientiously, and if there is something inside you that is of interest, that is what will come out. You will be the film; the film will always be you. A lot of the work that I've done since starting to work with film, even if it's not using that technique, has certainly used that strategy. It had to do with understanding that moving images rather than static images are a key thing for me. The provisionality of the drawings, the fact that one stage of the drawing is going to be succeeded by the next stage, was very good for me, as someone who's bad at knowing when to commit something to being finished. In making the film, the drawing would go on until the sequence was finished, and that would be the end of the drawing. ■

It Was Just a Dream

Kimsooja considers her earliest influences growing up in Korea and the role of *bottari* as a jumping off point in her work.

Interview by Susan Sollins at the artist's studio in New York City on January 30, 2009.

Art21—What is your earliest memory of making something creative?

Kimsooja—In Korea, we lived in a house with a straw roof and it was really cold. Even though we had a stove in the room, when I woke up in the morning there was frost all over the walls. I would scratch the frost, making lines and drawings. Maybe that was my first drawing piece. When I would go outside I'd make little sculptures out of the snow or mix it with sugar to make ice cream.

When did the idea of becoming an artist really strike you?

I think I first had consciousness as an artist when I was in middle school. When my art teacher asked me to go to art competitions, I refused it, because I thought art shouldn't be judged that way or given any prize. So I refused to participate in any competitions. So I think I was already aware of being an artist or of my identity as an artist.

How old were you?

Thirteen or fourteen years old, I think. But I always had a dream of being an artist when I was a little girl. Of course, it was just a dream, nothing really particular. When I was at public school in fifth grade, my teacher asked us to write down two different occupations we wanted to be. I don't know why he asked for two different ones, but I put one as a painter and the other as a "speaker," without knowing I meant philosopher—a speaker not to the public but who gives wisdom to the people. In 1994 when I was preparing my show in Korea, I realized I had been doing both art and philosophy.

Explain how the art and philosophy where manifesting together.

All the questions I had as an artist personally and professionally were always linked to life itself. And I saw art in life and life as art. I couldn't separate one from another. So my gaze to the world and my questions were always related to life itself.

What sorts of questions were you posing for yourself? Were there issues or questions that troubled you or provoked you?

It's very personal. I started sewing pieces, using a needle as a tool, when I prepared bed covers with my mother in 1993. And that was the moment when I was also searching for the inner structure

of the world and also searching as a painter for the structure of the surface. I was mostly interested in vertical and horizontal structures at the time, so I've been trying to see every single hidden structure in that perspective and then trying to find the right methodology to express that. When I was putting a needle into the silky fabric, I had a kind of exhilarating feeling, like my head was hit by a thunderbolt. And I felt the whole energy of the universe pass through my body and to this needle point through the fabric. I just was so struck by that fact and I thought, "This is it. This is the structure I was looking for." And it was interesting, too, because the fabric itself had a vertical and horizontal structure in it. And the sewing had another circulative, performance-like element but, at the same time, always the connection between art and life. And that's how my work started, from daily life activities.

Talk more about the path to becoming artist. There seems, to me, to be a discrepancy between Korea as a society where the roles are very defined, yet it was okay to go to art school.

Korean people are really focused on education. They believe it's the only way to pursue a better life or reach a higher level of society, because the country's very small and very competitive. There's not so much land and job variety, so parents will sacrifice their entire lives for their children. My father and mother were very open. I was raised in a liberal way. For example, my mother would never say no to anything; she always let me do

whatever I wanted. I wish she had said no sometimes, because I might have had an easier time in life. But I do appreciate her letting me choose my own way, so that I could learn a lot and be independent and strong. I think my experience was quite unusual—most Koreans are very restricted and follow traditions and family rules. But society is changing and younger generations are more liberal and can be more independent.

When you were in art school in Korea, did you study any of the traditional art forms? What were you looking at when you were a student?

I studied all the practices— drawings, oil paintings, Oriental traditional paintings, and some sculpture. We didn't have photo or video classes at the time. It's a strange thing to say but I actually majored in Western paintings. That meant I had to make oil paintings and learn Western art histories as well as Oriental art histories.

Who did you think were the masters when you were a student? Whose work fascinated you?

When I was a little girl, Cezanne influenced me. But my interests changed over time. I think the most influential artist for me was John Cage. Right after I graduated from college, while I was staying in Paris, he had a piece in the Paris Biennale. It was an empty container, but there was a panel all the way along the corner of the floor, written in French. In English I would say, "Whether you try to make it or not, the sound is heard." And I was just touched by the statement. And I immediately thought, "He is the master." Since

then, I tried to find a way not to make things. So I've been using a lot of found objects in daily life—not really to touch much or make things but to present as is, questioning different issues. *Bottari* was one of them. *Bottari* is actually everywhere in our country. We always keep *bottari*, which means "bundle" in Korean, in our family, to keep things and protect them or to put aside in attic, or to carry from one place another. Also in Korea, "making a bundle" (when it refers to women) it means leaving the family—that is, the woman leaves her family to pursue her own life. I first discovered *bottari* as two-dimensional painting and, at the same time, three-dimensional sculpture during my residency at P.S. 1. When I look back, there was a *bottari* that I made, which looked totally different from the ones before. I didn't realize it because I always had *bottari* to stack, and keep fabrics in. But then I saw it was a sculpture and, at the same time, as a wrapped painting made by only one knot. So I started working on that from a formalistic point of view, with existing objects, not making something new.

Tell me when your thinking about the *bottari* changed— the point when it became more than a bundle to you?

When I returned to Korea, where the *bottari* is our reality, I started seeing them in a different, more realistic, and more critical way than before. And I also realized, as a woman artist, the conflict in our society in terms of women's position and role. So *bottari* became more social, culture-related object than formalistic sculpture.

What caused the switch and how does that relate to women's roles?

I was frustrated when I left New York and went back to Korea, but I didn't realize it until later. Living in New York for one year had changed my point of view and I saw Korean society more critically and the condition of women there more frustrating. When I came back to New York again, I started looking at *bottari* in a formalistic way, as spatial and time dimension, more as sculpture or as painting. But when I returned to Korea I saw it more as kind of a loaded memory and history and frustration that also had time and space in it. So in a way *bottari* had an even broader and deeper meaning for me.

Does the *bottari* represent your work with your mother, or women's work?

When I was doing sewing pieces, I considered all the women's activities—sewing, cooking, laundry, pressing, cleaning the house, shopping, decorating—as two- and three-dimensional or performative activities. I wanted to appreciate that aspect and reveal the artistic context. So my work was all, in a way, related to women's activity, but then it was also linked to contemporary art issues.

Very often your work is seen through a feminist filter and I don't think that's really your intent. I think it would be interesting if you articulated your position.

Although I've been working a lot using femininity and female activities, I never considered myself as a feminist. The only thing I can agree to is that "feminist" is part

Kimsooja, *To Breathe—A Mirror Woman* (2006). Installation view at The Crystal Palace, Madrid. Production still from the *Art in the Twenty-First Century* Season 5 episode, "Systems." © Art21, Inc. 2009.

of "humanist." So I don't even participate in feminist shows because that really simplifies and limits my ideas. I refuse to be in a specific "ism." But my practice can be perceived as in different "isms"—like conceptualism, globalism, feminism, minimalism. My intention is to reach to the totality of our life in art, so that's also one reason my practice is quite broad and diverse—to reach that complexity and comprehensiveness.

What was the impulse to become an artist who is seen as part of the work? How did you take the step from sewing to video?

After doing sewing practices for more than a decade, I started seeing my body as a symbolic needle. But at the same time the truth was already embedded in the nature of the needle, because a needle is a tool that is an extension of our hands and body. And the needle is a hermaphrodite-tool that has a masculine and feminine side—a healing part and also a hurting part. So how it functions is always ambiguous. The needle had a complexity in it, and I've been pulling out different meanings since I first considered my body as a needle. I made a performance using my body as a symbolic needle, in the first video *Needle Woman* (1999) in Tokyo. That allowed me to broaden my concepts and my practices.

How did you come to the installation at Crystal Palace and how do you position that work within your practice?

To Breathe—A Mirror Woman (2006), an installation at the Crystal Palace in Madrid, is the meeting point of my *bottari* and sewing practices. I see the piece as a *bottari* of light and sound and reflection—not really creating

Kimsooja, *Lotus: Zone of Zero* (2008). Installation view at the Rotunda at Galerie Ravenstein, Brussels. Production still from the *Art in the Twenty-First Century* Season 5 episode, "Systems." © Art21, Inc. 2009.

something physical but putting the void all the way to the surface of the Crystal Palace window glass, using diffraction grating film that diffuses light into rainbow spectrum. At the same time I connected my voice, my breathing practice, to my sewing practice. A mirror, all over the floor, reflects the whole structure of the Crystal Palace. I thought the space should be empty and that I should use it just as space, putting the sound of my breathing inside of it, occupying the whole space.

It occurs to me that the Crystal Palace functions as a body. Is that correct? If so, can you talk about the work as a body?

In this space that is occupied by the sound of my breathing, people feel that they enter into someone else's body. They try to integrate the rhythm of my breathing with their own and feel the sensation of the rainbows diffused from the film and the reflection from the mirror of the structure. So in a way they experience my body, my breathing, and the audience's breathing as architecture, but at the same time they create their own rhythm and relate to their own reflections, to the structure within and without, and to discovering themselves. The audience's body functions as a needle into the mirror. It's another way of sewing and breathing, using your eyes. ∎

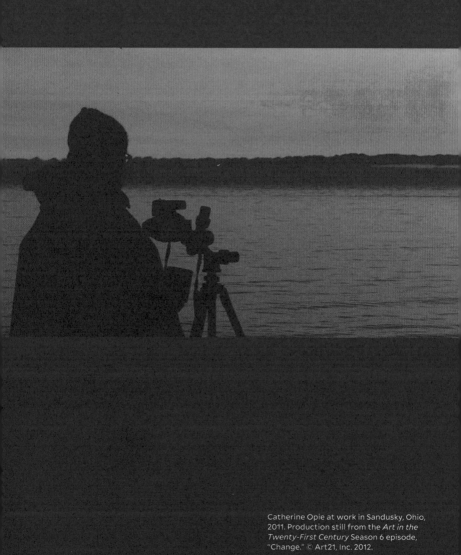

Catherine Opie at work in Sandusky, Ohio, 2011. Production still from the *Art in the Twenty-First Century* Season 6 episode, "Change." © Art21, Inc. 2012.

Observations on the Real and Not Real

Catherine Opie discusses the influence of historical Western painting and the photographic tradition on her work and art's utopian and dystopian notions.

Interview by Susan Sollins at the artist's studio in Los Angeles on May 17, 2011.

Art21—Talk about the impact that paintings had on you, growing up.

Opie—I have vivid memories of going to the National Portrait Gallery. I was probably eight or nine. So often, we relate much easier to a visual world. I've always been a heavy reader; I love fiction. That provides other kinds of images for me in my mind. But I really felt very good about seeing those early paintings, and that's one of the reasons why I've always been in love with a kind of rich light. And I think that's why people often call my work paintings—because I'm using tropes of lighting more in relationship to painting than photography. I like faces to disappear in a shadow, which they would do very easily in a painting. In a photograph, that's bad lighting. When I was printing all of my work, it was printed very dark. I remember my teachers saying, "You know, you're printing a little heavy-handed. And I would just say, "I like the way that looks."

What do you mean by "early" paintings?

Renaissance paintings. Dutch still lifes. I still sit with books of Dutch still lifes. I have a hard time with things that are formally messy. To the core, I have formal ideas of the way that things should look. And I think that also goes back to seeing those paintings in my childhood. They just felt right to me. Everything was in its place.

Could you describe the line of documentary photography that you descend from, and then explain how you have gone off in your own direction?

I picked up a camera when I was nine. I was interested in photography first through the sources that were at home. It was *Life Magazine*; it was *Look*; it was *National Geographic*. It was the notion that photography came out of a need to create a narrative in relation to life, and that you created this sense of a document that also was history. When I went to San Francisco Art Institute and I was studying with Henry Wessel, Jr., Larry Sultan, John Collier, Jr., it was directly out of the Szarkowski

school of photography: looking always at Winogrand, at Arbus; reading Szarkowski's book *Looking At Photographs*; looking at that whole history of MoMA collecting, from Steichen to Szarkowski. I was really interested, early on, in being a street photographer. I loved the images of Helen Levitt. I was amazed by what Robert Frank did—that photography worked best in relationship to pure observation. That was the core of it in relationship to its medium. But at the same time, the up-and-rising contemporary conversation in art in relationship to photography was the Pictures Generation—having Sherrie Levine begin to photograph Walker Evans and say that it was hers. Cindy Sherman. Richard Prince. That work was never really a part of my discourse at San Francisco Art Institute. When I went to CalArts it was challenging to have practiced and be fairly competent at a craft and feel that I absolutely didn't know anything that was happening on a contemporary level. I was studying with Allan Sekula and Catherine Lord. We weren't reading semiotics; post-modernism wasn't being discussed. We didn't all have *October* opened up, reading what Rosalind Krauss had to say. Within that two-year period there was an expectation for me to completely adopt and adapt that language in relationship to my practice. It was really difficult at first. I felt completely displaced in what a photograph could do. So I kept going out and making photographs of what I was observing. And I would bring them back in and I would talk about them in critique class and be questioned a lot. They were really hard questions to answer.

Then I would go out and I would make more photographs instead of stopping working because I thought it was all bullshit, which is what a lot of my other fellow students were doing. And I realized at a certain point, after working on the same thing for two years and trying to break up what they were saying to me and what I believed in, that I could still create something in relationship to ideas of representation that felt like a document for me. But what I had to do at the same time was begin to critique the validity of it. Instead of it being real, which is what I came off of in terms of the street photography, it became representational. So there was a time when I thought, "Oh, I just need to shift my language here. I can still do what I'm doing, but in terms of being a practicing contemporary artist, I need to be able to shift certain ways that I construct things and look at them."

I started to go inside myself a little bit more in relationship to my belief of what I was framing and portraying and representing for my audience versus trying to hold onto street photography and observation as being real. I had to fight that impulse of wanting it to exist just because it was important that it existed. And I think to a certain extent I still fight that a little bit. I still think that photography operates both in terms of the real and the not-real—that it is my construct. So the fight for me now is in relationship to Photoshop. I don't take things out and I don't put things in.

It's really important for me that I still can find something valuable in relationship to the idea of an early observational photographer—

that it can be found and I can wait for it. I can wait for light to change, and I can have a moment of meditation. I can allow that to happen. And that is my "real" that still comes from the platform of being an observational photographer, which is defined in relationship to a documentary practice.

You come from a part of the country that had utopian colonies. How do notions of utopia affect and maybe reflect out of your work? And how might you talk about this to someone who wouldn't have connected utopian thinking to your work?

I am really interested in utopia and also dystopia. I've read a lot of sci-fi novels that play with those ideas, and I'm a huge Octavia Butler fan. I'm interested in how she constructs ideas—not only of sexuality but also what is utopic and dystopic. In a way, it's the same kind of binary as normal and abnormal. Supposedly we construct those binaries to be able to create a model to live by. My utopic notion is humanity: I'm utterly devoted and dedicated to being a humanitarian and trying to live my life in a way in which both my work and myself allow a kind of representation that creates kindness and a way to observe the world in relationship to how I think about it and view it. I have a hard time with mean photographs. There is already so much meanness and discouragement in this world. I'm not sure what it means to create representations of people that show them in their worst light. So I believe in creating representations that are sometimes tough but, at the same time, the core of humanitarian ideas exists within that. Even though there are some tough ideas in the work, it's still done in such a way that's not meant to ever be disturbing. So, my perfect world (which I'll never see because I don't believe that it exists) is about acts of kindness. It's about the fact that we have the ability not to have people starve. We have the ability not to go into war over religious ideology. We could become a sustainable country; we could stop global warming if we chose to. We choose not to. And that's the dystopic nature of us as humans. I could represent that, but I'm not interested in representing that. That's my everyday; that's the front-page newspaper. That's the Channel 4 News that I'm interested in creating a dialogue with in relationship to my time and what I observe. But I'm not interested in trying to make images that reflect what is so prevailing.

Are there one or two bodies of work that you want to talk about?

I think *Inauguration* is interesting. Describing that event photographically compared to what the media was showing also hinges on ideas of utopia and dystopia. I decided that I wanted to create a portrait of our time in America, in relationship to the incredible opposition discourse. What I'm interested in is the notion of America being the great democracy (and I'm not sure that it's the great democracy). Within this notion there are always binaries—normal/abnormal, utopic/dystopic, Republican/Democratic. I really wanted to make American landscapes in terms of identity—

Catherine Opie at work in Sandusky, Ohio, 2011. Production still from the *Art in the Twenty-First Century* Season 6 episode, "Change." © Art21, Inc. 2012.

through Tea Party rallies, the inauguration of Obama, Boy Scout jamborees, the Michigan Womyn's Music Festival, immigration marches. I became really aware of people taking space—exercising their freedom of speech. I was more interested in the way they occupied landscape, whether or not I believe what was being spoken.

All of these things are always coming up in relation to the nightly news, and I'm fascinated with it as a construct. I love the nightly news; I have watched it since I was a kid. And that's probably because I was born in '61, and the nightly news was the constant source of information: Vietnam and the civil rights movement. Those

were the images that profoundly affected me—that formed me as a person—like the images of the Renaissance and paintings that I saw as a child in the art museums. And that's also probably, going deeper, the relationship to the notion of document or documentary in my work.

Right after 9/11 or when I had finished *Wall Street* (2001), I was looking at exhibitions around Chelsea, and there was just one flower exhibition after another. The way that photography was radically changing within the art world was frustrating for me. If you made work that had street-photography language within it, you were thought of as a photojournalist,

and "documentary" as a language started getting wiped out. I was like, "Why aren't people observing anymore? What's wrong with this kind of observation?" I was compelled to pick up a camera and start photographing. I think it started with *In and Around Home* (2004–05), and I ended up photographing crowds of people. There are photographs in that body of work that are really important to me, that signified this shift of wanting to photograph larger groups.

Which photographs are they?

There's one of a University of Southern California tailgate party (*Football Landscape #16*, 2009); another of a demonstration at one of the houses in my neighborhood because thirty-one registered sex offenders were living there (*In Protest to Sex Offenders*, 2005); and there's another of a Martin Luther King Day march.

I was back on the street with a camera in my hand, like I was in the early '80s in San Francisco. I was looking at groups of people that had come together, and I realized that it was really important for me to no longer empty out the landscape but to fulfill this other notion of creating documents of our time, in relationship to going out and observing—creating another way of looking at American landscape.

Are you thinking of building on that body of work?

I don't think that any body of work is really finished for me, even though I want to do other things. Like, I really want to photograph a mass baptism in a river in the south. I'm interested in how religion has defined the politics of America.

I'm trying to figure out a different way of imagining those ideas.

Does religion or some notion of religion in some strange way permeate all that you do?

I'm fascinated with people's absolute belief systems. The permission they have taken in relationship to ideas of what it is to be a Christian is profound in my mind, in terms of the absolute hatred they profess. Religion comes up a lot, I think, in relationship to being queer. I have had signs held up to me saying, "God hates you; you will go to Hell." God hates me? I will go to Hell? What does that mean for you to be telling me that? I'm interested in the notion that religion is supposed to be the idea of a higher self. I am not sure why everybody is trying to define that his or her belief is the better belief system. I really struggle with this as a human being in relationship to a philosophical model of a system of belief in which people think they have it right, instead of everybody just saying, "Okay, you have your beliefs and maybe that's the way that you need for it to be constructed, but does it mean that I have to follow along?" I dig into the subjects of the work in an ongoing conversation in relation to the dilemmas that I have within my own mind. And I think that the clearest way to speak about it is that the art for me is about the ability to create a conversation in terms of these disparate thoughts, these greater philosophical ideas. ∎

Culture and Aesthetic Sensibility
Lari Pittman talks about his relationship to the West Coast and how he navigates the extreme poles of populism and elitism in art.

Interview by Susan Sollins at the artist's studio in Los Angeles and home in La Cresenta, California, on June 14 and 15, 2006.

Art21—Who influenced your work, when you were an art student?

Pittman—One of the things that was valuable to me at CalArts was the possibility of relooking at histories that had fallen between the cracks based on modernist criteria. We looked at artists who I still love to this day, the female Surrealists: Remedios Varo, Leonor Fini, Leonora Carrington, Frida Kahlo. Also, Florine Stettheimer and Suzanne Duchamp. It was great to understand that Marcel Duchamp was very devoted to Stettheimer and really loved her work. Looking at the work of female artists was a particular lens, but it revealed a different approach that was part of neither the canon of The Museum of Modern Art nor the canon of the art critic Clement Greenberg.

I come solidly out of a revisionist moment. Painting was moribund at the time and needed fixing up. For me, it was serendipitous that this structure of thinking was seen as exhausted. As a young artist, I went through exercises of historical revisionism, saying, "Maybe I could see my face there." I identify with so many works that are by female artists, and they were excluded from the modernist canon.

Do you feel like an outsider, in the way these women artists were?

Maybe it's the way that my parents loved me, but I always have felt complete centrality. But that doesn't mean that the world's going to accord me that. So, I've never felt like an outsider, but I understand Otherness.

Who were some of your teachers?

Elizabeth Murray and Vija Celmins—the professors who I had at CalArts—were both very hard on me but very encouraging. That was part of the coming of age, that and seeing, adoring, and envying a certain type of reductiveness. I love minimalism, but I realize I can neither physically do it nor see my own face in it. I look at minimalism as Other; I am capable of Othering it. But the aesthetics of my work come out of the groundwork of an ideological coming of age.

Is there a kind of Orientalism in your paintings?

What you're talking about is a type of obtuse and almost incorrect Orientalism in the work. I think

that is a part of it, and I completely understand the problematics of that discussion. Where I find some sort of permission to indulge in a type of Orientalism is deep within the codes of mid-century sexuality; Orientalism was historically a code for homosexuality. For me, Orientalism is a very broad colonialist term. I see it as an obtuse, highly encoded vehicle for the discussion of identity, which is useful to me. All through my paintings, there are hints of exoticism; the aesthetics are aestheticized. I think it's a part of the world you want to escape to. Maybe Orientalism isn't the most accurate way of describing it, but for me, that word is still useful. It's a very decadent idea; I understand that.

But it doesn't have to be decadent, does it?

It's a completely fabricated, highly mannerist moment. Either you go with it, or you resent it. The experience of standing in front of one of my paintings is not a simulation of anything, but it is a highly artificial moment of representation. And the paintings have always been relentless about that. You have the same type of negotiation as a contemporary viewer going to see opera; there has to be a complete understanding and acceptance of the whole mannerist endeavor, or else you're just not going to enjoy it. All the paintings set up this intense mannerism. Everything is hyperbolized and highly decorated. Even the decoration is decorated. It's trying to insist on the possibility of a primary experience within the confines of something very artificial. The work doesn't shy away from that. It's not

about naturalism on any level.

Do you often think about who your audience is?

I like that the work is visually available to everybody. I think that multiple viewers can approach it very differently. For example, I'm always excited when the UPS man or the water man comes in to the studio to make a delivery, and they immediately respond to the work—give a thumbs-up, that type of thing. I'm really taken by that: the work is available on a very quotidian level. That makes me happy.

But I'm also interested in the work occupying a denser critical territory that would require a different type of audience, a different type of visual literacy. I'm thrilled that the work is not confined to one demographic; it is astoundingly mobile in that sense. I think that's a political resonance of the work. It doesn't occupy just the confines of a type of writing that might occur in *Artforum* or in *October*. I think it has to do with its visual generosity. A lot of work can only occupy specific linguistic or critical territories. But I think that my work has the capacity to navigate between the very distant poles of populist and elitist.

Where do you fall on those two poles?

I'm grateful and thankful for having a charmed life and a certain amount of privilege. Within that framework, of living somewhat inside a bubble, I think what keeps me radicalized is being aware of the overwhelming hatred that is exhibited by the American population through legislation passed against homosexuals. So, I can lead quite a pretty life, but it's always brought

Lari Pittman

down by very aggressive strains in American culture, which in a way wonderfully puts me in my place.

How does living in Los Angeles influence your work?

Sadly, ironically, or even perversely, as chaotic as American culture is, I thrive on it. [From the chaos] I'm able to carve out a tremendous amount of freedom, particularly in Los Angeles. I don't think I would be capable of carving that out in, let's say, Europe or Latin America.

Can you explain why?

If there's a stronger side to my dual identity as both American and Latino, I think [it is the Latino]; there is a strong Mediterranean core to who I am. I need a lot of sun. I can't live under a cloud cover that doesn't allow for a big open sky. It comes down to something as climactic as that: I need to have a lot of light, and I get depressed when there isn't enough. I equate light with a type of freedom; I combine those two ideas. Also, on a personal level, I think I can control this idea of aesthetics and beauty—micromanage it—more here than I could in cultural situations where there is an established code of aesthetics. Here, it's still the Wild West on some levels; you can still paint any way you want. ■

Family History and the History of Objects

Kiki Smith talks about the roles that her family, domesticity, and death play in her work

Interview by Susan Sollins at the artist's studio in New York City on September 17, 2002.

Art21—What is it that you like about domestic objects?

Smith—[All the things] we use in our daily lives are these forms that have these deep, long histories to them. Those are special things to pay attention to. It's important to pay attention. Like I was saying when we were talking about beauty—I think you are supposed to have a beautiful environment in your private life. But sometimes, in art, maybe it is like Richard Tuttle was saying—that it's important to make things ugly, also. It's always about shifting the possibilities of what can be beautiful.

One's self is always shifting in relationship to beauty, and you always have to be able to incorporate yourself or your new self into life. Like, your skin starts hanging off your arms and stuff, and then you have to think, "Well, that's really beautiful, too. It just isn't beautiful in a way that I knew it was beautiful before."

You always have to be shifting what your idea of beauty is to make your life wonderful. I think, in your private life, you're supposed to make it like a paradise garden, like Islamic paradise gardens, where you're to make heaven on earth. Earth is to be a representation of our vision of heaven. That's why you're supposed to be attentive to your environment in your private life, and then in the social realm and in nature and everything. Your private life is a place where you have some possibilities that are not determined by economics, but just determined by paying attention, by being attentive.

I use my house as a studio, so most of the time it's just a wreck. It's like a domestic house that then has a studio on top of it. And I don't really care. I'm really lucky to have a housekeeper; it knocks the damage back a little bit. But in my fantasy life, everything is very clean and orderly, in order for it to be beautiful.

The most important thing for me is looking at objects. Looking at things that people have made. I'm sort of a private person, and my life isn't so much about my social relationships to people. It's more about looking at what people have made—appreciating people through what they have made, or what they do, or something like that—rather

Kiki Smith revising the copper printing plate for *Two* (2002) at Harlan & Weaver, New York, 2002. Production still from the *Extended Play* film, *Kiki Smith: Printmaking*. © Art21, Inc. 2013.

than having too much interaction with people. So, I need to go look at things all the time—having things is just about looking at them—and then I don't have to be so attached to them for endless quantities of time. Maybe you see something once, and then it resonates in your mind for long periods of time afterwards, for years sometimes.

My suffering is that I see that there are these really great forms. They're holy in a way, like they have this really incredible power about them. And all I can do is recognize it. My ego wants to be able to make one also. I want to be able to make something in that tradition. But it's really difficult; it's totally different.

Designing—that's an absolutely different way of working. To will something or to want something into the world rather than just, you know, the listening version. It has to be a collaboration between listening and your own interest and access to making something. You have to have all those things in place.

So, printmaking is one area where you listen but you also make.

Well, you have to. It's like a physical devotion or dedication. You have to just be stubborn and persevere until you get it right. That's why I like printmaking or working in sculpture. It's a generous way of working, in the sense that you can go forwards and backwards. You can make a mark or, like with drawing, you can make a mark and then you can erase it. And then you can make it again, and erase it, and make it, and erase it. You can do it fifty billion times 'til you get it some way.

I just made a print now, and it's the first time I drew a real person in a print. And it was because I had been drawing these dead animals, and then I thought, "Well, I can move up the chain and draw a person." And it was really difficult. My assistant said, "Oh, it looks really great" in the beginning, and I was saying that maybe what I was ending up with didn't have as much art in it or something. I want that pleasure of struggle. That's the really fun part of just being left alone.

Lots of times, I watch television. I don't watch it so much as I listen to it. It's like a meditation. It's just clears my brain, and I stop thinking about whatever I'm thinking about, and then I'm just free and I sit and work. It's also because lots of the work that I'm doing is just labor. One second, you have an idea to make things. And then you have to actually do them, and that takes hours and hours of time to do it. A lot of it's just, like, scratching on things or smoothening it; it's not that interesting. A lot of it is just labor. But the labor part, to me, makes me feel free. I enjoy that the most.

That reminds me of a picture of you and your sisters, sitting around a table, making models for your father's sculptures.

I definitely didn't have the same love when I was a child, doing labor for my father. But I realize how much I got from it afterwards. He would give us these lectures. We'd be, like, six or seven years old, and you'd make the slightest mistake of asking a question about how something worked, and then you'd get a five-hour lecture about how to use a slide rule. Maybe for

about two or three days, you could remember how to use a slide rule. And after that, it just went right out…

It was obviously things that he was thinking about and that he was interested in, like maps. I remember there was a certain point where someone had invented how to make a map with three colors, and so we'd do that. Or he would have us paint words on wood and put them all over the house. We'd do all these things, which at the time I was sort of semi-half-involved with and then also trying to get out of it.

When I think of my childhood, it was all spent helping my father. We'd do yard work, and then we'd help him with his sculpture. Other kids would go out to day camp or whatever people did, and we'd be there dividing twigs. He'd make us divide twigs into different sizes— you know, just endless things. He'd save all the boxes, or he'd save all the newspapers and stuff.

At the time, I was always the one who tried to get out of it the most. But I see how it's really beneficial to me in my life now. I'm always moving the furniture around, always from one place to another, and I think, "Well, I grew up doing this." I have this belief that everything has this mobility, this possibility for mobility in it, and that nothing is fixed. Working and the things that I hated the most as a child are what I appreciate the most as an adult now. I see that really formed my personality. It's funny.

We were a little bit like *The Addams Family*. We lived in this big house, and there was a gravestone with our name in front of the house. We had this enormous sculpture in the back of the house. And we were really unpopular, and the kids would say I was a witch. And my father had a beard and a Porsche, and we were really mortified—embarrassed, you know, that he had a car like that and didn't have a big, woody station wagon. He had a beard, and we would beg my mother to have him drop us off a block before school, so we wouldn't be seen with a father with a beard. And then, in the sixties, all of a sudden it was really cool and popular. All the boys liked to be around us because my father had a beard and was an artist. So then, it worked to my advantage, all of it. But before that, it wasn't so much fun always being the weirdos. But you know, I am the weirdo now. I grew up in a kind of morbid household, and now I'm a morbid adult, and it suits me just fine.

Whose gravestone was it in front of your house?

I think one of my father's brothers nipped it from a graveyard. It just said "Smith" on it. In fact, one whole part of our house was all my father's parents' clothing, all from the late 1800s. He was born in 1912, so it was all this beautiful Victorian stuff—and teeth, people's dentures. His parents died within a short time, when he was young. I think one aunt came and took all the furniture away and all the things that nobody wanted, like letters and things that were put in the attic. We'd go in there, and it was this whole room full of things from the turn of the century. Shortly after, maybe up 'til the '20s or '30s, it was all death, death everywhere. I liked it a lot.

Is that where some of this storytelling comes from, in your work?

I don't know; I'm not sure. In my family, there was always a kind of morbidity. My father would always say that it's Irish Catholic to be morbid, or the Irish are morbid people. When I was little, I lived in a wing of the house where no one else lived. My father's parents made fire hydrants, the prototypical American fire hydrant; it's all A. P. Smith Manufacturing. And he had about five brothers and one sister, so he built a gymnasium for the boys so that they wouldn't ruin the house. And then that sister lived above the gym, in this private wing of her own. And so, I lived there.

In the room, I had a skull. My father had a skull of someone—for drawing, you know, for art. And I put a picture of Charlie Manson (when he was on the cover of *Look* or *Life* magazine) on the skull; every time I'd walk in the room, I'd always go, "You can't get me Charlie Manson!" I must have been pretty old by then. I guess it was 1967.

I always think that somebody's going to get murdered or something like that when the phone rings. I used to be—in my old house—afraid to come home because I thought somebody would have died. And something always did happen the second I walked in the building. Nobody died, but the fire department would come immediately and say, "You have to clean out your hallways in twenty-four hours" or something bad was going to happen.

When I was a kid, I expected death all the time, any second. Everything was going to die and disappear, all the time. Now, it's less. Now, half my family is dead, so I'm getting used to it. You kind of realize that it's perfectly okay, people dying. It's the most normal thing in the world. But as a kid, I didn't really like it.

My work now is much less preoccupied with death than it was. When I first started making things about the body, for probably the first five years or so, it was all about death. My father died, so I was trying to think about why it was okay, being dead. When people are dying, I have to always remember that I'm not dying. I'll see that you can sort of start to act as if you're leaving, too. But you're not leaving; you're perfectly fine. I think you don't want to separate from them.

I'm much less that way, now; I get to have other interests. For me, when I first made work, it was more about survival. I really had to protect myself and to survive, maybe to survive myself and protect myself to survive myself. When I was about forty, I started being able to make work about what was interesting to me. And then my work became much weirder and personally egocentric. I always think I never would have an art career if I had started now. But I've got to have a much wider world other than just surviving. I would say I still have a very deep necessity in my work, for self-expression, and to make this mediated stuff in between me and the world. But it's much freer now.

I think art is like that: making things to protect yourself. I always say my art's like my army in the world. That's how you make a lot of it. You store it up and hoard it and get it like your army—strong—to protect you. It's this thing that you put out in the world that's the most exposing thing

Kiki Smith

that you can show about yourself. It's the most exposed you can be, but it's mediated. It's like a doll that is a space between you and the world. You're very protected because you can always go, "Oh, that's the work."

Lots of times, like when I was younger, I would talk about my work, and I'd talk about very personally why I made it—because it comes just out of ordinary, everyday life interests, or something like that. But if someone would call you on it, it was if they knew you. And I would always go, "Oh, no, that's different!" You can't make an assumption of knowing me privately. I retain and hold my privacy to myself. I like that—that you can have this very exposed version in public. It's a little bit like having a transitional object or something that functions in an intermediary space.

Do you think morbidity and the more personal pieces you are doing now are like two different strands running through your work?

No, I wouldn't. In terms of strands, I would say that basically I'm just a curious person, and I'm trying to get an education in my slow way. I practically flunked out of school. I went to an unaccredited high school. I went to a trade school for baking afterwards, because I had this idea I was going to be an Irish washerwoman otherwise, and I better figure out something. And so, I went to trade school for baking, and that wasn't really much fun because it was just industrial baking.

Basically, I think art has all these other elements, but it's just a way to have the opportunity to think about things. I don't have a place I'm trying to make it go. I'm not trying

to control it at all. Sometimes it's more interesting to other people, and sometimes it's not. It's like standing in the wind and letting it pull you whatever direction it wants to go. Some stuff is really direct. Things start telling you what you're supposed to pay attention to. It really just comes in you and tells you, "Pay attention to this" and "Make this." I have lots of times where my work just said, "Make it like this." And then, it's like you're a faithful servant: I make this meditation or give myself to this work. ∎

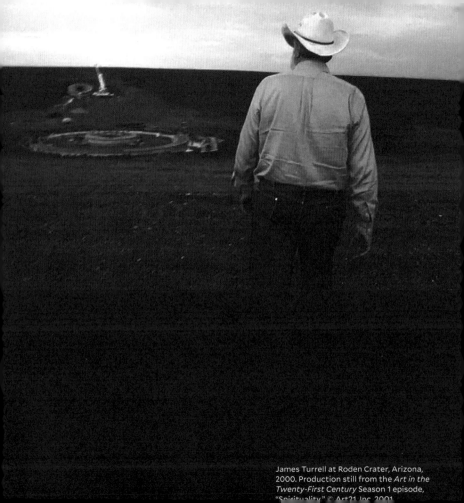

James Turrell at Roden Crater, Arizona, 2000. Production still from the *Art in the Twenty-First Century* Season 1 episode, "Spirituality." © Art21, Inc. 2001.

On Light and Space

Drawing upon his upbringing, **James Turrell** finds parallels between the Quaker meetinghouse and his ongoing work of land art, *Roden Crater.*

Interview by Susan Sollins outside of Flagstaff, Arizona, on August 30, 2000.

Art21—How did you come to design the Quaker meetinghouse in Houston? Was that your idea, or did the Friends there contact you?

Turrell—The meetinghouse was the idea of Hiram Butler, a Houston gallery owner. He became interested in the different projects regarding art and religion in Houston. The Rothko Chapel is probably the best-known example. He was also thinking about the stained-glass windows in the [Trinity] Episcopal Church. Perhaps he wanted to get Richard Serra to do a synagogue.

Butler had become interested in Quakers, and the Live Oak Friends Meeting in Houston was without a meetinghouse. They were meeting in a dance studio. They had a location picked out for a meetinghouse, but they didn't have the funding for it. He thought it would be a good idea to make this project similar to the Rothko Chapel, so that donors could come from outside [the Quaker community], particularly from the art world. He proceeded to create a situation where donations were given largely from the art community, and from the Meeting as well, for the building of the meetinghouse. He did this by asking me to be involved in the design of the meetinghouse and, in particular, put some kind of artwork in there.

The piece I have at P.S.1 is called *Meeting* because of that interest. First of all, there's this four-square sitting area with seating toward each other. The space creates some silence, allowing something to develop slowly over time, particularly at sunset. Also, the title *Meeting* relates to the meeting of the space that visitors are in and the space of the sky. The sky seems no longer to be out there but rather to be brought close in, touching you and the space where you sit.

What sort of dialogue did you have with the Friends while working on the Houston meetinghouse?

I was involved with discussions about the needs, the size, and the materials of the meetinghouse. And Leslie Elkins, who was the architect, had a part because Quaker decision-making is by consensus. This is a rather slow process, purposefully so. Some

people think that Quakers are sort of the ultimate passive-aggressive people, in that decision-making can be nearly like procrastination.

For you, growing up a Quaker, this meetinghouse must have had some special significance.

It was the kind of meetinghouse I always wanted to see. I like the literal quality or feeling or sensation; I want to feel light physically. We drink it as vitamin D; it's actually a food. We are heliotropic. The skin can produce vitamin D. We also have a psychological relationship to light. All or most spiritual and near-death experiences are described with a vocabulary of light. For me, this quality to feel light exists, almost like we see it in a dream. I was very happy to do this project. It just took a lot to plan it.

How did the design of the building take shape, especially regarding the removable ceiling?

The meetinghouse is like that of the Gunpowder Meeting or some of the earlier American Quaker Meetings, like Third Haven in Easton, Maryland, which is from the 1680s and one of the earliest structures that's been in continuous use. The long house form of the Gunpowder meetinghouse is traditional. That's what I started with, as an idea. In terms of the size and the use that was asked for, the Live Oak meetinghouse is a very traditional form, except it's convertible. The top opens, and it makes a sky space; it's like the sky is brought down to you, and your awareness of it is made quite different. Anyway, I suggested a roof that opens, and it was a novel

idea. But they were very interested, and we started fundraising.

How does the meaning of light relate to the Quaker tradition?

Well, George Fox talked about the light, both in a literal and a figurative sense, or allegorical sense. A revelation is a light, as in a bright idea can light. I was interested in this literal look at it—actually greeting this light that you find in meditation—and following that. But that's not its entire meaning, and I think that's why I express it that way. But it's certainly something that I've related to and like.

Do you remember your first Meeting?

We had early Meetings. Some of them were longer than one hour, so it's something for a child to be introduced to the Meeting. There is a time, when you no longer are in First Day School but you actually come and join the Meeting. My grandmother was trying to tell me what to do. Her explanation to me was: you go inside to greet the light. This idea—to go inside to find that light within, literally as well as figuratively—really propelled me at the time. I thought that's what I should do. Of course, I'm still trying to figure out exactly what she meant. But I like that quality.

You have to remember that I fell away from all this—for nearly twenty-five years, I had no interest whatsoever in this—but I carried on this involvement with light. Talking about this idea of light—particularly the light not seen with the eyes—was very important. When you think of a dream—where does the light come from, in the dream? Here is

a way of seeing—with richer, more lucid color and certainly equal if not better clarity in some dreams [than actual vision]—and you have your eyes completely closed. So, you ask yourself, "Is this just memory? Well, then, how do you explain this sort of déjà vu? Maybe this is memory, and the dream is the reality." We have ways of thinking about reality, and a lot of what we're doing is figuring out how we create our own reality, that we then live within. That's very interesting to me because art has a lot to do with changing our sense of reality.

How do these ideas relate to your work, *Roden Crater*?

I'm interested in the spaces that one is in and how they relate to the outside—how they open to the outside—and that this reality is somehow changed. That is, when you go in the space, the sky is a different color and exists in a different place than when you're outside the space. And these two spaces: I've very interested in how you live in them. This space you come and live in; you check in, sort of like the crater. This other space you meet in a meetinghouse. So, there are spaces that are used or have some sort of function. There were several marriages in the piece in P.S.1 and, I was told, several conceptions. So, the idea is that this would be a place that you actually live in.

Where are we, right now?

We're on top of Roden Crater, which is on the western edge of the Painted Desert, and we're looking at the San Francisco Peaks volcanic field. There are over four hundred craters; this is one of them. This is the easternmost crater, perhaps tied with South Sheba. This is a new crater in this field, but it's about three hundred eighty thousand years old.

How did you find the spot for for the work?

I flew over the western states, looking for likely spots and opportunities. This was my first choice, and there were two others; I still have the mining lease on one. This has been mined a little bit and was also a motorcycle hill climb. It had its uses at the time.

Could you describe your first sighting of Roden Crater— how you knew this would be the one you wanted to use?

I was coming over the field from the west—about this time of day, about four-thirty in the afternoon— in November. The sun was just about to set, earlier in the winter. And I saw the craters in this field. There were two that I sort of looked at: SP Mountain, that flat one over there, and Antelope Hill, on the Babbitt Ranch. And I saw this one. This is really beautiful when the sun hits it in the afternoon because you get the red and the black—that separation of the two craters from the west side. It really stood out. The nice thing about it was that it was off by itself, so it didn't have other volcanoes that would be in the horizon when you were inside it. I landed out here and walked up into it and stayed overnight and went all around it. The next day, I went to the county seat, Flagstaff, to see how it was owned. It was privately held, so I thought, "Oh, I should be able to get this." That's another story.

A long story, I imagine.

Anyway, that was how I found it. I spent seven months flying over the western states, sleeping

Previous: *Live Oak Friends Meeting House*, Houston, Texas (2000). Production still from the *Art in the Twenty-First Century* Season 1 episode, "Spirituality." © Art21, Inc. 2001.

under the wing of the plane; every third night, I stayed in a Holiday Inn, to clean myself up. Every site that I saw that was interesting generated new work or new ideas. It was really a rich time for me.

What started you on a quest for this place?

Well, my interest is working with light and space. And here you got light and space; there's no doubt of that. It's always something to work with light in the outdoors. That's something that I wanted to do: I wanted to shape space, to use the light that was here naturally. Also, I wanted to use the very fine qualities of light, [especially] moonlight, and there's a space where you can see your shadow from the light of Venus alone—things like this.

I also wanted to gather starlight: not only light from the planetary system (which would be from the sun or reflected off the moon or a planet) but also light emanating from the galactic planes, an older light that's away from even the light of our galaxy. That light would be at least three and a half billion years old—light that's older than our solar system. It's possible to gather that light—it takes a good bit of stars to do that—and have a good look into older skies, away from the Milky Way. You can gather that old light and physically have it in place, so that it's present—to feel this old light. It's a blended light, of course, but it's also red-shifted, so it's a different tone of light than we're normally

used to. But that's something that you can do here, in a place like this, where you have good, dark skies.

To have this sort of new, eight-and-a-half-minute-old light from the sun and to have this sort of old blended light—it's like having [two wines], a Beaujolais and a finer, older mature blend. I wanted to look at light that way: to feel it physically—almost in the way that we taste things—was a quality I wanted. And this is where you can work with light like that.

Why do you want to work with light?

Certainly, when people describe near-death experiences, they use a vocabulary of light. And also, when we have dreams—a lucid dream that's in this color—that really is quite astonishing. If we can think about what light can do and what it is, by thinking about itself, not about what we want it to do for other things... We've used light, in the sense that we use it to light paintings [to see them]; we use it to light [books] to read. We don't really pay much attention to the light itself.

Letting light and sound speak for themselves is how you figure out these different relationships and rules. There's sensory synesthesia as well, in that the feeling of light—the perception through vision—creates a sensation in taste. You probably have seen or handled a lemon and felt the taste suddenly flood your mouth. The same thing can happen in sound, and sound can change the perception of color.

We think of color as a thing that we're receiving. If you go into one of the sky spaces, you can see that it's possible to change the color of the sky. Now, I obviously don't

change the [actual] color of the sky, but I change the context of vision. This is similar to simultaneous contrast, where you see a yellow dot on a blue field versus a yellow dot on a red field. The same yellow dot will be seen as two different colors. The same frequencies come into your eyes through a difference of context of vision and are perceived differently. We actually create this color. Color is a response to what we are perceiving. So, there isn't something out there that we perceive; we are actually creating this vision. That we are responsible for it is something we're rather unaware of.

I look at my art as being somewhere between the limits of perception of the creatures that we are—that is, what we can actually perceive and not perceive, like the limits of hearing or seeing—and that of learned perception or (what we could call) prejudice perception. In that situation, we have learned to perceive a certain way, but we're unaware that we learned it. Sometimes, this can work against you. Working between those limits and pointing them out is something I enjoy doing. It's not just that the cosmos is brought down into the space but also that your perception helps create it, so that you are the co-creator of what you're seeing.

Can works of art impart a sense of spirituality?

People talk about the spiritual in art, and I think that's been the territory of artists, all along. The great cathedrals and their light, made by architects and artisans, create a sense of awe that often is greater than what people feel from anything they read or from any sort of rhetoric by the priesthood. This can be very powerful, in a visual sense, and is not something new; artists have always been involved in this. Sometimes, it's easier for people to approach that portion of the spiritual through the visual than through organized religion, and perhaps that's true today. But while gratification through the senses can direct you toward the spiritual, it also will hold you back from a full [experience]. That's the limit of art. So, I don't think that art is terribly spiritual, but it's something that can be along the way [to spirituality], a gesture toward it. ∎

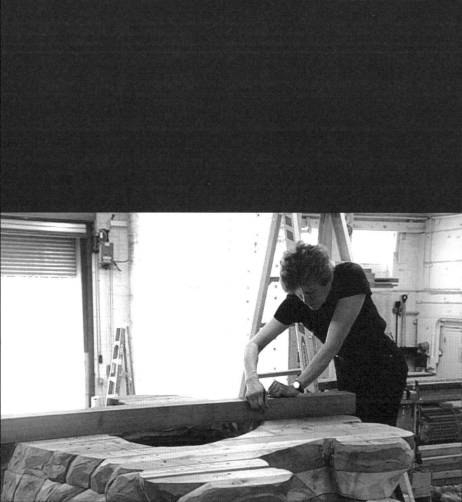

Childhood and Influences
Ursula von Rydingsvard discusses how she came to live in the United States and the ways in which her earliest memories inform her work.

Interview by Susan Sollins at the artist's studio in Brooklyn, New York, on July 26, 2006.

Art21—When did you first come to the United States?

Von Rydingsvard—I came to this country in 1950, in December, and I started school right away. They put me in fourth grade. I don't quite know why, because I was only eight years old. I was also in fourth again the following year, but I learned English in about six months. I had a wonderful teacher, Miss McNamara, who made a fuss over my being there—because in a place like Plainville, Connecticut, where we settled and lived, there were not many people who came from another country. So, I was exotic.

The clothing that I wore was truly exotic: I still had pants that flared out, tight at the bottom and flared. I'm not quite sure how to describe them, but they were made from U.S. army blankets, which were rationed out to us in the camps. So, I was wearing those with some sort of a pathetic top. I truly was exotic—to the extent where, on Valentine's Day, my teacher bought me this beautiful red velvet dress with all this white lace, a big collar, and little puffy sleeves. It was so beautiful, but I could not get myself to wear it. I gave it away as a gift; I don't even know to whom. We needed a gift at school to give to someone else, and since we were too poor for me to be able to do that, I just gave away the dress. It was so girly and so sweet that I couldn't quite make the transition from these great blanket pantaloons to this dress, that quickly.

Where were you born?

I was born in 1942 in a beautiful little town called Deensen, in Germany. Between 1942 and '45, my father was a forced laborer on farms. When the war ended, my father saw no opportunities. He decided to try to go to America—a huge wish, given that he had seven children. You could go alone as a single man, but it was much more difficult to go as a member of a family of nine. Both he and my mother made the decision to go through the postwar refugee camps for Polish people who didn't go back to Poland. So, we went through eight camps, working our way north. From Bremerhaven, the northernmost port in Germany, we took a ship to the United States. It was a military ship that fed us divine food. We couldn't believe what we were being fed, but we were so seasick that we couldn't appreciate it. We came to the port of New York City.

We saw the Statue of Liberty, because everybody was called on board to see that. I think we got off at one of the piers on the west side of Manhattan.

Did your family have to work in the camp?

In Deensen, my father farmed the land, and they wanted my mother to do that, too. But at that time, she had a newborn baby, a two-year-old, a four-year-old, a six-year-old, an eight-year-old, and so on, so it was not something that she could do. She was able to wrench her way out of it, in good part because my father was such a spectacular worker. When he would use the scythe to take the wheat down, they would say to him, "Ignaz, in a day, seven men couldn't do this much work!"

The camps had a whole other order. Basically, none of the men worked. There were no jobs. Periodically they were all sent to some factory for three weeks, or some such thing. And I remember one of the factories actually exploding. The Marshall Plan that was set up by the United States government helped us enormously. It was specifically made for the post-World War II refugees, to enable them to survive. I think the men were the most troubled of the lot. The women continued to raise their children as they normally would. They were under circumstances that were extraordinarily difficult, but they were paying attention to the children. The men would play cards, or they'd drink a lot. And what they would drink was just terribly cheap, lousy stuff that they would manage to make on their own, because there was really nothing for them to do. The women were more religious than the men. They allowed the Catholic Church to guide them more stringently. So, the Catholic Church was our law. There were no police, nothing to organize people's lives.

Periodically, if we stayed again in a camp for a longer period of time, there were former teachers who came to teach. They just organized this among themselves, which I think was extraordinarily helpful for the children. I remember those classes very well. And I remember how serious those teachers were. They were all male teachers who were extraordinarily strict. I was the conscientious type. So, if a child didn't do his lesson properly, I would be the one who would have to whip the kid with a leather belt. And the sound had to be a certain kind of sound, when you whipped the kid, in order to make that whipping credible. So, I had to muster up everything I could. I think that a lot of Europe had that kind of teaching, though. I don't think it was that unusual.

Why didn't the teacher just give the beating himself?

It's about the teacher giving me the power to control this other child, and showing it in public, in front of the entire class. He who learns will be in control, and he who doesn't learn will be the victim.

How old were you when this was happening?

I was in second grade.

It's so shocking.

I think it wouldn't have occurred to anybody that this was something out of the ordinary. The children were so used to seeing it, and the adults as well. I don't think that the teaching was that different in other parts of Europe, whether

you went through the war or not.

What else do you remember from this time?

Paper was very hard to come by, but I actually got a little pad with lines on it and unbleached paper. When you wrote in that book, you considered with such care. It needed to be absolutely perfect. If you made a mistake—there were no erasers—you had to wet your fingertip and rub it in such a way that you didn't rub through. And you had to rub it so that it wouldn't leave this awful mark behind. Sometimes we would get books that we would share. And all of these things felt very privileged and wonderful, like they belonged to another world.

Do these early experiences affect your work in any way?

If I were to point to something from the camps that one can see most directly in my work, it is that we stayed in barracks—with raw wooden floors, walls, and ceilings. I have a feeling that that fed into my working with wood. And the first time I ever saw Poland, all of the villages, all the homes there, were made of wood. There were stacks of wood, doors and troughs of wood. Wood was the building material. So, it's somewhere in my blood, and I'm dipping into that source. The way in which I manipulate the cedar is very important to me, but I have a feeling that I even learned from things that I never saw. Working with it and looking at it feels familiar.

I actually visited the home where I was born, and it is made out of wood at the top. The bottom is made out of those dark beams with white plaster in between the beams. There was a basement in which the animals and the beets and the potatoes were kept. That was wooden, too.

Do your memories get absorbed into the work?

I remember sitting on steps and having on something like a nightgown. This nightgown was made of a raw linen that was quite stiff, and it folded in ways that had almost mountainous landscapes to it—a kind of erect landscape that made all kinds of indentations and crevices, little hilltops, and so on. And I just remember feeling it on my body—the harshness of it and, at the same time, the softness of the parts that were more worn down. And I remember the sun hitting those structures on my body. That's a memory that has vagueness in it, but I've dipped into it a lot.

Given where you came from, it's kind of remarkable where you've ended up.

Obviously, it was impossible for me to consciously think that I was going to be an artist, because I'd never heard of anything like an artist until I came to the United States. I just know that I feel like I drank from the world through visual means—that was a huge source of the information by which I lived. My home was one in which words were not used very often. With my parents, the only words that were exchanged were in connection with assigning labor: "This is what you have to do" and "This is what has to be done." So, words were very sparse. And in fact, anybody who used too many words was automatically suspect. ∎

Evisceration, Insurrection
Kara Walker discusses how she explores a sense of self through the lens of a larger history.

Interview by Susan Sollins at the Solomon R. Guggenheim Museum in New York City on December 12, 2002.

Art21—What are your first thoughts about this piece here, at the Guggenheim?

Walker—Well, this piece is called *Insurrection! Our Tools Were Rudimentary, Yet We Pressed On*. I always wind up going back to the very beginning of everything with my pieces, so it seems like it's a continuation of a series of work that I've been doing—with large, narrative silhouette scenes, building around this idea of the cyclorama or a kind of historical exhibit. In this case, it's somewhat hysterical. The idea at the outset was an image of a slave revolt at some point, prior to me. And it was a slave revolt in the antebellum South, where the house slaves got after their master with their instruments, their utensils of everyday life. And really, it started with a sketch of a series of slaves disemboweling a master with a soup ladle. My references, in my mind, were the surgical theater paintings of Thomas Eakins and others.

And the overhead projectors came about... how?

I knew for a while that I wanted to make a piece that tried to engage the space a little more directly than the pieces that are just cut paper on the wall. And I had been using the overhead projectors as a kind of a shadow-play tool. (Not really as a tool for making the work—they're usually hand-drawn.) But I wanted to activate the space, in a way, and have these overhead projectors serve as a kind of stand-in for the viewer, as observers. And my thinking about the overhead projectors connected with my thinking about painting, as far as creating an illusion of depth, but in a very mundane, flat, almost didactic way.

But, back to surgical theater... Before I even started working with a narrative that circled around representations of Blackness, representations of race, racial history, minstrelsy, and everything that I wanted to investigate, I was making work that was painterly and about the body and the metaphorical qualities of the body. So, I always think about this work and think about history in terms of the body.

And this act of excavating that's been such a current and recurring theme—particularly in the histories of feminist artists, feminist writers, African-Americans, people of color—is about investigating and eviscerating this body of a collective experience, a history, sometimes to the point (at least in my reckoning) of leaving nothing intact. There's just this pile of parts and goo. I entered

into this project, this idea of being a Black woman artist, from the perspective of a person who has been presented with a pre-dissected body to work from, a pre-dissected body of information. These gall bladders and hearts and stomachs are all the things that would make me complete, should I choose to use them correctly and put them back together. So, in a way, it's Frankenstein-like.

Do your pieces, like *Insurrection*, always have a particular narrative that you want viewers to follow?

Actually, talking through my work has been one of those problems. There's a way in which I'm more interested in what viewers bring to this iconography that I'm constantly dredging out of my own subconscious. And as I dredge, I'm often surprised about what comes up and what seems an up-

holding of my own invention—what seems connected to a series of representations of the vulgar as paired with Blackness that have already existed and have been regurgitated over several hundred years, or over a history of African-Americana. So, I couldn't really name these characters or caricatures in the way that the wall texts at the museum or reviewers who've looked at my work have sought to, or have elected to. I think these figures are phantom-like. They're fantasies. They don't represent anything real. It's just the end result of so many fabrications of a fabricated identity.

And yet, your own name often appears in the title of your works. Are you treating yourself as a fictional character?

I think part of that is a game that I've played with—the naming

Kara Walker installing *For the Benefit of All the Races of Mankind (Mos' Specially the Master One, Boss) An Exhibition of Artifacts, Remnants, and Effluvia EXCAVATED from the Black Heart of a Negress III* (2002) at the Tang Museum, Saratoga Springs, New York, 2003. Production still from the *Art in the Twenty-First Century* Season 2 episode, "Stories." © Art21, Inc. 2003.

of the pieces and the way that I've represented myself as the maker of these images, always with this jab at the notion of privilege or entitlement as it's been doled out occasionally to young women in my position: African-American, female, young. I was interested in slave narratives and the romantic novel of, now, one hundred fifty years ago.

When Phillis Wheatley's book of poems had to be verified by upstanding White men in the community, and they put their stamp of approval on the authenticity of these words, as though it were an impossibility that a Black woman could think of anything on her own... Now, it's debatable, you know, how artistically worthy what she thought of on her own was, but that's really not the point. I like the idea of suddenly finding myself in the desirable echelons of the art world and presenting myself in this manner. So, I am incredibly grateful for the approval of White society, those who understand that I am an anomaly. It should raise questions, I think, maybe more than it does.

It seems like you keep a lot of information in your mind, simultaneously—numerous perspectives.

There's a lot of information, but it's not nearly as researched as I want it to be. It depends, really, from piece to piece and from moment to moment in my life. Things have sped up so much, with the career aspect of being an artist, that I always have my suspicions that that's to keep me out of the books. But no, it's twofold. There's a way that this work is two parts research and one part paranoid hysteria. I've always kind of

liked that. I've always possessed that impulse of concocting half-baked theories based on the reading of a selective tome—I mean, I don't trust it. I don't want to put it out there without some self-consciousness, without being reflective about it. But it's a fascinating slippery slope, when you start.

When I started investigating my relationship to my identity and what my identity means, it was in the context of artists doing identity-based art. I envy and have a love for people who research in great detail history or some moment in history (say, feminist history), and then present it in a way that's somewhat didactic and matter-of-fact—and, really, with an effort, a sincere effort to throw meaning out to an audience that, maybe, isn't conscious of this aspect of history. But I'm incredibly suspicious of that impulse, too. I think that it's all going to be filtered through one's subjectivity. And my subjectivity— as a young person at the end of the twentieth century—is one of a sexual woman, as a person who makes sometimes really bad decisions. There was no nobility in trying to do research like that, and in trying to filter my sense of self through the lens of a larger history. It was going to get complicated, and I liked the complications that I was finding.

Where does *Insurrection* fit, with the more recent projection works?

This is the first piece I did. I used the projection and overhead projectors as a feature. And I exhibited it in Geneva, at the Center for Contemporary Art. I built the piece in a very painterly way. It's

actually the antithesis of the way that I think that I should work: starting with the backgrounds and moving to the foreground and then reworking the backgrounds, and basically cutting and pasting these colored gels, and drawing on the top, and slapping them on top of the overhead projectors in a very slapdash way.

The images grew around this central piece with the surgical theater or whatever you want to call it—evisceration, insurrection—and I decided to build it into a triptych based on the space that I had at the time. All of the pieces that I worked on have transformed, depending on the space where they're exhibited. But this one was built as a triptych with the indoor scene in the center. The windows came on top of that. And then I thought I'd have what's going on, on the outside, and try to reduce the mayhem that I was envisioning to a few set incidences, where there is some turbulence, there's some give and take: castration and self-castration, offerings and stealing.

What do the projections mean to you?

Projections came about as one of a series of steps. It's an easy answer to the idea of projecting—projecting one's desires, fears, and conditions onto other bodies, which all of my work has tried to engage with, using the silhouette. And it also created a space where the viewer's shadow would also be projected into the scene—so that they would become captured and implicated in a way that is very didactic. Overhead projectors are a didactic tool; they're schoolroom tools. So, they're about conveying facts. The work that I do is about

projecting fictions into those facts.

And the fact that they're beautiful—how does that play out?

Beauty is just an accident, a happenstance. Beauty is the remainder of being a painter. The work becomes pretty because I wouldn't be able to look at a work about something as grotesque as what I'm thinking about and as grotesque as projecting one's ugly soul onto another's pretty body, and representing that in an ugly way. I have always been attracted to the lure—work that draws a viewer in through a kind of seductive offering: "Here's something to look at. Stay a while."

Did you discover something for yourself, when creating this piece?

Well, this way of working was new, with the projections. It was actually a lot of formal discoveries—spatial relationships, things like that.

I think one of the things that's happened here and there with the work that I've done is, because it mimics narrative—and narrative is kind of a given when it comes to work that's produced by Black women in this country—there's almost an expectation for something cohesive. There's an understanding within America about where that resolution is. You know what that means: to have a *Color Purple* scenario, where things resolve, in a way; and a female heroine actualizes through a process of self-discovery and historical discovery, and comes out from under her oppressors, and maybe doesn't become a hero but is a hero for herself.

And nothing ever comes of

that, in the pieces that I'm making. I'm increasingly aware of wanting to make that clear: that, to some extent, there's a failure for that kind of resolution, and she doesn't become a... You know she's not evil. She's not a hero either, but then she sort of engages these oppositions constantly and keeps it open, always knowing that the next question is: "Who is she?"

I just say she is dot, dot, dot. That's where I have this problem with language and naming, right now: the Negress of earlier titles, the "Negress of noteworthy talent"— who is me, who is not me, who is that entity of somewhat powerful sisterhood negritude—that is an idealization that stems partially out of the Black Power movement and partially out of a mainstream desire for the juicy, strange Other, the Josephine-Baker-banana-skirt kind of desire. Otherness embodied, and Otherness that embodies herself, and Otherness that plays at Otherness. But who is she? Is she one or all of the characters in the work?

I think of the work in the way that you have dream images, and the door and the hippopotamus actually represent the same thing. They're all stemming from the same impulse, somehow, which is something like a will toward chaos or a will toward attempting resolution, with the certainty that chaos reigns.

This is so hard. Yes, she's an idealization, disembodied, and also a re-embodied presence, with a will and a desire towards chaos. There is a will towards resolving that chaos with a certainty that it will never quite end. It will never quite reach a clear conclusion. It will progress. ∎

Kara Walker, *Insurrection! (Our Tools Were Rudimentary, Yet We Pressed On)* (2002). Installation view at the Solomon R. Guggenheim Museum, New York, 2002. Production still from the *Art in the Twenty-First Century* Season 2 episode, "Stories." © Art21, Inc. 2003.

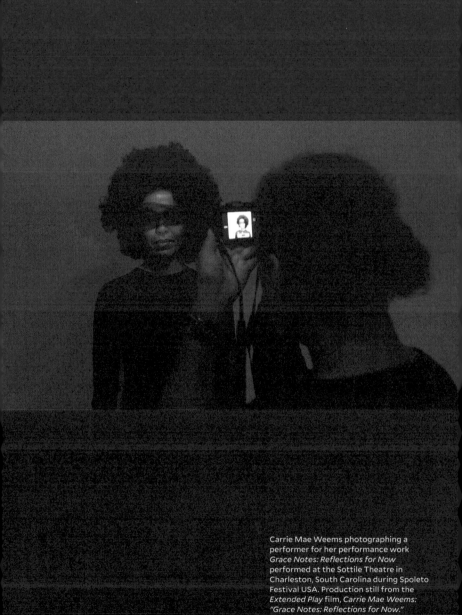

Carrie Mae Weems photographing a
performer for her performance work
Grace Notes: Reflections for Now
performed at the Sottile Theatre in
Charleston, South Carolina during Spoleto
Festival USA. Production still from the
Extended Play film, *Carrie Mae Weems:
"Grace Notes: Reflections for Now."*
© Art21, Inc. 2016.

On Photography
Carrie Mae Weems meditates on the photographers who influenced her work and how she constructs an image.

Interview by Susan Sollins at Sound Lounge in New York City on August 13, 2008.

Art21—Who are the masters for you? Whose work did you look towards or revere, or still do revere?

Weems—I think my initial influences were the great photographers of the twentieth century, all those people who John Szarkowski [at MoMA] rolled out for us. We knew those people. I knew Garry Winogrand; he was a great dancer and could move you around the floor in a really terrific way. I knew and admired photographers like Tom Roma and Tod Papageorge; I thought their way of working was very interesting. But they were deeply chauvinistic; there were no women in the set.

Then there were the earlier ones, like Henri Cartier-Bresson and Walker Evans, who was a master. Evans and Robert Frank were two of the men I paid attention to because they understood something that I wanted to be close to: they had a way of approaching and describing the world that I deeply admired. I thought that Evans moved with a great deal of compassion, with his extraordinary vision for how to really define things, using the camera and light to describe and illuminate things in a specific way. I love that.

I think it was Roy DeCarava who really nailed it for me in this country: an American photographer who was working at the same moment and doing very much what Evans was doing. I realized that they were both working from a deep cultural resonance. Evans was using everything from zone 5 to zone 10, and DeCarava was using everything from zone 5 to zero. You had this incredible cool white of Evans and then these enormous and deep and rich blacks with DeCarava. They were both trying to define something that was culturally definitive and were moving through aesthetic territory—emotional, cultural, and visionary territory. I thought that was remarkable. I've always been interested in the fact that nobody else has talked about this, as a way of examining the different ways that photography took root in the United States, or in other places, for that matter.

How do we use light to describe the essence of ourselves? I think it was really an enormous idea. You can't use the same light registry for African Americans that you do for White people. White people really do look better in zone 5 or 4; Black people really do look better in zone

5 or 6. It becomes very mechanical, in a way. There's a wonderful book called *In Praise Of Shadows*, written by a Japanese photographer and designer. It has to do with the way in which light is culturally used; the way that a shaft of light falls into a room to illuminate the pot that's sitting on the table is one aesthetic dimension and idea.

There is a German or Brechtian idea, in which the light is so brilliant, bright, hard, and brash that nothing can hide from it; nothing is escapable in that realm of light. Everything is there to be analyzed and examined. The light is telling you that. Those ideas and men—and they have been men for the most part—have been very interesting to me, and I think about them often. I think about the ways Brecht and DeCarava use light and the way that Beckett thinks about light.

How do you think about light?

I'm swimming in a terrain that's between two points of reference, between DeCarava and Evans. I think DeCarava was particularly interested in a description of African-American culture, but I don't simply portray that culture.

My work is involved with other levels of description, ones that move across several categories; so maybe on the one hand I might be interested in what's happening in issues of gender for men and women, Blacks and Whites and Asians, questions of globalism and class. It's not just in the way that I engage the subject but also in the equipment that I use. I am more concerned with my old Rollei, my distance from the subject, and my way of constructing the frame than with the zone systems, which are more about breaking down race or color.

What are your thoughts about beauty?

I spend a great deal of time thinking about what something looks like. It concerns me deeply. I'm interested in how I enter the porthole, into the space of making the work: What does it need to have? What does it need to feel like? Conceptually, what is it trying to do? Even when I'm not completely sure of the answers, at least I'm starting with a weird set of ideas and questions about entering that porthole. I'm always aware of the fact that I need to take somebody with me, that I don't want to experience any of this by myself, that the experience has to be shared. My way of sharing is to be as thoughtful as possible about how the work is constructed, so that the viewer will enter along with me.

I think the photographs are a contemplation of the sublime. I think that the work is also about confrontations of power. I have a sense that if there is a beauty and elegance that allows the viewer to be lost in the work for a moment, to be engaged with it, then the viewer will be more willing to enter the terrain and ask the difficult questions that are there. I think a certain level of grace allows for the entry. I work in a down–and-dirty way, yet my work is quite exquisite. The works are tender and nurtured and cared for, but doing the work is sort of rough. I'm usually traveling by myself; 95 percent of the time, I'm alone. I have a beautiful Hasselblad that I almost never use because I hate the way that it records the world. I use it only on occasion.

I have a Leica that I use every once in a while, but I need a larger format. I've been working with this busted-up camera that I traded for a car in college. It has been everywhere with me; sometimes I sleep with it; I know it like the back of my hand. I love being alone and being out in the world and going into difficult places alone and confronting it by myself and doing whatever I need to do to get the photograph. I use a simple tripod and a simple camera and roll film.

I think about how beauty functions in the work and the idea of construction because my works are so highly constructed. My work called *A Requiem* makes that evident, using all of the tropes of construction to make the image. But all that stuff doesn't get in the way of the heart of the subject; it simply frames where we are. The idea of framing, of course, is from the Renaissance. The frame was developed to carry all of the emblems of the profession of the person in the image: Is this a worker, a middle-class person, an authority figure, a pope? Who is this person? The frame tells us who that person is. In my works are wonderful points that could and should be explored. But because we are so profoundly troubled by race, my work has been stuck in the discourse about race for a long time. From this point on, any serious curators will have to take that to heart, or I don't think I'd be interested in working with them. ■

The Power of the Public

Mark Bradford
Cai Guo-Qiang
Theaster Gates
Jenny Holzer
Barbara Kruger
Maya Lin
Ursula von Rydingsvard

Market>Place
Mark Bradford discusses the palimpsests that inform his work.

Interview by Susan Sollins at the Los Angeles County Museum of Art, on June 16, 2006.

Art21—What was the inspiration behind your installation, *Market >Place*?

Bradford—In *Market >Place*, I wanted to create an environment that had something to do with trade, with public space, and the way people use it for pleasure, for business, for meetings, for secrets. I like that. And this was the amalgamation of all that put together. I mean, you have "100% Roaches Gone" next to "Are You A Licensed Barber?" next to "Lifetime Hair, 100% Virgin Indian Hair," "All Workers AFDC Get Paid."

What's interesting about signage is that it's about the conditions at a particular location. Informal advertising has always been around. But it just exploded in 1992 after the civil unrest in Los Angeles, when buildings were burned down and demolished. The riots cleared the land; they created huge open spaces. Because the memory of what cleared the space was violent, people made barricades. They put up cyclone fencing or plywood, so it felt like a walled city. You had all these interiors, and peripherals, with memories of something. Memory still inhabited the land, but there was nothing there. But there was all this free advertising space, and that's when you saw explosions of informal advertising, sort of like parasitic systems, coming and laying on top of these spaces.

You decided to co-opt this and build it into your work?

Early on, I was interested in using material that came from my merchant roots. My mother was a hair stylist; I was a hair stylist. But then I started thinking, "Where is what I do?" It doesn't sound right, but that was my question. And the answer to "where?" was "community." Once I looked out of the hair salon and became interested in the environment around me—and the language of that environment—everything that I had been trying to talk about was already there, speaking and having dialogues. I wanted to engage that material more directly. The conversations I was interested in were about community, fluidity—about a merchant dynamic and the details that point to a genus of change. The species I use sometimes are racial, sexual, cultural, stereotypical. But the genus I'm always interested in is change.

Did your experience working in the hair salon inform the work?

Mark Bradford, Market>Place (2006). Installation view at Los Angeles County Museum of Art, 2006. Production still from the Art in the Twenty-First Century Season 4 episode, "Paradox." © Art21, Inc. 2007.

It's really interesting coming from a merchant family because you learn things through merchant culture. For instance, we had a hair salon out on Washington and Western, and next door to us was a Latin family, Jeanie and Horatio, who sold mattresses. Next door to them was a Nigerian (I think his name was Ali) who sold things from Nigeria. Next door to that was a Chinese man who sold used televisions. And so, this palimpsest of cultures all circulated around trade. The thing I learned the most from being in that environment is how everything overlaps and intersects each other.

How difficult was it to work during the Los Angeles riots of 1992?

The media only showed the negative. During the riots, they didn't show the Koreans and the Blacks working together to save their businesses, as we did. Two doors down from us, there was a Korean family that owned a hair salon, and we were going back and forth with supplies after the curfew. We really weren't supposed to be working. Everything shut down at six o'clock after the civil unrest. There were no stores; there was a curfew imposed. Well, to merchants, six o'clock was just not going to work. For a hair stylist who had a lot of customers coming in after six o'clock, that just wasn't going to happen. So, what a lot of people did was put up black curtains, or they didn't open the shutters, and business continued. Every business was still open, but it became this invisible economy.

Was this experience in some way the impetus for Market >Place?

I wanted to create the feeling of being outdoors and indoors at the same time—those little passageways, alleyways, or narrow spaces between buildings that people turn into private places to talk and gather in. It was metaphoric, almost like a funhouse. I wanted to create a saturation—and reflections and memory of things you thought you saw that weren't quite clear—which to me is what happens when you're in a public environment or walking down the street. If you relate the story back, it's going to be about memories that layer on top of each other, reflect each other, and about conversations between the two.

I'm like a modern-day flâneur. I like to walk through the city and find details and then abstract them and make them my own. I'm not speaking for a community or trying to make a sociopolitical point. At the end, it's my mapping, my subjectivity.

What is your goal in filming? How do you decide on the posters?

The goal of the filming is a certain essence that I'm trying to capture. The posters are always merchant posters. I don't collect all posters. I generally collect merchant posters because they talk about a service, the service talks about a body, that body talks about a community, and that community talks about many different conversations.

And the posters are also connected to your interest in public space?

I scan when I'm walking. Maybe it's about mapping or tracing the ghost of cities past. It's the pulling off of a layer and finding another

underneath. It's the reference and the details that point to people saying, "We exist; we were here." It's like excavating Rome and finding there was another Rome underneath. That's what I find interesting about public space.

Graffiti is interesting to me because it's in the public domain but it's full of secrets, and unless you're part of that system, you can't unlock those secrets. I can see it for its shapes, its forms, but I don't understand it. Another person will say, "Oh, you can't read that?" And he'll tell me this means this; that means that. It's all the interconnected secrets and overlays that I really find interesting in public space. I guess I keep talking about that. Why not private space? Because private space is private, and public space has the potential to be inclusive. It's the difference between instant messaging on the computer and going to a café or bar to meet and talk. When you're home, you're behind closed doors. That's another kind of conversation.

Is the relationship between public and private important to you in your work?

I see the relationship between public and private over and over in my work. It's not something I set out to do. I take a lot of information from the public sector. Then I go to my very private studio and I make something that exists between the two. Maybe it has a lot to do with me as a person. I'm in a very public body: six-feet-eight is very public, and I don't have much privacy when I'm out. At any moment, someone will just tap me on the shoulder and say, "Excuse me... uh... how tall are you?" So, I've always been aware of that relationship between public and private in regard to my body. And I'm sure that it bleeds into the work.

And how we experience public and private moments has a lot do with language, with how we communicate them to others...

Recently, there was a lot of language from civil rights used in the immigration rally, where 500,000 people took over downtown Los Angeles. Many people used Martin Luther King's "We Shall Overcome." I don't know if people talked about it. I don't even know if it was in the news, but you actually saw a sort of borrowing and palimpsest. I'm comfortable with *palimpsest*, which is the layering and layering of texts. It's an old term. I don't think it's used that much anymore, but monks would write on papyrus and, because they didn't have a lot of papyrus, they would rub it out and put another text on top. But many times, the text that they rubbed out didn't rub out completely, so you had these layers upon layers of text, which is really interesting to me. ■

Reflection

Cai Guo-Qiang shares the experience of building a local project that took on significance at a grander scale.

Interview by Susan Sollins at the Hirshhorn Museum & Sculpture Garden and Freer Gallery of Art in Washington, D.C., on January 18, 2005.

Art21—**Can you talk about how the Iwaki village in Japan has changed over time, from your visit many years ago to today, and how the boat piece, *Reflection*, came about?**

Cai—This work arose out of a couple of interesting points in Japanese history. One is that Japan went through a period of transformation that's probably very similar to what China is going through right now, except China is going through it in a very uneven way. There's a difference between the rich and the poor, whereas Japan changed very rapidly, uniformly. All of a sudden, wooden boats were completely obsolete; they were replaced by iron, metal, and resin boats. And for me, it was a very shocking thing to see because in my hometown we still had wooden boats. In Japan you would see these beautiful little boats that looked and behaved just like wooden boats, but when you got up close, knocked on them, they actually made this hollow

sound. When you pushed or pulled them they were very light. Whereas in my hometown it took many men to push a wooden boat into the ocean, here it was completely different.

In the Meiji period, Japan went through over a hundred years of modernization, which all came through Western science, theories, and ideas. So, they felt like modern Japan was a product of Western thought and influence. At this time, when I was going to Iwaki, there was a wave of new science coming out of San Francisco. The Japanese were quite excited by this. They thought that this was the time of the Pan Pacific, that a new age had come. So, there was a lot of excitement that got generated during this time. They felt that, here, Japan could truly have some kind of contribution to the world. That it was no longer a discussion of Western culture or Eastern culture but that we could rise above these discussions; it would be a global community.

This was the background for where the exhibition happened. When I came to Iwaki, I came barehanded, with nothing. I wanted to begin a dialogue with the local people. I wanted to have a dialogue with the earth and the universe and the cosmos here. So,

104

the idea was to start with nothing, to begin very local and to reach for something much grander in scale.

I inherited something that Chairman Mao passed down to us: create slogans that people can get behind. The slogan I came up with for Iwaki was: "Begin a story here. Create an artwork here. Begin a dialogue with the universe here. Create a story of this time with the people here." The idea was that everything should begin here, in this location. We should forget discussions about globalization or the Pan Pacific. All these things could be put aside. What was important was that everything would begin with the people here and now. And we could have a dialogue with the universe at large.

Was it a shared artwork? Did everyone in the village participate?

The project was actually first known only by a small number of people. Slowly it was made known to the more general public. These people, the core group, first started working out of the goodness of their hearts, out of charity, because the museum had very little money. They just felt, like, maybe they could help out a little bit. But through the process of the project they became so involved, much more than they anticipated. They felt that through the project they found things that were very meaningful to them.

For example, in order to excavate this boat on the beach, we had to find the old ship makers of the village. They were very old, in their eighties, because that art is kind of lost. But we had to get them to come out to show us how and where to pull the boat. Also, how to cut it,

so that the boat wouldn't fall apart and could still be put back together again. These kinds of things revived some of the things that were lost.

And at the same time, I also made another piece on the horizon called, *The Pan Pacific Horizon*, which had five kilometers of gunpowder fuse ignited on the water to sketch out the horizon line between the ocean and sky. When we did this, I actually proposed this idea where any citizen of the city could purchase one meter of the gunpowder fuse with ten U.S. dollars. We ended up with a 5,000-meter-long fuse. Over 2,000 people participated and bought sections of it, so we had realized this through the help of these people. And the same time, they started this thing where they asked everybody along the coast in the area to turn off their lights during the project, because they thought the line would be much more believable. The project was part of the larger *Project for Extraterrestrials*. It's meant as a message to the universe. The people understood it thoroughly and felt that, by turning off the lights, they could make the piece more complete and more beautiful. So, they were even participating in the creative process.

Can you say more about *Reflection*—about the statuary, perhaps? What do the figures represent?

Kuan Yin is a god or goddess that I hold very close, a god that I worship. And when you say that, you're relying on some kind of eternal power this figure has. However, when I look at the Kuan Yin statues in the museum, I see that they are artworks. I do not see them as gods

and goddesses. They are artistic representations that are different from the types of idols that we use to draw a link between us and the eternal power of the deity. So here, in *Reflection*, we have a few tons of Kuan Yin figures, seen as artistic objects. They are placed here for that purpose. But of course, because of the nature of these statues, what they allude to brings on very strong emotions, and that becomes part of the richness of the work.

For me, it's really important that the work here displays an aesthetic of decay, along with the sunken boat with the broken ceramic pieces. They form a unity in showing the power of destruction, the beauty of destruction, whether it's from nature—because the boat has sunk—or through other forces. It's really the beauty of decay and death that holds a power here.

So, the meaning and power that the statues have relies on context?

Dehua's very well known for its white porcelain production; it's the southern capital for porcelain in China. A number of years ago, I visited this factory in Dehua and saw all these statues that looked perfectly fine, but they were rejects. It could be a crack somewhere or a finger broken off or sometimes even a grain of sand. Because of these imperfections, the statues are no longer considered deities. I thought it was very strange that without these imperfections, these would be figures that people worshipped. It seemed so arbitrary. I thought it was such a waste, so I said, "I'll buy these from you, at a fraction of the cost." I've been looking for an appropriate place to use these for some time.

I've been sitting here thinking that I should take one of the Kuan Yin figures from this stack and put it in my studio. This Kuan Yin is what we call on to bless the home with a son, with a male heir. If this were at my home, it would seem appropriate; but in the studio, with all my staff there, maybe it's not the most appropriate Kuan Yin to have. Here, I see them as artwork, like I said earlier; they don't hold as much power as a deity. But if I take one and put it in the studio, I think very naturally my emotions will shift; I will see that as an object to be worshipped. And if I brought my Kuan Yin from home to here, the role will shift yet again; it will become an artwork and cease to be an object of worship, of ritual. I think this is really quite interesting; it's very complex and there are a lot of nuances. And it's very close to many things being discussed in contemporary art. This very fine line—what defines the nature of an object?

Can you describe how the Chinese principle of "anyway" relates to your work, or give an American analogy?

It's difficult to say. Maybe the idea is like seeds and a field. A field is where you work and the weather is the climate, in the broader sense of climate—political, artistic, or otherwise. My approach in the way I farm is very much at ease. I know what the soil grows, I know what kind of weather comes when, and I know what these seeds are, but where the seeds fall and how it's nurtured I let happen naturally. We take advantage of the climate, the weather, whether it's rain or shine,

Cai Guo-Qiang, *Reflection* (2004).
Installation view at Freer Gallery of Art
and Arthur M. Sackler Gallery, Smithsonian
Institution, Washington D.C., 2005.
Production still from the *Art in the
Twenty-First Century* Season 3 episode,
"Power." © Art21, Inc. 2005.

and the temperature—these are all figured in. So, the approach is, in a very naturalistic way, going with nature to see what may be fostered, what may come out of the field and become fertilized.

This is a little bit abstract, but I think overall it's a more holistic way that Eastern philosophy looks at something. Things are always in a constant state of changing, shifting, and adjusting. We are constantly shifting and adjusting to the natural elements, so it's not stagnant; it's alive. It's a living, breathing system.

It also seems like you rely on chance or luck in your work.

I had a streak of bad luck from 2003 to 2004, and it was told to me repeatedly, through various ways. Bad luck or unlucky things are in themselves a work; it is a work of a very neutral nature. I felt that it was actually very interesting to look at this. You are a person; you undergo all kinds of conditions and weather. When you have sun, on the other side you have shadow. You should look at what kind of fruit bears in the light as well as what conditions arise when you're in the shadow. This is all very interesting for me as a person and as an artist. These are all fascinating things to examine and investigate. ∎

Chicago & City Planning

Theater Gates talks about his childhood in Chicago, and describes his work as an artist, builder, and teacher.

Interview by Stanley Nelson at the artist's studio in Chicago on January 11, 2016.

Art21—What was it like for you, growing up in Chicago?

Gates—It was a good boyhood, I did well in school. Like many young people I got bused out of the neighborhood and ended up going to a middle school that was on the North Side, called Reilly Elementary. From Reilly I went to a better high school, and it was there that I could start to see this divide between me and my peers—kids who stayed at the local elementary school and then went to the local middle school. These new cultural shifts were starting to happen to me and through me as a result of taking the bus up north every day, and being in this other culture where I was not the smartest kid in the class anymore. It was an interesting moment where there was this early shift that started to establish my life as slightly different from some of the people around me.

How did school affect your decision to be an artist?

There's this idea that there are forces in the world that are dangerous and violent and could take you off the path, and those things are right next door. My mom would talk about that as a reality and as a metaphor. She would say, "Every day you've got to go to the bus stop and make decisions about what's important." That idea of this hedge of protection, it was this constant knowing that if good things were going to happen in the world, they would because one had to make a significant effort to do the [right] thing. Bad things were all around, but to do the good thing would require some real forethought and girding. Especially as I got older, friends who I grew up with were choosing other paths, and I had to figure out what to do with those friendships. I love these guys, my homies. But trying to love them and also accept that the path that was being laid for me, or that I was laying for myself, was a little different. I was getting exposed to these things that were very different from what was around me on the West Side.

There was that dynamic of people who were involved in the sophisticated world, not just the struggling crack-infested world—they were involved in these other worlds that were worldly and good and fashionable. I thought these more sophisticated apertures could refocus my life, and that was very exciting.

So much of who you are is rooted in those experiences

in Chicago.

By the time I finished high school I was clear about one thing: I would not be embarrassed about where I'm from, no matter how much these other worlds tried to share with me that where I was from was bad or different. I had already developed a kind of fortitude that what my mama and my daddy gave me at 701 North Harding was some good stuff, and I would find a way to carry that forward.

How does that inform your art practice now?

There is this principle calling that feels like it's about me putting things in the world. But those things aren't necessarily objects. They could be interruptions in the city. They could be new building structures. They could be the creation of a new platform, a not-for-profit or for-profit foundation that could support bodies of work over time. This is not new to art, but art in its modernistic tendencies and in its capitalistic pursuit want so badly for us to only focus the artist on the production of things.

Talk more about this combination of the city planner/artist.

One of the tricks that I've had to figure out in my head is [how] to describe to other people what I do. I say I wear three hats: I am an artist

Top: Theaster Gates, *Listening House and Archive House* (2009-present), used as a gallery, community nexus, and archive. Production still from the *Art in the Twenty-First Century* Season 8 episode, "Chicago." © Art21, Inc. 2016.

Bottom: Theaster Gates in his studio, Chicago, 2016. Production still from the *Art in the Twenty-First Century* Season 8 episode, "Chicago." © Art21, Inc. 2016.

with a studio, I build these buildings, and I'm a professor at the University of Chicago. I don't actually think about myself in three parts; I think about my whole self. My whole self makes things—I'm an artist and I make things. Sometimes those are things that we call art and other times they seem like other things. But in fact, I'm always making a pot; it just doesn't always look like a pot.

There are times when I make an object out of flooring that is made for the wall. And then there are times that I make flooring that is flooring. Both of those things require the same skills, require the same brain, require the same amount of administration in some cases. But they need to do different things, so you're talking about their effect. There are times when I need to put a floor on the wall to demonstrate that fifty-two schools were closed in Chicago, and then there are times when I need to fix the floor of a floor because its restoration has as much of an affect as putting the floor on the wall. Both of those things are art, but the signatures are not all registering as art, and I have to accept that.

There are times when I build buildings and they function like buildings. Then there are times when I'm reflecting on space and what comes out is more notably a work of art. Because there is this transgression between those worlds, there are times when people don't know what they're judging. Am I looking at a work of art, or am I looking at a building? But the question that I like better is, "How do you spend your day?" and I spend my day making things. Sometimes I'm making things in my studio

and sometimes I'm making things somewhere else. But I'm always making or thinking about making, or encouraging and administering other people's making. It's a good question because in answering how I spend my day, I show what I value. And what I value is not just studio time—I really believe that artists have other kinds of roles that we could play in the world, things that we would be good at, things that we could also leverage our skill sets for.

Sometimes I want to be about the business of good governance in our city, or the business of creating opportunities for other artists, or the business of these acts of restoration in a neighborhood where thirty percent of the buildings are vacant. All of that stuff, it goes in the same journal, it comes out of the same mind. They have similar weight. Not all of them go to museums, not all of them are made. Some of them are realized so that people who would normally go to museums in other parts of the world might want to come here and see this part of my practice too. ∎

Many Different Voices

Jenny Holzer explains her works *For 7 World Trade, Redaction Paintings,* and *Truisms,* as well as her love of clichés and comic relief.

Interview by Susan Sollins at Sound Lounge on Hudson in New York City on December 6, 2006.

Art21—How did you decide on the text for the World Trade Center piece?

Holzer—I was invited to make something for the lobby at 7 World Trade Center. After much stewing, I came up with the idea of doing text in the wall—not memorial text but text about the joy of being in New York City. I despaired of writing for the piece, as I often do, and I came to poems by a number of different authors—everyone from Walt Whitman to William Carlos Williams, Elizabeth Bishop, and many more.

I stopped writing my own text in 2001. I found that I couldn't say enough adequately, and so it was with great pleasure that I went to the texts of others. I'd begun practicing that for projects such as the one at the Reichstag, where I went to the stenographic records of what had been said by various political parties about everything from the boundaries of Germany to the role of women in society. After doing that, I started looking at this as a solution for projects such as *For 7 World Trade.* **You are happy to relinquish the text to others.**

My pleasure is in reading and not in writing. I've read quite a bit for many years, and now the reading ranges from fiction to the declassified documents from which I'm making paintings. About the use of poetry in projects such as *For 7 World Trade* and in the projections—this is courtesy of my adult education, given to me by the American poet, Henri Cole.

I've spent a fair amount of time alone, on my work, and so it's with real joy that I go to other people to make something larger than I could have done solo. I've liked working with other artists on projects like *Sign on a Truck* and collaborative project shows. I'm heavily dependent on consultants for these poetry projects or for the ones that have to do with history.

It's clear that my work is not poetry. Occasionally people have charged me with it not being poetry, and they're correct. I've always been certain that it's not. It might take the shape of a poem, but that has nothing to do with literature. It has to do with the demands of the medium on which I place it. The space at 7 World Trade Center demanded that I fill the lobby—in particular, the glass wall—and I thought that the text should float by. To make the piece, I had to look at a number of drawings and renderings, make

Jenny Holzer at work on *Inflammatory Essays* and *Redaction Paintings*. Production still from the *Art in the Twenty-First Century* Season 4 episode, "Protest." © Art21, Inc. 2007.

quite a few site visits, and not only stare at the space but also walk it and feel it. After innumerable visits, I finally had some confidence in what I should do next. I like to make pieces that fill interiors. Glass walls are my friends because they let people outside see what's happening inside.

With the projections, it's a different process. I will project light and words on the exteriors, on the facades of buildings, and then sometimes will see the text creep into the offices and the public spaces inside. I hope the installations are atmospheric. I want color to suffuse the space and pulse and do all kinds of tricks.

So, you're a magician?

No, I'm not a magician. The big installations not only include the creation or choice of the text, but they also have much to do with filling the space and programming the electronics. That programming includes pauses, flashes, phrasing, and more. I really like the programming aspect. I was a typesetter, and typesetting is not unlike programming. You have to make text correct, complete, and pretty—and fitted. The presentation needs to make sense with the content and then needs to engage people. The poetics come from poetry by others, not from myself, but what I can contribute is something like a visual poetics that can have to do with the color, the pauses, and the omissions. I don't know how to program, so I'm reliant on others to do it, but I participate. We often decide what to do in the place, at the site of the installation, not in advance. We will have our ideas about what's going to happen, and then we go and see if they were right. And often they aren't, and we'll fix

them. There are many ways to have it wrong—if it's boring, if it seems wrong for the content, if it doesn't complete the space—and often you can't tell until you're there.

Why did you stop writing?

It has always been hard for me to write, as I think it is for anyone who wants to write well. I was pleased to leave it, and I have no idea whether I'll write again. One reason why I stopped was because I tend to write about ghastly subjects. So, it's not just the difficulty of having something turn out right, but it's also the difficulty of staying with the material long enough to complete it. It's necessary to be emotionally engaged when writing about these topics. It's exhausting.

I know that my researchers and I have had to stop, at various times, reading the material for these redacted paintings. Sometimes it's a relief to come to the pages that are wholly blacked out because then, for at least a page or so, you don't have to read what was there. The redaction paintings include many pages that are almost completely blacked out. Before the documents were released, the government blackened or excised portions for security or unknowable reasons.

Do you ever use texts written in the first person?

Often, I'll use the first person in my work. I will assume that voice. Or I will represent many people in the first person. There are lots of *I*'s and *You*'s in the *Inflammatory Essays*, but they're not me. They're many different voices on a host of unmentionable subjects. I'm present in the choice of the subjects addressed in the work, in the form

that they take, and the places they go.

There's a reason I'm anonymous in my work: I like to be absolutely out of view and out of earshot. I don't sign my work because I think that would diminish its effectiveness. It would be the work of just one person. I would like it to be more useful than that—to be of utility to as many people as possible. I think if it were attributed to me, it would be easier to toss. I want people to concentrate on the content of the work and not "who done it?"

Can you talk about your project called *Truisms*?

The *Truisms* were perhaps an overly ambitious attempt to make an outline of everything that I wanted to do. I'm not sure I knew that at the time I wrote them, but that's what I've come to recognize. I wanted to have almost every subject represented, almost every possible point of view, and then I had to sort out what those sentences should appear on. That turned out to be the street posters. Subsequent series had different demands because they had to fit in any number of places. I had to find the right medium, be that stone or electronics. So, I tried to sort this out as I went. I'm afraid to talk about values these days. Usually, any time values are invoked, it's to dismiss or maybe incarcerate somebody! I do make work that focuses on unnecessary cruelty, in the hope that people will recoil. I would like there to be less fear and cruelty.

And I'd like to think I have some plain old empathy, too.

Could you expand on that statement?

I liked that one. That's the first sentence I've liked. I'll stand on it.

How do you go about obtaining the politically based texts?

I've only worked with material that already has been released. I have not done any Freedom of Information Act requests on my own because there's so much to sift through that's already out there. I draw on everything, from the National Security Archives collection to old material from the FBI's website, to postings by the ACLU and a number of other places. I go looking all the time.

I've focused on documents about the conflict in the Middle East, both the last Gulf War and this one—that's one group. I've also gone back to older things for comic relief, such as the FBI following around Alice Neel because she was a Communist.

Any other examples of comic relief?

One other funny thing was the FBI interviewing Marian Anderson's neighbors to see if she was a good person—and having people testify that she was because when she came home from tours, she would do the dishes, and this made her A-OK. I guess that's funny.

I have one thing… there was much ink spilled about Brecht being observed in his pajamas, spending a lot of time at the typewriter.

You like clichés.

I love them.

Can you talk more about why you love them?

Clichés are truth telling, time tested, and short. These are all fine things in words. People attend to clichés, so important subject matter can be disseminated. Clichés are highly refined through time.

Talk about the handprint paintings.

I made a number of paintings of redacted handprints. We have found some handprints of dead people, handprints that were made postmortem, and these are extraordinary. You'll see that sometimes the handprints are almost completely muddy because the person pressing down didn't know how hard to press. I turn these handprints into paintings, with apologies to the dead, and then move to make them as precise, as clear as possible. Most of the paintings are only three times page size because I wanted them to refer to the actual documents. Other ones I made very tall, so that they would be physically overwhelming.

Are these works a form of protest?

Presenting the documents about torture is a protest. Showing love poems is not. ∎

Breaking the Bubble
Barbara Kruger addresses the role of media and consumerism in analyzing the use of language in culture.

Interview by Ian Forster in New York City on December 19, 2017.

Art21—**Your early works have stood the test of time and continue to resonate. Could you discuss the impetus for my personal favorite from the early '80s:** *Untitled (You construct intricate rituals, which allow you to touch the skin of other men)***?**

Kruger—It has to do with the notion of a comfort or discomfort with sameness and difference, and that somehow sports, for instance, is a way that men can be allowed physical contact that is so disallowed in a homophobic culture. Not only in the play of the game, but in the viewership of the game. How sports promote a kind of romance or a group understanding and intimacy around the notion of teams, about the notion of men together, men's bodies together. And that's true in the military also, it's true of cultures in certain countries, which disallow difference, which are homophobic, and at the same time are engaged in a war for a world without women.

Now of course things are so different because the binaries of gender have changed so intensely in the past ten years, problematizing the assignment of gender itself that in many ways for many lives has been very productive and emancipatory.

You're often discussed in the context of feminism. How do you define your relationship to that movement?

Well, of course I'm a feminist, but I speak about feminism as a plural, that there are feminisms and those feminisms are acted out in terms of site specificity: context, race, class, gender, location. They also connect now with a larger term, which is very much in use now, but I've always understood organically, and that's *intersectionality*.

There is always a connection between issues of race and gender and class—they don't ever exist separately, and those people who feel that they live them separately are really not understanding the multiple forces that are impacting their identity and their lives. You just can't talk about sexuality and gender without engaging the complicated issues of race, and you can't talk about race without engaging complicated, under-recognized issues of class. And it's wrong to trivialize any one of those things at the price of the other, and we saw the results of that with Trump, of what

happens when you don't understand the expanse of ideas and faces and skin colors and income brackets that comprise value systems.

How do you stay up-to-date with these complicated, evolving issues? What media do you consume?

I think television was and is very important, and now, of course I read online all the time, newspaper websites, *New York Times, LA Times, The Guardian, Washington Post*. I go to aggregators but I also go to a lot of right-wing websites, and I watch Fox, of course.

Why do you go to the right-wing websites and watch Fox?

Because I don't live in a liberal bubble, and it's that liberal bubble that brought us the regime that we have now. People were really ignorant of the forces around them and how they were gathering force. And I knew that to be the case by reading Storm Front, InfoWars, watching Fox—especially now with Jeanine Pirro and the campaign to discredit Robert Mueller—for years.

So it's kind of research to see how they're using media?

No, just their use of language and how easy it is to con people who want to be conned and the incredible power of White grievance and White rage globally.

The failure of so-called progressive culture or the left is that bubbleness. And that bubbleness is promoted even more in silos, they call them now, in both the right, the left and the middle, by our online identities, by our bookmarks, by where we go. When you used to read a newspaper, you read a hard copy newspaper, you read it all. I read it all: business, sports, everything. Now, you read online and you don't read as rigorously. But you know where you go. You go to people's bookmarks, you can pretty much read their autobiography on a certain level. So I think that there's something interesting about that, but also frighteningly reductivist.

Perhaps in contrast to that conventional media, what do you see as the power and potential of art?

I've always had a very broad definition of what art is, and it always struck me as funny that how come any piece of canvas with some pigment on it gets to be called art, and some movies or music is considered art and some isn't. It's complicated. I don't know the answers to that, but I do know that art is the creation of commentary. I think that art is the ability to textualize or visualize or musicalize your experience of the world. Not on a diaristic literal level, but in a way that creates a commentary about what it feels to live another day.

The goal for every human being, including myself, is to live an examined life. To really think about what makes us who we are in the world and how culture constructs and contains us. That's what I'm interested in.

A large part of that construction of culture is how we depict each other. The images of people in your work are always found, you never take them. Why?

Well, I was never a fan of street photography. I always thought that it was a brutal search on the streets for the most divine grotesquery

Barbara Kruger, *Untitled (Skate)* (2017). Installation view of commission for the Performa 17 Biennial at the Coleman Square Playground in New York. Production still from the *Extended Play* film, *Barbara Kruger: Part of the Discourse*. © Art21, Inc. 2018.

or the most Other. I was always so suspect of that. I think that there's a brutality about that and a lot of photographers don't understand that. There are some photographers who picture people quite brilliantly. A colleague of mine at UCLA, Catherine Opie, is an example. But I think photojournalists are incredibly naïve and many of them think they have a halo over their heads, that they are witnessing this brutality but somehow are apart from it.

I have people in my videos; they're actors. I pay them. I don't go looking around for that.

One issue you've examined in-depth is consumerism. Can you talk about *I shop therefore I am*?

I had read Walter Benjamin and I'll paraphrase: "If the soul of the commodity existed, it would want to nestle in the home and hearth of every shopper that passed its way." I just thought that was amazing. And I think, in reading *Moscow Diary*, I realized Walter Benjamin was a compulsive shopper. He's always shopping for something, and it was about framing his image of perfection.

I remember when artists in my peer group, my colleagues, were first being discussed and our work was first being sold, and I thought, "Well, if my work is developing this commodity status, I have to address it in the work." ∎

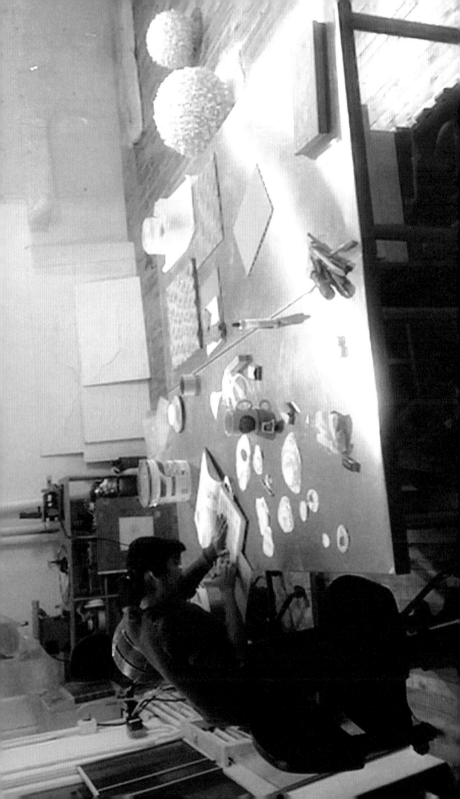

Art + Architecture

Maya Lin addresses the role of art and architecture in a practice that employs both.

Interview by Susan Sollins at the artist's studio in New York City on January 23, 2001.

Art21—Tell us about Groundswell.

Lin—*Groundswell* is a piece that I made for the Wexner Center for the Arts. It would be their first permanent installation, and Sara Rogers, the curator at the Wexner Center at the time, had contacted me, as she was very aware of the smaller studio sculptures. I had been concurrently building the *Civil Rights Memorial* as I was making *Topo* and all these outdoor pieces. I was working in my studio. Some of the works were being shown with broken car glass, lead, beeswax. There were smaller, personally scaled works I could physically make myself. The rule was: I had to be able to make it. And I think Sara and I discussed the idea of bringing something of my studio works out of doors. And I was completely interested in doing that, knowing that it was a museum, knowing that—unlike a lot of art in outdoor places where you really have to almost gear yourself up for maintenance-free works—a work

Maya Lin in her studio, New York, 2000. Production still from the *Art in the Twenty-First Century* Season 1 episode, "Identity." © Art21, Inc. 2001.

here could be more delicate. I took one look at the Wexner Center and I knew that. I had been for years wanting to use the broken glass out of doors, but inherently it's still glass, and you just can't touch it. You can't put it out there, just free, for everyday walkers-by.

So, when I visited the Wexner Center, I realized that, when Eisenmann designed the space, he had pretty much combined two disparate grids, and spaces were occurring naturally. They were what I would call his unplanned spaces, and they were occurring in very visible locations. At the front entrance, you looked out on this graveled rooftop. At the cafe, you looked down on an eight-foot-deep, very odd sort of pit, filling up with gum wrappers. And there was another one on the upper level where the administration was—highly visible but physically non-accessible, because each of these areas was walled off. It was something that you could look out on, both from inside and outside the building. And I knew right away that I could use broken glass. But at the same time, what I was thinking of doing would require dump-truck loads of broken car glass, which basically I had not really ever dealt with. I mean, I had taken something that was, like—these pieces I was

The Power of the Public 121

making inside were no longer than a table. They were very small. But I knew that I wanted to do this.

The other thing that was very important to me was that—unlike the intense amount of planning, modeling, preparing that I go into to make some of the large-scale outdoor works—I wanted to bring to this piece more the act of spontaneously making the work of art. Which meant all that I actually did as drawings and planning was two or three very rough sketches on Xeroxes of the photographs of the existing place. I deliberately wanted to treat it the way I go into my studio, not knowing what I'm going to do, and make something. And inherently, the difference—when an artist literally has a blueprint for an idea and then lets other people build it, or whether you can actually at a larger scale physically go out and spontaneously make something—is something I really wanted to explore in this piece.

So, on a given day, forty-three tons of car glass arrived. I had a crew of three people, and we just made this piece. I was terrified because I also realized, "Well, if it's an absolute disaster, I'm out there in full view." A studio's a wonderful place, because if it doesn't work, nobody would hear about it. Here I was, with school groups coming by, watching this, and I'm out there not having a clue as to what I might want to do. It took me three or four days. And the way in which the glass was carried in... The architect in me kicked in, at some point earlier in the process, and I realized, "This is no different from getting roofing gravel up to the top of a roof." So, I called up a roofing contractor, and I said, "Well, I've

got these three rooftops that I need re-graveled," and they were, like, "No problem." Then I told them it was broken glass, and they said, "Slightly no problem." And the wonderful thing about it is—to get all that gravel up, you need a boom crane and a conical bucket—and we dropped the glass, bucket load by bucket load.

And I knew that the piece would be about that because, again, these works are also about process. I think I'm absolutely coming out of a '70s attitude in art, where the process of the making of the piece oftentimes can play into the piece. And for this, it is about a meeting of East and West. It's a play on the Japanese raked gardens of Kyoto, as well as the Indian burial and effigy mounds of Athens, Ohio. So, it's a real blend.

Could you talk a little more about these references?

The Wexner Center is in Columbus, Ohio. It's forty minutes away from Mound City, which is the largest grouping of these mounds. So, it's a melding of a conscious idea on my part to sort of blend East/West culture, but it's also about bringing a studio artwork mentality out of doors. And also it's about process. And I think [Robert] Smithson had done a piece for Kent State, called *Asphalt Pour*, in the '70s. He took a dump truck full of asphalt and just dumped it on the side of a hill. And I think he buried a shed with it (or was that another artist?). It was about bringing in—tying in—a spontaneous process into the piece. But for me, it was my first artwork that I made that I was having a problem. Because I knew when I had done the monuments that I was still searching for something.

I really do feel the memorials are separate; [they] stand apart. I think monuments, unlike artworks, are a blending of art and architecture. They have a function, but their function is for the most part purely symbolic, so they're in between. They're sort of the true hybrid between art and architecture.

I knew, for me, that I was struggling in the studio works—and in an earlier piece called *Topo*—to get back to the land in a much more fluid yet intuitive way. And I think, when I had made *Groundswell*, I realized that, for me, it was my first artwork, and I knew that I was very interested in where it was going to go. And where it went was to *The Wave Field*, which again led me to the whole "Topologies" show. So I think, for me, my sculptures deal with naturally occurring phenomena, and they're embedded and very closely aligned with geology and landscape and natural earth formations. I think that someone's work—like Alice Aycock or Scott Burton's work—dealt with a language that tied it back into architecture.

Why is there such a distinction in your thinking between art and architecture?

I actually keep them separate; that's just a choice I made. I don't know why I did it. I felt compelled to do it, basically. I have two sides: creativity and the architecture. It's got ideas about framing the landscape, being ecologically and environmentally sensitive—not that a lot of the artworks aren't using recycled materials and about nature in another way. But formally, I liked that they're different, that I don't want my architecture looking like my sculptures, and I don't want the sculptures being at all architectonic in their form. And that's just a choice I made, or a choice that was made. I don't think I ever really thought about it. I don't think I woke up one day and said, "I'm going to be an artist on some days and…" It was more that I couldn't choose between the two, nor did I choose to blend them. I think it's taken me a body of work to see how I am developing.

Can you talk some more about this?

I think there's a very easy segue into it, which I think is interesting. I have one huge concern because I sort of split my time between the artworks and the architecture that—in a way, the processes of making them are very different. And I've always been afraid that there'd be a real split, or a schizophrenia that would begin to occur, between my life and my creative process as an architect and my life in art.

Concurrent to the "Topologies" show, I had been asked by Knoll, a furniture company, to design their sixtieth anniversary collection. And from a designer's point of view, from the design/architectural world, the chair is, in a way, the closest to a self-portrait. What do you look like, if you were a chair? And that was a very tough struggle for me, because I was searching for something. And I started researching the history of the chair. And what I came up with is something I ended up titling *Stones*, and they are as much about sculpture as they are about design and architecture. And the form is… you can't quite tell. It's a very simple elliptical stool that you

sit on—ever so slightly concave in the center. They're lightweight concrete. And they are about that merger, or that dialogue, I have between art and design; they're a hybrid.

And the whole series is called "The Earth Is (Not Flat)"; they deal with the curvature of the Earth. There's a chaise lounge called *Longitude*, which literally is the same inspiration I had to make *The Wave Field*. It's a slight undulation in the ground plan. But it also is playing off of design, taking Mies van der Rohe's classic psychiatrist flat daybed and literally throwing a curve onto that, from a design point of view. I think, for me, the *Stones* are my favorite, if you can have favorites (it's always terrible to say your favorite).

But because, in their simplicity, they both talk to the sculptural world and the architectural world, and in that sense they really talk about who I am and where I'm coming from, they're very important to me. So that, simultaneously, I could be doing an art show called "Topologies" and a commercial line of furniture entitled "The Earth Is (Not Flat)," and yet they're the same voice. For the first time, and that was a couple of years ago, I was sort of made to feel whole. But I think it is hard to separate yourself into two worlds. So, it's very nice when you know that the worlds, though separate, are in close dialogue, and that they're in step with one another. And that's been very important for me in my aesthetic, artistic development. ∎

Public Art
Ursula von Rydingsvard shares her motivations for creating work in public spaces and her 2006 series of sculptures installed in New York City's Madison Square Park.

Interview by Susan Sollins at the artist's studio in Brooklyn, New York, on July 26, 2006.

Art21—**Tell us about your four pieces, including *Damski Czepek*, that were installed in Madison Square Park in New York City.**

Von Rydingsvard—I think the project at Madison Square Park evolved about three years ago. The urethane bonnet was extraordinarily time-consuming. I did the entire bonnet out of cedar first, and the cedar walls were very slender.

I sent that bonnet—a life-size form in cedar of exactly what was made in urethane—across the country, to the Walla Walla Foundry in Washington. I think it's the biggest pour that was ever done, in the history of this kind of urethane. And there were huge amounts of things that failed, in the process of learning how this material works. I wanted a transparent look of walls that the light went through. I wanted a very agitated surface. And the hood that is over the bonnet—almost like a little porch—is very erratic and very celebratory, and it needed that translucency of the light. It's not just the sun. When the skies are cloudy, there's a whole different thing that happens with that material.

It's one of only two pieces I've made that actually get used by the public. The other one was the Microsoft piece. It's the only outdoor piece that the Microsoft campus has. This one has two little rivers on the side that are also made out of the urethane—a kind of beckoning to go into the center of this bonnet.

Have you observed people interacting with *Damski Czepek*?

I have, and it's not what one would think. I tend to be so protective of that piece getting harmed or hurt, that I would rather not be around it. But I think—more critically—I don't want to hear what people say about the work. That often feels all wrong to me. Not that I want in any way to direct what they think or their reactions—I just don't want to hear it.

I think there were twelve marriages that took place inside the bonnet. It's been so used, in fact, that we've had to change the grass. This is the third time that we're putting in the new—uh, what do you call that grass that you unroll?

Sod?

Yes, sod. We replaced the entire interior of the bonnet many times

already because it's been trampled on and used. Actually, I shouldn't be so negative about my observations. There were times when I loved seeing it used, when it made me feel like the piece was a big success. I knew that people were going to interact with it, but it's one thing to know it, and it's another thing to watch it. What happens when the layer of sod is worn out is that there's a pathetic look to it. It looks like a wet puddle with earth underneath. That makes me feel as though the piece deserves a better context. So, we replaced the sod, and she looks proud again. Then I'm more able to embrace people's use of that piece.

Is making public art, or art in public spaces, important to you as an artist?

I come from people that have never been to a museum before in their lives. I don't think they even know what a museum is. People, meaning my parents: they could barely read and write.

To be able to show my work to a public at large is important. People are not entering any holy place that's meant only for art. Art is not placed on a platform. And I strongly believe it doesn't have to be, in order for it to still be potent. There is a way in which people can engage or not engage—on their way to work, on their way to get a shake. It doesn't have to be a serious, genuflecting, silent, deep-rest kind of thing. It can be much more casual and easy. So, it's a real privilege to have had this opportunity.

Have elements from your upbringing crept into the pieces here, in the park?

I had a sweater as a little girl in the refugee camps in Germany, and it was hand-knit out of unbleached wool from sheep. It had wonderful *babelkami* (popcorn stitches) on it, on the grid that was at the top part of the body. And of course, in no time at all (because it was not as though I had more than one of these—it was actually the only sweater I had during all those years) it got worn on the sleeve, around the shoulders and around the belly, so that it was kind of wayward. The grid got disrupted. It went organically wayward. It started flowing; it started falling. So, I used that, or a kind of intrigue with that, in part, as a source of my imagery for this enormous bowl—actually, the biggest I've ever built. She sits there, and her profile from the side is very slender. From a three-quarter view, she spreads out. She's like a sail, eleven feet wide at the top.

Have you taken your parents to see your work?

Actually, my mother's been to an exhibition. I took her to the exhibition at Storm King Art Center in New York. I think her understanding of my work was something that I couldn't have predicted. When she looks at my sculptures, she refers to me (in Polish) as a chicken that keeps digging into the mud to get little seeds. That was her reaction to the work. And then to Storm King itself, to all that beautiful landscape and space— she asked me, "How much did you pay to rent this place?" That's the

Ursula von Rydingsvard at work on *Ona* (2013), a large-scale sculpture permanently installed outside of Barclays Center in Brooklyn, New York. Production still from the *Extended Play* film, *Ursula von Rydingsvard: "Ona."* © Art21, Inc. 2013.

realm of her understanding of those situations. Of course, there is no such thing as renting Storm King. They ask you to do the exhibition, and then you react to the land as you see fit, with your work.

How did her comment resonate with you?

I think the image is a good one. I mean, it's insulting, but it's good. There's a futility in it, too, and a reference to constant work.

Where did the bonnet form that you've used in your work originate?

The idea of a bonnet surfaced in connection with a piece I made for an enormous private farm in the southwestern part of Massachusetts, about two years ago. I chose a spot in the woods that wasn't dense with trees. It was a little circle, and in it I placed these bonnets facing outward. Below, there was a ravine where water trickled down. So, it was almost like a stage. I looked at the entire one hundred fifty acres and fell in love with this part. It was my reaction to the land that motivated me to make those structures around it.

How did the title for the bonnet piece come about?

I never wanted to be literal. I never want the explanation to be so simple and so clear with a hard dot at the end of it. But I didn't know how else to refer it. In the process of working, I always need a working title. And that was the working title, *The Bonnet*. I tried so hard to get rid of it. I tried not to make references to it, with the people who I worked with at Madison Square Park. But it just kept falling out. But the name that I have finally titled it is *Damski Czepek. Czepek* is something that

belongs to the Old World: a bonnet for a woman. *Damski* means "belonging to a woman."

Are you influenced by other sculptors or sculptures?

I'm not even sure that it's sculpture that I drink the most from to reap imagery for my work. I think it's vernacular architecture—everyday kinds of objects like bowls and cups—that enables me to springboard. And that gives me a lot of room and a lot of leeway, because none of it has been so explicitly defined. Usually the utilitarian object is just that; it's made to be used. And the whole design, if one wants to call it "design," is made for the purpose of its being used, so that the options surrounding it are huge.

If I were to say how it is that I break the convention of sculpture—and I'm not sure that's what I do or even if that's what I want to do—it would be by climbing into the work in a way that's highly personal, that I can claim as being mine. I have this feeling that the more mine it is, the more I'm able to break the convention. So, it's not radically erasing, with this drama, what's been done in the more immediate past. It's more like finding many ways into the work that feel potent psychologically—that feel potent emotionally—but only feel potent for me. And maybe that'll overlap onto what others might or might not see. But I think the most important thing for me is to figure out what it is that'll give me a rise, what it is that'll turn me on, what it is that feels really interesting to me. Or, what it is that feels compelling—why I would be driven to do something like that seventeen-foot bowl

with all the *babelkami* on it.

I strongly believe in the individual, as opposed to the institution. Whether it be a religion or a corporation—whatever the nature of the institution—I strongly believe in the potential of the creative process.

What kind of projects do you hope to complete in the future?

There's this strong desire I have to make a sculpture. I think that this will have to be on a scale that I've never worked on before, and it won't have anything to do with a series of objects. It'll be the point at which something manmade meets nature.

I've seen many of the ruins in Mexico, Guatemala, and China. I've seen them all over the world. I love looking at those moments— when nature has encroached upon something in a very dramatic way, yet you can feel the lines of man absolutely involved in that composition. And usually these things are quite low to the ground because the walls are already eaten off.

I've had dreams of making a stone cliff. I've had dreams of taking the implications of what nature has already done, and then starting to build on top of that with the same kind of stone, but much more obviously manmade. I keep thinking that the trickiest part would be the point at which the stone that I cut would meet nature's stone. It's something I would love to do. ∎

The Role of the Artist

Tania Bruguera
Theaster Gates
Mike Kelley
Jeff Koons
Glenn Ligon
Kerry James Marshall
Zanele Muholi
Raymond Pettibon
Pedro Reyes
Doris Salcedo
Stephanie Syjuco
Sarah Sze

Defining An Artist

Tania Bruguera explains the term Arte Util in relationship to the social responsibility of art.

Interview by Susan Sollins at the Queens Museum in Queens, New York, on March 24, 2014.

Art21—Can you explain Arte Util?

Bruguera—After working for a long time with political art and social art, I came to the realization that there are two kinds of artists. The first are those artists who think that, through art, they can unveil something that is happening in society, with people or whatever the subject is. These artists rely on the visual and the possibility art has to literally show us something.

The second kind of artist thinks they can do something with that knowledge and can use art as a tool for change. Arte Util artists are not satisfied by just showing that there is a social problem or an inequality or by only telling you what's going on. What gives them the aesthetic moment is [thinking about] how one can use all the tools of art to change reality and how to incorporate themselves as artists and civic servants into that reality, with the knowledge that art can change some of those paradigms.

What is your definition of an artist?

My definition of an artist is somebody who specializes in creativity, in knowing and acquiring tools by which they can imagine something different and make it happen in reality. Artists are people who are very good at imagining a thing and finding the way in which that can be built and exist for others. Basically [an artist is] somebody who doesn't comply with what is happening at the moment. For a long time, artists were doing it for themselves and keeping it for themselves, [which leads to the] idea of the crazy artist or the bohemian artist. But now there are artists who have social responsibility: to share and to implicate other people in that dream and in that way of seeing reality.

What makes an artist who feels a social responsibility different from a person who works with groups of people to envision some kind of new future, like a politician or social scientist?

I think the difference between artists and scientists, politicians, professors, civic servants, or activists—other people who are trying to change things—is the fact that artists have much more freedom. Scientists have to work with certain truths; activists have to work with certain guidelines, ethics, or parameters in order to gain the trust of people. The artists do not need any of that. The artist is

somebody who can participate in all of those activities; [being an artist is] not a specialized practice. The artist is somebody who can bring together people from other spheres to work in a vision of a different reality. The artist is the one who has to push the others to get away from their disciplinary boundaries.

We observed your *Immigrant Movement International* project in Queens. How do you explain that project to a viewer who sees it as a social-activist project, one that provides large groups of people access to tools that they wanted but didn't have or couldn't reach? How would you explain it as a work of art or a work that needs to be created by an artist?

An artist can bring [something] to the discussion of social change and working with others, like scientists, activists, teachers, or politicians. When people know art is involved, they lower their defenses, and they understand that it is a tradition of [art] to [be] about humanity and how human beings are in time and in place, without further interest— whereas they know that [a politician] is going to take something out of a conversation or is going to profit from whatever is happening.

It is not easy, as an artist, to collaborate with other people because there are some prejudices against what the role of the artist is and how artists have been situated in the political spectrum. Most people see artists as leftist, but they also don't see artists as completely committed to political endeavors and

issues because the relationship with the market creates some distrust.

Artists need to make people understand what the role of art is today and then show that to other people. Artists today should be not only about producing but also about being one effective part of another ecology.

I know everybody can imagine things, and anybody can have a vision, but I feel that artists are more eloquent in knowing how to pick what works and what has the idea of beauty. By *beauty*, I mean a landscape of ethics from very different places. An artist is like a sponge that is open to everything and anything, all the time, no matter if it comes from a physicist's experiment, a lawyer's case, or a politician. Artists have the capability to understand intuitively what can work and what can affect people because it's in their nature to be extremely open to being susceptible.

Artists practice how one can be vulnerable in the world, to receive it and bring [something to] it. That gives a lot of freedom to the artist: to search instead of do a specific practice or follow a specific protocol.

If I met all those descriptions, then am I an artist?

If you're open to being susceptible to what works and to find the moments in which things are catalyzed in a way that can concentrate a set of anxieties, accomplishments, desires, and projections in one action or one moment, then yes, you are an artist. You don't need to be trained in a school; you just need to train yourself to be aware of what to do. The fact that you can see it makes

Tania Bruguera

you susceptible to understanding art. But an artist is somebody who sees, understands, and does something with all of that and shares it with other people or tries to advance it into another stage.

Would it be fair to say that you're changing the definition of the word, *art*?

I don't think I'm changing the understanding of *art*. I'm taking the work of people like Allan Kaprow, Joseph Beuys, and Marcel Duchamp and the writings of artists and theorists in performance art—all that I've been reading, seeing, and looking at—and saying what I'm seeing.

I created the idea of Arte Util because I started traveling and seeing people doing things a little differently. They were in the same package, they were in the same bag, but they wanted to use art for something other than the fact that it exists as art.

Why do you think Arte Util is art?

I think art is a state of things. It's not a permanent condition, and it's not something that is going to happen forever.

In the moment in which we are living, art should not be forever. It should be art for now and for the urgencies of today. I see the role of the artist at the moment as somebody who can propose [actions] to the rest of the people, whether that be creating an environment for something to happen or giving the tools to people to do certain activities on their own. A role we have now is showing to people: this is what we can do, these are the tools, take them. I see the artist as somebody who is providing a tool kit for people. If somebody who's not an artist is doing the same thing, what is wrong with that?

Why then do you even have to call it *art*?

It's important to call it *art* because people need to understand that what we do now, as artists, is that practice. It's a way we can assure that art has a role in society. Artists can keep their freedom to say what other people might not be able to say—because they don't have places to say it, or they work in certain fields where they cannot say it, or they are afraid, or they haven't created an idea of what they are feeling.

It's important to call all of this *art* to preserve the necessity of experimentation, of a space in which to try out ways of talking about things that we as a society might not have arrived at yet. ■

Expanding the Role of the Artist

Theaster Gates reveals what he sees are the possibilities for artists to go beyond the making of objects, to actively contribute to and better communities.

Interview by Stanley Nelson at the artist's studio in Chicago on January 11, 2016.

Art21—Do you see artists as having another role outside the traditional one?

Gates—Even mentioning that artists would be involved in things that are outside of our studios is quite controversial for other artists. And I've seen this conversation play itself out, that in fact we should not have to be called upon to patch the problems of struggling communities. We should not have to be the ones who take on the question of police brutality or Black male violence in our country. We should not have to be the ones thinking about unfair labor practices. But in fact there are artists who are willing to take up these causes. Artists who understand that sometimes the artistic effect is better than policy, it's more complicatedly inclusive than the town hall meeting. There are these ways in which artists can wield the world and make really amazing things happen because they're not just dependent upon the money that can be raised to generate a protest, [because] the protest is in the work.

So when I think about the work that Rick Lowe is doing in Houston or I think about Laurie Anderson being in conversation with this guy from Guantanamo Bay, that in this way artists are attempting to have real-world things emerge, raising issues that would not be raised in the same way on a media network. Those moments we could do much more than create an object of desire: that's cool. Maybe even that it's necessary. That at some point the object of desire, does what it does where it does it. And I just think: whoa. Is there more for me to do in a day? I think there is.

How do you see object-versus engagement-based art?

So if we were to accept that there are these possible two camps, one camp would be object-based practices and one would be engagement-based. I'm going to deal with this as a kind of dichotomy for the moment. Object-based practices are what we traditionally imagine as art. It's a thing that you can look at on a wall. It's a sculptural object that you can see in a museum. It's a thing to be touched. The engagement-based stuff is a little bit more complicated. It's often based in relationships. Sometimes it produces a set of things

but not always. Sometimes it only wants to produce an effect. It takes many forms. It could take any form that is sometimes object-based and [sometimes] not. But I think that both parts of those things live within my practice. I am a lover of sculpture and painting and drawing, and I spend a tremendous amount of my time thinking about that stuff and making art in that way. But I feel like whatever would be an engagement-based approach is simply a way of saying that people are also important to the work that I do. And that by engagement I am asking someone else to enter the territory of art with me, saying, can we do this together? Whether it's the Black Monks of Mississippi making music with me—a temporary gospel choir, and we're all singing about Dave the Slave Potter, with new music I've produced—or a set of Turkish plasterers who are helping me to conceive of new bodies of work, or the creation of a political party by Tania Bruguera: There are ways artists are [pursuing] these things outside of our studios that include other people. This is a moment where it feels like there is gross permission, both by the artists ourselves and within this creation of art history, that people are starting to do that.

Art just has so many colors and flavors and ways of presenting itself. And we're calling out two ways, engagement- and object-based, but we would need a lot of words that would function as descriptors for [different] kinds of practices. And maybe the value of those words is that they help people focus themselves, like they see a thing happening and they can say,

"Oh that's art, right." One of the things that has me very excited is that there are things I want to make for which people may not snap and have an "a-ha" moment. They may miss it as art altogether. I think that might be a kind of artistic future that I can invest in, that in fact you won't know what you're looking at.

What relationship do you see between materials and discarded communities?

I know that the work is always acting as a stand-in for a more complicated set of questions. That is, what if I didn't just have the gymnasium floors? Is there a conversation that I should be having about the future of education for young Black boys? For the 26,000 men and women who are detained in our jail system in Chicago, for the 100,000 men and women who are detained per year in that space? Is there a way that there's some other kind of education opportunity that would act as a redeeming function? But I don't know what that is yet. I don't have jobs for the 10,000 men that might come out of jail this month. But man, what if I did?

And so I'm always thinking about that gym floor, and the gym floor is trying to answer an artistic imperative. But there's this other thing that I want. I actually want a solution for the 10,000 brothers coming out of jail. Is the gym floor important? To say that education is important, these schools are closed, this thing is happening, these are challenges. But what advice can I give my friends in government? What advice could they could give me that might inform the way that I use St. Lawrence Elementary School, this

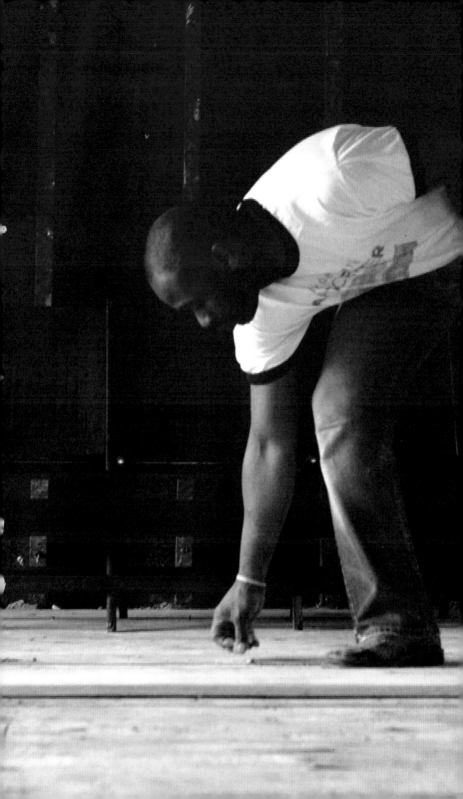

Exhibition space at Theaster Gates's Stony Island Arts Bank, Chicago. Production still from the *Art in the Twenty-First Century* Season 8 episode, "Chicago." © Art21, Inc. 2016.

Previous: Theaster Gates in his studio, Chicago, 2016. Production still from the *Art in the Twenty-First Century* Season 8 episode, "Chicago." © Art21, Inc. 2016.

building that we acquired down the street? I'm still wrestling with the relationship between the symbolic work that ends up on a wall and the pragmatic work that changes lives or creates new education options, or creates new employment pathways. All of that stuff feels like a good creative problem to solve. I'm actually excited about this idea that a work could at the same time be itself, be the demonstration of a thing, and be part of the solution of the problem that it's referencing.

How could it become the solution?

It becomes part of the economic opportunity that allows for the restoration of a building. It becomes the solution that allows for the hiring of a couple men or women. It becomes a reminder to others, who don't have to look at the ugliness of poor places,

that there are poor places, and that starts to do its own work.

As I'm thinking about the objects that I want to put in the world, the people who I'm engaged with, I cannot think about the impact that we're trying to have on the South Side without thinking also about the fact that these are luxury items that live in a market. In the same way that my going to the university every day has value, my making these works of art has a value. And my incomes allow me to do this thing that feels bigger than the everyday work of development, or bigger than the everyday work of planning a new school. It feels like I'm participating in changing the mindset of how people imagine Black spaces. And I don't mind the bigness of it, and I don't mind the investment. But I would be remiss if I didn't say that part of what allows this work to happen is

that there's a set of objects that are made and those objects go out into a very hungry market that has an appetite for the objects that I make.

I love that artists are also important to our cities, that there's a way in which maybe the solutions that we have for our cities are slightly different from traditional solutions, and the models that we use to get to a solution are slightly different.

How have you seen these kinds of solutions at work in Chicago?

If I had to answer this question —can art and culture revitalize communities?—I would want to say, no. It shouldn't be the job of art and culture to deal with water problems and unemployment. Should art and culture be the thing that has the burden of changing communities? Probably not. Are there other things alongside art and culture that need to happen in order for a healthy community to emerge? Absolutely. Like art and culture may not be after-school tutoring. It may not be the healthcare center. But I think that when art and culture are present, when it's doing its thing well, it becomes a kind of magnet for lots of different possibilities.

When art and culture are present, other kinds of things want to be present. Schools want to be better, neighbors want more for themselves, government is willing to do more to advance the built environment in those places. And I feel like I'm involved in that work. I'm involved both at the level of making art happen and then making culture evident. And sometimes making culture evident is simply giving a platform so that culture can do what it does. ∎

Language and Psychology
Mike Kelley muses on psychological theories, beauty, and the sublime.

Interview by Susan Sollins at the artist's studio in Los Angeles on November 16, 2004.

Art21—How much do psychological theories factor into your work?

Kelley—I don't think it's something that's there all the time. In certain projects it is. In the *Uncanny* project, it's there because Freud wrote (really) the only essay on the uncanny, so I used that as a reference point.

I can't say that I'm particularly invested in Freudian ideas, though I do really like Freud's writings; I think they're really beautifully written. A lot of psychoanalytic writings are just not very interesting to read, and Freud really is interesting to read. So, I like him as a writer, but in terms of the theory—so much of that theory's been absorbed in the popular culture. To get into the nitpicky little details about all the squabbles between the analysts and all those different psychological theories—I don't want to get to that. That's far too complicated, and that's not my focus, really. I tend to use writers and theories for my own ends. And generally they're poetic ends. I tend to use psychoanalytic writing or psychological literature that way.

I'm actually a big fan of the writings of [Sandor] Ferenczi, who's a contemporary of Freud, and also [Wilhelm] Reich and [Carl] Lange, whereas Lacan doesn't interest me very much. I just don't find the writings speak to me as literature. I tend to really like that psychological and psychoanalytical writing tries to tackle basic human motivations and problems. Also the way that those people write about sublimation—the fact that one idea can be substituted for another or block another. That's very much like metaphor, and that's very much, to me, like art. I really think art's about representation. And I don't believe in nonobjective art; I don't think there's such a thing. That's not to say that I'm a realist, but I think all things operate on multiple associational levels. That's how people look at the world. So, I'm drawn to discourses that are interested in that. Psychoanalytic writing tends to be about people's daily problems; it's more rooted in reality and daily life. I'm more drawn to it than abstract philosophical writings.

For example, in my paintings, I was thinking of just taking random quotations from Ferenczi, as if that explained the paintings. Ferenczi has a lot of fantastic little snippets that could be taken out of context. It's not serious; it's just meant to throw the whole thing into some kind of light. It provokes the viewer to project into it in a more controlled way than they would naturally.

I've also been reading recently—oh, what's her name, the British psychotherapist who did a lot with children and play theory? Melanie Klein. I've been reading a lot of her work and thinking of making some sculptures particularly related to her ideas of play therapy—but in a musical context. That genre of writing is one of my favorite genres. In fact, it's taken the place for me in my reading over literature, because I don't find much literature that interests me nowadays. When I was younger, I was really a bookworm and read a lot of literature. But I don't get pleasure from it anymore, whereas I still get pleasure from reading "shrink" books.

Can you talk about your own writing?

When I was younger, all my writing was generated for performance work. So, it was writing that had to have a kind of flow. I was very much influenced by writers like Raymond Roussel, Samuel Beckett, Gertrude Stein, and Thomas Aquinas. There's always a sense of presence, but at the same time, things shift—like in Aquinas's "proofs" or how reiteration is used in Beckett or Stein. A lot of my writing at that period was very associational but trying to be structured in a way, where ideas could be a stream of consciousness but be simple enough to flow, one to the next. Where you could flow and contradict yourself but the audience—because of the durational aspect of the performance—wouldn't remember. They'd remember the content, but they wouldn't remember that things change. And that really interests me about older forms like oral narrative.

I started doing more critical writing in the '80s, when I was very unhappy with how my work was being written about and how other artists who I respected or had some association with were being radically misrepresented in the art press. But now I've tired of that. I don't feel like I need to be the voice of my generation or my group, and I don't care so much about art-world politics. So now, I'm much more interested in getting back into creative writing. This project [*Day Is Done*] is very much a way for me to get back into writing. And because I don't have the time just to do it, I have to work it into my work, somehow—like music. I didn't have time to play music anymore, so I had to make a project where I forced myself to make music. That was the reality of it; otherwise I wasn't ever going to get to do it. But I still, on occasion, write catalog essays or things like that. When I remounted the *Uncanny* exhibition, I had to write a new preface for that because the art world had changed a lot in fifteen years, and I needed to update my thoughts. But it wasn't something I really wanted to do; it was something I had to do.

What about your books?

I've just published, in the past two years, two books of my essays and informational writings about my work. What hasn't been published

This page: Mike Kelley in his studio, Los Angeles, 2004. Production still from the *Art in the Twenty-First Century* Season 3 episode, "Memory." © Art21, Inc. 2005.

Previous: Mike Kelley on the set of *Final Procession from Day Is Done* (2005), Valley Plaza Recreation Center, North Hollywood, 2004. Production still from the *Art in the Twenty-First Century* Season 3 episode, "Memory." © Art21, Inc. 2005.

are all the performance texts and writings for video. That's the project I want to do next, but that's massive because I've written a lot more of that than I have critical texts.

Is there a limit to what you would include?

Oh, for sure. There are certain kinds of things that I wouldn't publish, like song lyrics, because they're just so stupid; they don't make any sense outside of the musical context. But I would rework the performance texts for publication. I think they can function as a kind of poetry.

Are the titles of your projects important?

Very much so. Often my titles are quite lengthy, and they're meant to be descriptive. They're trying to be clear, trying to say what it is, but at the same time they reveal aesthetic clashes, or their wordiness gets to the point of incomprehensibility. I like poetry, for example, in which the language can fall into pure sound. Yet there's always this tension between the musicality of the language or the fact that it falls into rhythm, into something you find in really complicated language, like theory or legalese. And I'm drawn to that kind of language. A title like *Extracurricular Activity Projective Reconstruction*. When you say it, it's hard to take it in; it's a mouthful of words. But it's not meaningless—that's what it is. Not all the titles are complicated like that. Some are really simple.

How have critics understood your work?

I was associated with this so-called Abject Art movement, in which notions of failure came into play in the discussion of art. And because a lot of my work looks towards so-called low forms, like folk art or lower-end mass culture, critics of my work tended to confuse my use of that with some kind of investment. That this is some kind of "blue collar" aesthetic. Well, I might come from that, but I have no love of it.

The art world's changed a lot because recently such things have found a place in the art world—fifteen years ago, you'd never see in every gallery in New York some kind of mass-culture referent. Now every gallery has such things, and *slackers* has become a positive term rather than a negative term. This kind of discussion doesn't interest me whatsoever, because who defines these things? I can't talk about it so abstractly; it's meaningless. So, I don't feel like getting into specifics about that, relative to other artists' production.

What about the idea of beauty?

This was a really big topic in contemporary art. The so-called New Beauty camp—art becoming beautiful again. I think they're talking about conventional ideas of beauty, and I'm more interested in the sublime. I think it's a kind of neo-conservatism that fits right in with Republican ideology. It's backward-looking, and I'm not interested because the New Beauty is old-fashioned beauty, as far as I see it.

What do you think is beautiful?

I think what I make is beautiful. I think it's beautiful because terms and divisions between terms are confused, and divisions between categories start to slip. That produces what I think of as a sublime effect, or it produces humor. And both

things interest me. When you use the word *sublime*, traditionally it's associated with metaphysics. It's a nineteenth-century usage, like the sublimity of a mountain that becomes like nature and God. I don't mean to evoke it in that way. I'm interested in a less elevated beauty.

Can you say a little more about the sublime?

Well, like I said, I think that kind of discussion of the sublime is a nineteenth-century metaphysical discussion, like Edmund Burke or the American Transcendentalists. And that's not where I'm coming from. For me, psychedelia was sublime because in psychedelia, your worldview fell apart. That was a sublime revelation, that was my youth, and that was my notion of beauty. And that was a kind of cataclysmic sublime. It was very interiorized, it wasn't about a metaphysical outside; it was about your own consciousness. That's my starting point of the sublime, and I've had to take that into a more conceptual sphere, which is perhaps an analytical sublime. Like, how do you produce a sublime effect? Preaching is a production of sublime effect. Poetry is a production of sublime effect. Hypnosis is the production of sublime effect. And those are all examples of it, produced through language. I think you can also produce it through image— image clash, image resonance, things like that.

When did you know you wanted to be an artist?

I knew by the time I was a teenager that I was going to be an artist; there's no doubt about that. There was nothing else for me to be. I didn't even want to be the other things that at the time were outside the general culture. I didn't want to be a rock musician; I wanted to be an artist. And I think the reason I chose it was that, at that time, it was the most despicable thing you could be in American culture. To be an artist at that time had absolutely no social value. It was like planned failure. You could never be a success. And the fact that I'm now a professional artist? At that time, it seemed like a contradiction of terms. I came from a milieu in which artists were despised, whereas rock musicians and drug dealers were hipster culture heroes. ∎

Jeff Koons, *Lobster* (2003). Installation view at Château de Versailles, France, 2008. Production still from the *Art in the Twenty-First Century* Season 5 episode, "Fantasy." © Art21, Inc. 2009.

Art Changes Every Day

Referencing art history, **Jeff Koons** reveals the iconography of his work and explores what it communicates.

Interview by Susan Sollins at the artist's studio in New York City on February 3, 2009.

Art21—How has your relationship with art has evolved over time?

Koons—One of the amazing things about art is that it changes every day, and its meaning to you changes every day. When I was young, it was really a vehicle that gave me a sense of self. My sister was three years older—so I couldn't do anything as well as she could. She could always do everything better. But when my parents saw me draw, they made me feel like I could finally do something at her level. From that point I had a feeling that I had a place, and it gave me a sense of being. I started off having no idea what the power of art could be. As I developed a sense of personal iconography I learned that you start to become comfortable with yourself, to accept yourself. Once that happens, you want to go external. You go from subjective to objective art, and art becomes a journey, which is really about sharing with people. When I was young I really didn't have a base in art history. On my first day in art school, we went to the Baltimore Museum and at that moment I realized how naïve I was. I didn't know who Braque was. I didn't know Manet. I knew nobody.

I knew Dali, Warhol, and probably Rauschenberg, and Michelangelo, but I had no sense of art history. I survived that day and I think that's one of the reasons I'm here now. I was hungry to learn. I wanted something to transform my life. And art has that ability to present everything in the world, all the disciplines of the world, and to unite them.

How would you describe your personal iconography, and is there something you can look back and see consistently in your work?

Artists are asked quite often whether there's anything repetitive in their work. If I look at all the work that I've done over the years, I can see that I continue with certain themes. I like flowers; I like certain sensual images. There are certain things that I like to work with: it's really how you look at life, how open you are to life and its spiritual aspects. A lot of things come into play. If I look at a Warhol soup can or a urinal by Duchamp: these are cries of communication. I don't think they're about the objects. Duchamp would probably roll over on hearing this: I think that objects are metaphors for people. So it's not about accepting the object in high-mode culture; it's about acceptance of others. I think what people want from art is gesture. And when I say *gesture*, I don't mean

just a physical gesture but a form that says everybody wants to live life to its fullest and to feel life within their blood system. What does it mean, to be alive? What's my potential? That's what you look for from art, whether you're looking at dance or listening to music or looking at a visual artist's work. You want gesture: you want the person to be in the moment to show you how far you can go, and the freedom of what that means. So the job of the artist is to make a gesture and really show people what their potential is. It's not about the object, and it's not about the image; it's about the viewer. That's where the art happens. The objects are absolutely valueless. But what happens inside the viewer—that's where the value is.

Is that, coupled with your own pleasure in making things, what motivates you?

I've always enjoyed interacting with people. From the time that I was a child, I would take care of myself. I was brought up to be really self-reliant. I would go door-to-door, selling gift-wrapping paper, candies, chocolates—and I always enjoyed that I never knew who would open the door. It's the same interaction that happens as an artist, wanting this communication. All of a sudden that door opens and you don't know what odor is going to come out of the house. You don't know what's on the stove, cooking. You don't know what the furniture is going to look like, what type of clothing the person's going to have on, if he or she is going to be old, young, grumpy, happy. You just dive into that moment and start trying to communicate, to have an interaction in which both of you can find meaning.

What happened the day you opened the door to Château de Versailles?

The first time that I ever worked with an image that made reference to Louis XIV was in 1986. I did a bust of Louis XIV, and I really used him as a symbol. After the French Revolution, artists had all the freedom they wanted to use art in any manner. But Louis was a symbol of what happens to art under a monarch (whoever controls it, it will eventually reflect his or her ego and simply become decorative). I was making reference to that because if I wanted that responsibility or had that opportunity, the same thing would eventually happen. *Puppy* (1992) is a large sculpture made out of 60,000 flowers. I conceived that piece thinking that it would be the type of work that Louis would have the fantasy for. He'd wake up in the morning, look out of his palace window, and think, "What do I want to see today? I want to see a puppy, and I want to see it made out of 60,000 plants, and I want to see it by this evening. Go to it!" And he would come home that night and voilà, there it would be! *Split-Rocker* (2000) is also made out of live plants—90,000 of them. I was at Versailles for about three weeks, planting the piece with a team of gardeners. It was the first time that I planted a floral piece completely mathematically. It's based on a pattern of five, and I have light, dark, and mid-colors and different values in those colors. I thought it was appropriate for Versailles and the gardens because of the way Louis and his gardeners laid everything out. You can see that there's a sense of chaos and disorder,

but it's all very mathematical and repetitive. There are also theatrical aspects to Versailles.

It was amazing to see.

It's very much a place for show—and my works want to show themselves. They're extroverted. The spaces and the major salons at Versailles are about public interactions. But there are surprising, wonderful parts. Whenever the king or queen would move, their environment would change with them. So if the king walked through the gardens, all the fountains would start to flow as he entered. And then, as he left an area, the fountains would be turned off—and they'd be turned on in the area toward which he was proceeding. Or the same could happen with all the plants and all the flowers. He could go to bed one night when every flower in his garden outside the palace might be red—and wake up in the morning to find that during the night hundreds of gardeners had changed every plant to blue.

Choosing the different objects to be shown at Versailles, I just opened myself up and listened to the works that I created. What wanted to present itself in certain salons, or out in the gardens? What would be appropriate? Today you can use computers and various technologies so that you can know exactly how an exhibition's going to look like. So, even before anything was hung or placed, I knew exactly how it was going to react in its environment. And I spent about five weeks, at different times, just being in the gardens and going through the palace. I even had to almost position myself in a certain way, just as any artist at court would have had to present himself. And the way I did that was that I showed my self-portrait bust. I put the bust on top of a plinth, a base that was designed by Bernini. It was probably about eleven feet up in the air. When I made the suggestion, some of the assistants at Versailles started to giggle, probably thinking, "How can he do that?" How could I put myself in a position like that, on a Bernini base? But I realized that it was kind of necessary. It was across from the portrait of Louis XIV by Hyacinthe Rigaud. If I hadn't put myself on a base like that, I wouldn't have been accepted. I had Louis XIV on one side and Louis XVI on the other. It was kind of like being in a sandwich, and so I had to put my portrait on a monumental level also.

How did it feel to show your work at Versailles?

Showing at Versailles felt very natural, and the works felt very comfortable there. *Rabbit* (1986) was in the Salon de l'Abondance. Usually the rabbit reflects the environment of a gallery or a museum, but to reflect the interior of Versailles was very special. *Lobster* (2003) was hanging in the Salon de Mars; it's a little bit like a performer, an acrobat with broad arms, and the tentacles are like a moustache. But, if you look closely, the graphics on the lobster are like somebody being burned at the stake. So you also have this sense that if you're in the public eye long enough, that's an inevitable fate.

I enjoy making reference to or communicating with other artists and dialogues throughout art history. So works like *Bourgeois Bust—Jeff and Ilona* (1991) and *Self-Portrait* (1991) make reference to

Baroque sculpture, but they're both unique in their own right. With the base of *Self-Portrait* and all those crystals coming off I wanted to represent something profound that came from a very deep place and, at the same time, something very masculine and strong. With *Bourgeois Bust—Jeff and Ilona*, I wanted to create something that was very romantic—a bourgeois couple, kissing. But I wanted to be able to bring Ilona's body and my body down together in a point so that it's a heart—a symbol of love—and take the flesh and cut through it, to form it that way without any sense of violence.

Are there perpetuated notions about your work that you want to correct?

I don't think there's anything I want to correct. I'm pleased that there's a dialogue about my work. I've always taken the opportunity to try to let everyone know what I really care about and what's important to me about my work—how art can perform and what it means to me. But there have been some misrepresentations. Some people think that my work is just about money. Certain aspects are about money because my work also talks about desire, and it wants people to feel what it means to be alive and to continue to live and thrive. But the work's not about money and it's not about just making something to sell. People think that I have a large factory that just knocks out work. I do have a lot of people who work with me, but we make very few paintings a year. I feel a moral responsibility, every time I make something, to give a hundred percent because I care about the viewer. Today it's

not unusual for artists to have large studios. If you're interested in making more than one painting a year, or if you're interested in making more than one sculpture, and you want to work in different mediums and make public works, you need to have support that can help you do these things while you are also thinking about other areas to investigate. I like to work with people because I don't want to be in a room by myself. I love the sense of family that I have with my studio; it's a community. ■

Using Text

Glenn Ligon explains the multiple meanings in making artworks and paintings that quote and employ difficult texts.

Interview by Susan Sollins at the artist's studio in Brooklyn, New York, on February 11, 2011.

Art21—**Reading is a skill that plays a large role in your life. Talk a little about the role of literature and text in your work.**

Ligon—At a certain moment I decided that being an abstract expressionist wasn't quite going to do it. And that produced a kind of crisis in the studio. What I decided to do was to incorporate the things that I was thinking about, the things I was reading, into the work directly. The models for that were people like Jasper Johns or Rauschenberg, people who had used text in their work. When I first started, I decided that I was just going to use my handwriting. Then after a while I decided, no, I'm interested in what other people have to say; I'm not interested in telling my own stories. The work became more about quotation, using texts from various literary sources. [So I started using] stencils, in order to have a little bit of distance from the source material, or a little bit of distance from the notion of handwriting and self-expression.

What made you think that self-expression wasn't the right way to go?

There's nothing wrong with self-expression; it just has its limits. The things that I was interested in were already in the world, and so they didn't need me to create them again in that way. They just needed for me to have them brought into the work. I started to make work at a moment when *appropriation* was a word in the air. Artists were using the stuff of the world—newspaper articles, magazine photos—trying to think about how this stuff has any relationship to the art world. My interest was a little different than that because I'm making paintings; they're not directly based on media images.

It's important for me to make paintings—that's the thing I'm really interested in. But it had to be more about taking something that I've read and something that I'm deeply invested in and finding a way to make that into a visual object. I'm using a material that's out in the world, this text that I've read, but also making it mine by the way it's stenciled onto a canvas or the way it's used in a drawing.

Why do you love making paintings? What drives the physicality of your work?

Paintings are hard work—I

don't love making paintings. But I think artists make things because they can't really do anything else. And I suppose that's a kind of love, but it's a tough love. Often when I'm struggling to work on a canvas and it's not working out, I think "Why am I doing this?" I guess what I'm committed to is not a love of painting but a love of making ideas. Art and ideas take a long time to be born, to gestate, to come into the world, and that process is hard. But that's what an artist does: sits around all day thinking about things, and making things that are about ideas. And I'd rather be doing that than anything else.

You say it's a struggle to get things where you want them to be—what do you struggle with?

The struggle's always the idea you have in your head about what you want to say in your work versus the means you have to say it with, or your abilities, your skills, or the technical limitations of the medium you're working in. There's always the ideal painting in your head and you never quite get to that. And that sort of dissatisfaction—the desire to say something better, the desire to make an image or a text work better in a painting, the desire to say more in the work than you've said before, to go out on limbs, to be adventurous, to not bore yourself—all of those things are what keep you going. That's the struggle.

We've talked earlier about the messiness of your text paintings being what the work "was about." How did you know that was right? What made that technique successful?

If you're making a painting with letters and those letters are from a sentence from an essay, and the letters that you make sit on that canvas very neatly, they're not so different from the book that you got them from. The fact that the letters that I was using in these paintings became very messy, became smudgy, they became almost abstractions, [which] meant to me that I was taking that text and making it do something else. Almost teasing out of it some other meanings.

Also, if you make a text painting, it wants to be read. And if you make a text painting that becomes difficult to read, it creates a kind of tension in the viewer—they want to read it, but they can't. I find that difficulty productive. I think it's always interesting to not make things easy for people, because often I've found that the texts that I was interested in weren't easy. They were about difficult things. And so the way the paintings were made had to in some ways reflect that difficulty.

Is text your still life?

No, text isn't my still life because text keeps changing. I read the same things over and over again, but [every time] you read something you get something different out of it. That kind of discovery, I suppose one could say that of a still life. Morandi painted the same bottles for years and years, but each painting is different. And I think text operates that way too.

You read the same book over and over again and each time you read it you find something different in it.

There's a curious mix of metaphors, or layers of meaning, in your work. What's the most significant element of using text, for you?

When I first started, I was interested in using texts that came from somewhere in particular. I guess the model is Jasper Johns. But Jasper Johns was less interested in the meaning of text than he was, I would argue, in text as a form— numbers and letters, but without words necessarily, or if there were words, they were single words.

I was interested in text that was in a web, [that] came from a particular place, a particular community, a particular kind of social experience, or a particular moment of political crisis or something. How to use that text became the interesting thing for me.

You deliberately use texts by writers who aren't you, but there seems to be a kind of dance back and forth between "I'm here," "I'm not here," or "I'm making this object but these words are from somewhere else." Is there a dance going on between hiding and revealing, between autobiographical and something that isn't autobiographical with these text paintings?

I started using quotation to get away from the autobiographical. But if one uses a quote from somebody else, it is autobiographical because

you've used it; it becomes part of who you are. "Glenn Ligon makes paintings using other people's texts." That's what it says on my Wikipedia page.

So it's a way of connecting to the world, but it's also a way of talking about things that mean something to me. Even as a quotation, the text is autobiographical in that sense. But it's autobiography filtered through other people's writings, or other people's images, or other people's thoughts.

Why not use a stencil that's word by word instead of letter by letter?

If you were using text with thousands of words, that's a very expensive process, to make stencils for each word. Also I think the paintings are more interesting because they're made letter by letter, because I can decide where those letters go and the space in between them. They're less regularized because I'm making them by hand, so it's sort of akin to handwriting rather than typing.

One wouldn't think of it as handwriting, though.

It's semi-mechanical, but that is important to me. The easy way to do this [would be to] make a stencil for the entire text and just scribble it in. That would be very labor-saving, but that's not what the work is about.

Have you looked to antecedents? Either out of curiosity or as models, or any other reason for the use of words in art-making over time?

I'm interested in text as it appears in lots of different artworks. I'm interested in Sumerian clay tablets; I'm interested in calligraphy.

I'm interested in manuscripts. I'm interested in the work of Jasper Johns and Cy Twombly. I guess that concern is always something I'm thinking about, but the source material is not necessarily current. I'm sort of mining the history of art and culture to look at the ways that people have used text and letters.

Although it's not said in any dramatic, overt way, when I saw that your retrospective at the Whitney Museum was titled *AMERICA*, it made me think of the entire exhibition as a portrait of us, collectively in some way, or rather a revealing of us on a lot of different levels. Could you talk a little about the title?

The title of the exhibition is based on the fact that the word, *America*, appears in many works that I've done. It appears in the writings of James Baldwin and Ralph Ellison. It appears in the covers of slave narratives. It appears in the work of Walt Whitman. And these are all authors and texts that I've used in making my work.

But I also think that the work has been consistently interested in American literature and American history. This show becomes a kind of portrait of America. The idea behind the title, which is very big and sort of immodest, really refers to the idea that an artist is embedded in history and embedded in the culture in which he or she lives.

The neons that I've done that use the word, *America*, are actually about Charles Dickens's *A Tale of Two Cities* and me trying to come to grips with the beginning of that novel. The famous opening paragraph where

he says, "It was the best of times, it was the worst of times," and trying to think about that in relationship to where we were as a culture. The first piece was made in 2006. Our economy was booming; we were in several wars. The latest piece that uses the word *America* was made in 2010. We're still in several wars and our economy is in the toilet.

So this opposition between things being on the right track and being hopelessly derailed, of America as this idea of enormous promise but also incredible failure and disappointment, is something that I was interested in and that I got from thinking about Dickens, who was a great chronicler of the times in which he lived but also a great miner of history. He was a very deep thinker about what it means to live in a society and how the past of that society shapes and influences its present.

Is there any misconception about your work, or a misunderstanding of your work, that's been carried along from one body of work to the next? Is there anything that needs a correction?

I think often my work has been thought about as an expression of my identity. While the work in some cases might touch on the notion of identity in general, it's never about my identity. My work is always quotation. So if it's about identity, it's about an American identity. The work starts from me because that's where any artist's work starts from, but it quickly becomes about other things. It's quickly about the way one is placed in the culture, in society. So it's not about me, it's about we. ∎

Rythm Mastr

Kerry James Marshall discusses his comic book series that places Black superheroes within the pages of comics—a place that had previously only been occupied by White characters.

Interview by Susan Sollins at the artist's studio in Chicago on January 27, 2000.

Art21—Let's talk a bit about the things in your studio right now. What are these comic book drawings here?

Marshall—What I'm doing right now is redoing a project I did for the Carnegie International this year, which was to develop a comic strip in newspaper form that I could use for a particular installation at the Carnegie Treasure Room. It was a place that had a set of vitrines that I wanted to block out with newspaper, but I wanted to block them out with a newspaper comic that I developed myself. And so, what I'm doing is kind of reverting back to my childhood, I guess.

The stage I'm at right now is doing a color separation with markers, because when I printed the piece the first time, the color and the black line were all in the same drawing. When the image was scanned to be converted into a plate, the fact that the various separations of color were stacked on top of each other ended up producing a halo around a lot of the black, which made it seem a little out of focus. So, what I'm doing now is a color separation, so that the color can be scanned by itself and then the black line can be scanned by itself.

Did you set out with a goal when you started working on this comic strip?

Part of the reason I started was because I saw that Black kids are interested in comics and superheroes just like everybody else. But the market has somehow never been able to sustain a set of Black superheroes in a way that could capture the imagination, not just of the Black populations but also of the general population as a whole. Now, when I was growing up, reading Marvel comics—*X-Men*, *The Fantastic Four*, *The Avengers*, *Thor*, *The Mighty Hulk*, *Spiderman*—all of those characters were amazing to me.

But there weren't any Black characters in the pantheon of superheroes until the Black Panther entered the scene in *The Fantastic Four*, Issue 52, in 1965. Since then, there have been Black superheroes as parts of teams of superheroes in Marvel comics, and in some other

comics, but there hadn't been many independent Black superheroes who had a comic of their own that could sustain itself for a long time. And not until the last five, six, seven years have there been a lot of attempts at trying to develop a series of Black superhero characters that could capture the imaginations of young people. But almost all of them have failed to a degree.

And so, part of the reason I started this project was to address that as an issue. I thought what I would do with this project would be to take a form that is, in some ways, already undervalued in America, take a subject that's underrepresented, and try to develop a comic strip with a set of characters that had cultural significance but also allowed for a kind of imaginative play and inspiration. What I hit on, as a subject, was that for Black people, the set of superheroes we come to know anything about have a lot to do with West African religious gods.

There's a pantheon of gods in the Yoruba tradition that is known as the Seven African Powers, and those African powers are represented in African sculpture symbolically. I saw that, when you go through the African art wing of a museum, you'll see representations of these things, and they exist historically for a lot of people. But the tradition from which they come doesn't have the same kind of currency that the tradition of Greek mythological heroes has, although there are parallels between those two traditions. So, when we go to the museum to see African art, those heroes or those symbolic representations of the heroes seem pretty inert.

We talk about them as statues that are from cultural practices that are either dead or obsolete.

I thought I would do would take those African sculptures, those African heroes, and reanimate them, in a sense, and make them into the superheroes—but not conventional superheroes that are overdeveloped with musculature. I selected a very specific set of African sculptures that had certain attributes that could easily be translated into superhero powers. I'm trying to find a way to make our knowledge of African history, our knowledge of mythology, and our love of fantasy and superheroes and things like that all come together in a vital and exciting way—by connecting it to a story that is meaningful, historically and culturally, and that says something about the way in which we can carry these traditions into the future, so that they don't have to dissipate and die.

Is beauty important to you?
I wouldn't say that I never think about beauty as an aesthetic issue. But I certainly think it's a much more complicated issue than it's imagined to be. I think, sometimes, when people think of beauty, they think of prettiness as a sign of beauty, but it's a lot more complicated and a lot deeper than that. The way I see beauty is: as a state of being for a thing that has a kind of fascination about it, or as a thing that presents a certain kind of fascination to you as a viewer. It's certainly something that's captivating; it's something's that's compelling. Beauty is a phenomenological experience, and a basic component of it is intrigue. I don't think that simply because I am

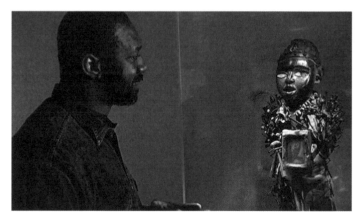

Kerry James Marshall viewing African sculpture in the Art Institute of Chicago. Production still from the *Art in the Twenty-First Century* Season 1 episode, "Identity." © Art21, Inc. 2001.

an artist, or because anybody is an artist, that people ought to give their attention to the things that we've made. In some ways, we have to earn our audience's attention, and one of the ways we earn our audience's attention is to make things that are phenomenologically fascinating.

Explain the term *phenomenological*.

When I say *phenomenological*, I mean a thing has a certain existential authority. What I think is that a thing is what it is. And it is interesting simply because it is, first, meaning that it has a certain presence; we accept its existence as a fact, and it is interesting just because it is. Not because it has a particular meaning, that it's significant to us in any particular way, but simply that it is.

It's like a rock, in a sense. Rocks just are. Some rocks are more interesting to look at than other

rocks. They all can tell a story, but we don't examine the stories that all rocks tell. Only certain rocks hold a kind of fascination that compels us to want to investigate further what it is about their nature that's so interesting. And it's that compelling component, that fascinating component, this other thing that we are engaged by, that I acquaint with something being beautiful. It's not that a smooth rock is more beautiful than a jagged rock. The jagged rock might be much more complicated, maybe more complex. That complexity, I think, is what makes that rock somehow more attractive to us to investigate. And that's what I mean by *phenomenological*, in a sense.

I mean, when the moon comes up in the evening and it's full, it's an amazing thing. And that's a phenomena that we don't have to explain; we just recognize it for what

it is. It has a certain authority and a certain presence, just because it is. When there's a tornado, we may be terrified by it, but it's fascinating nonetheless because it is what it is, not because we know anything about it per se, but because we respond to what it is. That's what I mean by a phenomenological existence.

So, when artists make things, I think we attempt to make things that have the same kind of authority, or the same kind of presence, as things like the moon, like the sun, like a tornado, like a rock—where you see it, and you know it. There are interesting things about it. And the more you penetrate it and probe into it, the more things it reveals to you or allows you to understand or allows you to make connections to other things. So, that's what I think we try to do, as artists. These are the means, the kinds of devices or ways the artist has of gaining an audience's attention.

I was going to say two things, from people who have been really meaningful to me. One is from Ray Bradbury's novel *Fahrenheit 451* and another is a statement from Roland Barthes about inviting people to take the semiotic challenge—meaning, to find out what a thing is about, or what a thing really means. Ray Bradbury's book has a phrase that says: "I hate a Roman named Status Quo... Stuff your eyes with wonder... live each day as if you'd drop dead in ten seconds." And Barthes says that the first moment in a semiotic challenge is the moment of amazement—that moment when you encounter a thing that is simply dazzling and fascinating to you, and that fascinating component compels you to want to know more

about it. So, when I make work as an artist, I am essentially trying to make work that affects people that way.

This goes back to a scrapbook I saw in kindergarten. I was simply amazed by all the things in that book. Partly amazed that they could have been made by somebody, but partly amazed simply because they were there. You know, you see a picture of a giraffe next to a picture of a locomotive—that's an amazing juxtaposition of things. And so, what I try to do with my work is create that same sense of amazement, that same sense of wonder, that same sense of authority, that same kind of presence—so that things seem at once familiar and indecipherable, at the same time. And that familiarity and indecipherability can be called *beauty*. ■

Visual Activism

Zanele Muholi questions the role of documentation and explains how she has built her own mode of visual activism in the LGBTI community in which she works.

Interview by Ian Forster at Stevenson Gallery and the artist's home in Johannesburg, South Africa, on May 10, 2017, and September 9, 2017.

Art21—I'm curious about the history of self-portraiture, or portraiture in general, in South Africa. Do you think there is a tradition to portraiture that is specific to South Africa?

Muholi—There is a lot of history in South Africa that is not documented. We can't talk of history that we don't know, that is unknown—the history that we had but never had the power to write because of politics or apartheid.

We're talking here about self-portraiture in terms of reversing the camera, turning the lens onto the self, and speaking on issues that make other people uncomfortable. How often do you see Black women on the covers of any magazine, in America or Europe? It's very rare. If they are there, maybe it speaks to some and doesn't speak to others; it becomes deeply political; it puts off people who don't want to hear about such issues. Racism is an issue for most people.

What is history? Whose history is it? Who documents it? Who gets the right to document whom—and for whose consumption? That's a different field altogether. In my work, I photograph a lot of LGBTI portraits, and I also train people because I believe that it has to be a two-way thing. People get to be documented; people document themselves. I get to document some of them because my worry is: if we don't document these moments, we can't complain and say we never got an opportunity to do it. So, that becomes part of my visual activism.

Can you tell me about the eye contact in these two images? In this one, it almost looks like you're looking beyond me; in this one, you seem to look right at me.

There's a tendency, in looking at women, in which people overlook the female figure—like, to [show] respect, you have to look away and avoid direct eye contact because it might mean something else. Some people might feel offended by being looked at directly because it's not supposed to be [done].

I play a lot with the gaze in most of these images—sometimes direct, sometimes looking away. In some with direct [gazes], the [person] is facing you with [a look of]

a question, which [is what] you see in most of the *Faces and Phases* portraits. I like this because it stabilizes the power of the viewer, in a way.

When did you start to turn your lens toward other people, in your community?

[I began] photographing other people in between many [other projects]. Then it was like trials; I made a lot of mistakes. It took time before I even learned how to frame [images] properly.

One of the things that forced me [was that] there were a lot of scholars and filmmakers who were interested in our lives—people like you, who came to South Africa and produced this content. It freaked me out, and it still does, because I don't understand why I have to speak to a person from abroad when we have the content here. We have our voices, and we are capable of doing it. [Why are] we giving our lives away, when you guys have your own issues in America, in Europe, in whatever parts of the world?

[I knew] I could do better. It's my voice, anyway. It's the people who I live with; it's my community. Because of a lack of resources, we end up giving up our lives, which pains me because that's how things became how they are now. Instead of complaining, I told myself that I will do better than any outsider who will project my story. [But] it's very important to share. I'm sharing knowledge because you need it; you may further teach your people that, actually, Africa is not a jungle.

I do not document [myself or other people] for the sake of producing some fine art. Basically, this is me, and I don't need to project myself in any preserved way. I have to give myself to you as raw as I am, besides my sexuality—always remembering that my race comes first, then my gender, and then my sexuality becomes another layer. I work [by] speaking resistance and existence. History can easily be projected and produced by those who live it.

How have you done that? When we were filming you and your group taking photographs, there were a lot of other cameras around, documenting. Can you talk about the people you involve in the process to take ownership of your story?

I come from the Market Photo Workshop, which was started by David Goldblatt, who later became my mentor. He became one of the most important human beings in my life because he financed my education. I've learned from David to say, "Sharing is caring." It means that life needs to be a two-way street. It shouldn't be just people receiving all the time; we should share. I provide cameras to people because I love visuals, and I want to encourage members of my community to do it themselves.

It's not just about you.

No, it's never been about me. I just happen to be a messenger of God. I don't go to church every Sunday, but I know how to be a messenger.

Does creating in collaboration with your community bring a feeling of safety?

I can't say it's safe, but it's another side of our lives that is not

projected by the media. We hardly find images or documentation that speak of the love and joys of LGBTI individuals. What sells in the media is brutality, maybe because that's what people want to hear or what some have become immune to.

A lot of the survival testimonies written by the subjects of *Brave Beauties* were about the love that they feel from their families. It seemed very important to show the positive side of things, on the wall in the gallery.

Creating the activist wall is a way in which we destabilize the peaceful gallery setting. In that setting, everything is white walls and beautiful images, and it seems as if there's no agency. I needed to say to the people who are coming to the gallery, "Our lives are beyond that. Yes, these are beautiful, young individuals who are on the walls, but they have their personal stories to tell." I needed to give those humans a space to express, which they cannot do on a daily basis. They are not given a space to be seen in that way.

When [*Brave Beauties* is] written about, it's about trans coming out, trans aggression, and trans negotiating spaces to be heard and be seen, but it's never enough. I needed to make sure that people see themselves as worthy humans, just like every other important woman in South African history or beyond South African borders. Major questions that I have are: What is a woman? Who is a woman? Is a woman what's in between her legs? I wanted to prioritize and give a voice to trans women and for them to claim that womanhood in a public space.

When you set out to make *Faces and Phases*, what was your initial goal?

At the beginning, [it was] to produce images that will live beyond us, images that are connected to South African visual history, featuring members of my community, people like me. We don't have many books here that deal with such visuals. *Faces and Phases* is the only book of its kind in the world where you have work on us that is produced by us, collectively, in a participatory way. I had to create that document for historical purposes. Like I said earlier, complaining won't help me; I had to do something to undo that absence of visuals. I always say to people: it's one thing to have the constitution, and it's something else to have that document that speaks to that constitution. It's a lifetime project.

Are you looking for a certain quality or connection between you and the subject? How do you know when you're satisfied with an image?

When I work, I don't work with subjects. I work with participants, people who are partaking in a historical project and informing many individuals, including me, about their lives. It's very important for me that I respect the fact that they've trusted me enough to be there. Trust is a very important relationship in all that I do.

Your self-portraits are all so different. Can you talk about the process of taking a self-portrait? How does that begin?

That's a journey and a half;

Zanele Muholi at work in Johannesburg, South Africa, 2017. Production still from the *Art in the Twenty-First Century* Season 9 episode, "Johannesburg." © Art21, Inc. 2018.

it takes time. It also takes a lot of energy for me, to be in that space. Sometimes I just wake up feeling good, and then I take the portraits—not selfies but self-portraits. Sometimes I feel really frustrated, down and out, crashed and wasted. But still I try to do it because I never know what will come out of it. [Even with] those frustrations and trying moments, sometimes I manage to get the best shot. But it's not easy to look at yourself, to accept the fact of how you look. The self-portraits are unnerving. I can't say I don't like doing them. But I enjoy looking at myself because I'm not myself when I look at the image.

In one of your catalogues, you talked about the history of skin bleaching, and in your self-portraits, you go the opposite route.

It reminds me of when I was young. Because I was pitch black, [I was given] the nickname "Coca Cola." It wasn't nice; I cried a lot. But I've learned to embrace my skin tone, my all, because I'm at a stage where I can't change anything. And I don't need to try harder.

I have real hair; it's my dreadlocks. I have me—no preservatives. But in respecting those who have taken a different route, it should be the opposite. The whole series *Somnyama Ngonyama* is about race and the racism that persists. [When] crossing borders, as Black people, we're questioned all the time. At customs, we're asked a hundred thousand questions, which pains

Zanele Muholi

me: "Where are you going? Prove it. Where are you going to stay? Who brought you here?" And so on. Some of the images are produced after such encounters. The whole project, *Somnyama Ngonyama*, speaks against or denounces racism and all that comes with Blackness—where we are sidelined, excluded, or pushed away from different spaces.

Your photograph, *Bona, Charlottesville*, is one of my favorite images. Can you tell me about it?

Bona—meaning "sea" and "day" [in Zulu]—was taken in an old hotel in Charlottesville. [In August 2017], there was commotion in Charlottesville. I like it when Americans say there is no racism in America; maybe it's [hidden], but it's so there. Many of the images in *Somnyama* capture American spaces where one has been tried or where one was forced to respond to those cases. I needed to capture a beautiful self-portrait, to mark my existence in that space. It took about thirty minutes to capture that image.

It's beautiful, but there is so much that I could say if I were to unpack it. It's a long story. Charlottesville is one of those places in the U.S. with a [history of] exclusion of Black people within the school systems. Its history, in that way, connected my body and humanness with that space, [as someone] speaking from a position of being excluded.

Why have you resisted the term, *artist*?

I like and respect artists and their work because I know that it takes so much effort for people to produce work. I just don't want to be called an *artist* because of a tendency of human beings who do not respect art. We come from families that, when you say you want to study art, don't take you seriously, saying, "How do you expect to survive?" I decided [my work is not art]; this is about activism specifically and producing these documents for a purpose. ∎

Political Cartoons, Patty Hearst, and the Presidents

Raymond Pettibon talks about walking the fine line between anger and humor.

Interview by Susan Sollins at the artist's home in Hermosa Beach, California, on February 4, 2003.

Art21—**There's an anger and a kind of social criticism in your work. Can you talk about that? Where does that anger come from?**

Pettibon—Well, it just wells up from deep inside me, so watch out: it's likely to blow any time!

I can't really say that it doesn't somewhat come from me, but my work is a lot more impersonal than most people give it credit for. It's not that I'm not angry; it's that it's not a really personal thing. Well, I don't even know about that. I think, when anything is worth getting angry about, you want to hold back and look at it from a distance and without this emotion, if possible.

Is the anger an undercurrent in the work?

It's a mistake to assume about any of my work that it's my own voice because that would be the most simple-minded, ineffective art that you can make. That would really be talking down to people. And if I had such a burning need to express my opinions or whatever, then I don't think art would be where I'd want to do it. It's not a good area for that.

But when we're talking about the schools and gangs and segregation and so forth, those are very obvious problems, and no one really needs my weighing in on it. But there are more underlying problems or issues, and those will be the things I would want to cover in my work.

And, that's what I do all the time. There is a very direct kind of anger in some of my work, to figures like Ronald Reagan or J. Edgar Hoover or whatever. You can have a million artists sign petitions, one side or another, and so what? You'd really have to go back to the Greeks and the Romans and to the satire or the very personal kind of rancor that they wrote about people of the day, to see what I'm doing: the pretentious, the powerful, the decadent, and the corrupt. It's not done from analyzing their positions and correcting them or weighing in your own solutions, because it's not the kind of form that works.

The usual person who is considered a hero is really the opposite of what I would consider [a hero]. And it's a way of trying to break down this kind of natural awe and respect that comes out of a fear or envy. There's this built-in respect that shouldn't be there, completely. I consider characters like Gumby

with respect. And anyone, I think, should compare cartoons to the President of the United States, this one or anything of them, really: those are the real cartoon figures, the ridiculous figures. I want to make works where someone like Gumby or Vavoom or Felix the Cat or whatever comes out as someone to respect and to listen to; and you're glad you did, when you're given that opportunity.

I've never considered myself much of a political artist. And most of my art doesn't really deal in explicitly political issues. But I'm not going to apologize or shy away from it any more than I would any other subject. But there is no area where anyone is dealing with this in the way I am—which is, for once, not to assume someone like the President automatically has a claim on anyone's respect, to follow him or to take him seriously. We don't see that at all because the real pathetic thing is this generation of journalists. Not that it was any better, really, that much before. But it is really incredible today because they probably pat themselves on the back and say, "Well, we're responsible journalists," and really they're just the punks of the political establishment they cover. I'm not trying to encourage art to become political. Just because you're artists doesn't mean you should have a platform. When Hollywood figures or artists decide to get on their platform, often that is going to do much more harm.

Anger and humor—it's a delicate line.

I don't think humor is a bad thing at any time, really. I make decisions, in my work, that I won't make fun of someone just for the sake of going for some cheap laugh. I won't do that if it hurts someone whom I would feel bad about. If it's based on things that people have no control

This page and next: Raymond Pettibon's studio, Hermosa Beach, California, 2003. Production still from the *Art in the Twenty-First Century* Season 2 episode, "Humor." © Art21, Inc. 2003.

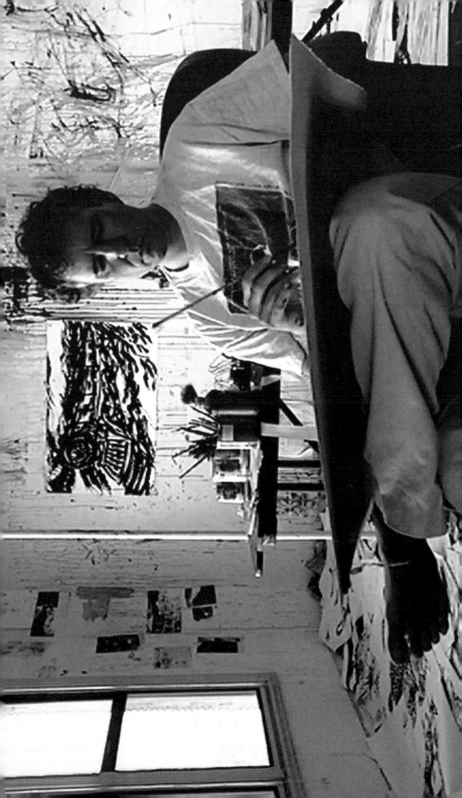

over—that should be condemned for any reason. We as humans still, so oftentimes, feel the need to have someone to pick on who is different.

I don't think there is subject matter to consider too important to use humor with. A lot of times, people wonder if any of this was intended like, humor is just by accident all the time, and maybe it's not a good thing to laugh, or maybe they're not getting it. Maybe they're seeing something in it that they shouldn't. But that's not the case. I have no problems with my own attempts at humor.

A recurring subject in your work is Patty Hearst and the SLA [Symbionese Liberation Army]. Can you talk about that, in relation to your use of humor?

Patty Hearst and the SLA would really be impossible not to treat with some broad comic aspect to it, because the SLA and the whole situation was such a broad burlesque. A lot of the best humor, whether it's the Three Stooges or Molière, is about someone who is really strident or pretentious. The SLA and a lot of political groups from the '60s and '70s—from any time period—are so strident and they're so full of their own righteousness for the moment.

Anyone from groups such as that, who have gravitated to the other extreme—such as the current radical right, the reigning power of the neo-conservatives... That all comes from a very left-wing position; almost all those guys were at one time the opposite. And so, it's hard to take that sort of thing seriously if you can see it from any historical distance. If you look at the Hearst case from the beginning to the end, it's like the Keystone Kops. That can happen by chance or by the kind of ideas behind it as well.

Humor doesn't trivialize the real consequences, the people who get hurt, for instance. I'm not making light of that. If I'm going to be condemned for broaching that subject from a comic angle, that is completely absurd. I'm not a fan of the underground or the SLA, personally or their politics. But to demonize them, in particular when you had a war going on that was killing millions (the Vietnamese people and all people who should be allowed to live)... It's a way for me to objectify the lines there, to even the playing field a little bit, rather than picking one enemy and demonizing them to basically cover your own ass. It's a way of making nothing sacrosanct and above comedy, and at the same time not taking away all their humanity by completely objectifying a whole group of people in a way that makes them totally disposable, either. I'm not doing that with any of those groups.

Portraying people is always tricky. For instance, some viewers might think the way you depict women is misogynist. How would you respond to that?

When I get asked something like that, I almost expect someone to be disingenuous about it. Of course, you can't read my mind. My work isn't coming from a very personal point, so to psychoanalyze my work isn't going to reveal anything. But then again, that becomes circular because you could say, "Well, maybe it's hidden under the surface and he just doesn't realize it," or whatever.

The Role of the Artist

But specifically, like with Gumby, I never had a doll phase or an action-figure phase, and certainly not now. So, that wasn't an obsession for me, or a personal thing. It came out of a certain subject matter, used in a certain way. I think a lot of the work that would be considered misogynist comes from a strain in my work that is usually described as a film-noir type. Most of my work that would be considered the most misogynist would be work where the woman character is like a caricature in comic books, like the Dragon Lady in a Milton Caniff, or a girl usually named Velma or Velva Lee or whatever.

I've been asked a few times, of my work, why all the characters, almost without exception, are White. That's a legitimate question. But there still is an element of caricature to my work, and I'm not representing this kind of multicultural melting pot in my work just for appearances sake. If you looked at my work based on race, the work would call attention to itself in ways that would make it a completely different kind of work. I don't make any apologies for not doing that because what purpose would that have?

This is not autobiographical work by any means, even the emotions involved. If someone thinks they understand me and disagree, then okay. But there's something in the nature of comedy and especially in the element of caricature and cartoons that my work retains. An editorial cartoon is trying to be positive. It's usually cloying and sappy, and there's no hook to it at all. I also don't like my humor to be in the service of making fun of people based on superficialities. People get picked on or looked down on. I'm conscious about that as a problem.

Do you think there are elements of failure and longing in your work?

Longing, yes, because I think it's work that is best when there isn't any resolution, when you don't finally arrive. And failure—maybe, because this sort of work tends to have more of a negative edge to it. There probably is more failure depicted in my work than there is success.

Is there sadness in the work?

Yeah, maybe it's as much as humor. It's just more latent. I think the life of the drawing is that you're always kept in suspense. It's like a serial, which goes on from day to day in the paper. There's always something from the sky just about to fall on you. Even though my work is usually just one drawing, it is more of a narrative than it is a cartoon with a punch line, a resolution, and a laugh at the end. ∎

Imagining Alternatives

Pedro Reyes shares a wide range of influences and discusses his use of play, humor, and optimism to create diverse works that sometimes function as public services.

Interview by Deborah Dickson at the artist's home and studio in Mexico City in August 2015 and January 2016.

Art21—Why do you make art?

Reyes—Art is one of the few cultural environments that allow you freedom; every artist has to come up with a definition of what art is. Art is like many different things. It is a way to interpret the world. It's also a way to study and understand the world. It also creates opportunity to reinvent things: institutions, relationships, materials, and forms.

I think that everyone can do art, but not everyone is an artist. I differ a little from what Joseph Beuys said, that everybody is an artist. You have to add that everybody can do art, but an artist is someone who has produced art over a certain period. He creates an opus. He creates a take on the world by this accumulative process. It's not the objects that the artist produces but [rather] the tools and the processes that he uses that contribute to the world a way to handle things.

You consider yourself a sculptor, but when I look at some of your projects, I see a very different idea of what sculpture is. Your work goes beyond sculpture, sometimes into the social realm.

As soon as I feel that I'm being identified with one kind of work, I try to run away from it and open a different line of investigation because I don't want to be pinpointed or identified with one thing. I want to change medium and subject because I'm very curious, and I get bored easily. I am also very promiscuous in my interests. I always want to explore a new thing.

One of your first projects, *Palas por Pistolas*, seems to have been the seed for other projects, like *Disarm*. How did that happen?

Palas por Pistolas is a synthesis of three of my mentors and sources of inspiration: Joseph Beuys, with planting trees [for the work *7000 Oaks*]; Antanas Mockus, who had campaigns to collect weapons in Bogotá and turn them into spoons; and an encounter that I had with Alejandro Jodorowsky, in which I asked him about a therapy method he does called *psicomagia* [psychomagic]. (There's a ritual to overcome a traumatic situation; it often ends with putting a plant into a pot; he

The Role of the Artist 173

told me that closure has to come with an opening of a new process.) I put together those different ideas from Jodorowsky, Antanas, and Beuys into this one project, *Palas por Pistolas*, in which the metal from the guns was [melted] but then cast into shovels, to become tools for planting trees.

Often my projects draw inspiration from resources that are not strictly artistic. For instance, Mockus is a politician, Jodorowsky is a filmmaker and therapist, and Beuys was trying to get out and go beyond the sphere of art. I believe the best use of an artist's time is to find resources beyond art history; otherwise, it can become a very rarified production.

Having your studio at your house must have certain advantages.

My library is one of the main tools I use for working. I think that my library is like my brain. I can get access to all these parts in a very fast way. For instance, there are sections for music, humor, film, theater, philosophy, mythology, mathematics, geometry, neurology, pacifism, poetry, psychology, the social sciences, feminism, social justice, Latin America, military history, and biology. There are sections on fashion, folk art, architecture, industrial design, graphic design, ancient art, contemporary art, eroticism, business, religions, fiction, and so on. Architecture in Mexico is [one of my] big obsessions. My wife and I collect a lot of books on popular arts from Mexico, like craft, photography, textiles, and indigenous culture. There are over eighty-three indigenous groups in Mexico that are very much alive and keep their textiles and festive traditions. [My wife] works directly with them. We both use every section of the library. Going to secondhand bookstores is a way to ensure that I'm not going to run out of ideas. It's a meditation process, in which I get into a trance and just grab whatever calls my attention. It's a reservoir of interests that very slowly crystallize into new developments.

You've talked about creating a space for violence, that there needs to be a space for it.

I believe that there can be spaces for creative outlets for violence. A lot of artists do this. There have always been elements in theater, in music performance, and in sculpture where artists have space to show their anger and frustration. That makes great art.

Can you describe your project, *pUN: People's United Nations*?

In [this alternate] U.N., [a delegate] represents a state. [Delegates] are appointed by their governments and represent their people, but they don't have to endorse the government or whatever policies are currently in place. That is one difference. The other is to have a very playful approach, using tools from theater, group therapy, pranks, et cetera: conflict-resolution techniques that are more spontaneous and allow collective creativity. [People] stop talking for themselves and start talking with and for a group.

How does role play figure into your work?

Role play is something that I use a lot. I love role play because it allows you to explore parts of yourself that otherwise you couldn't

access easily. For instance, role play is very present in *pUN* because on a daily basis [each delegate] is in the same room with people from many different countries.

These playful situations allow you to test things. It's precisely how children play. You create maps by placing objects that are models or representations of the larger world. It's about how you can provide yourself with an environment where you can discuss things in the effortless spirit of play.

It's about not being an expert. It's very important to de-professionalize psychology and politics. It's killing the expert, in a way; if you always rely on the expert, then you are preventing yourself from having an education and also from having a voice or a position. You have to do it yourself, somehow, and that's why play is important.

I use what Jacob L. Moreno, the inventor of psychodrama, calls *surplus reality*. Surplus reality is not reality itself, and it's not fiction. It's an extra reality, where you can rehearse how you could be. It's a rehearsal space where you can fail, be wild, be mean, be whatever you want in order to test what consequences would happen without those consequences actually happening; this is your rehearsal. Most of the time, the surplus reality is used to dare to be who you should be or to do what you should do. If you need to have a confrontation with someone, you can test that confrontation in this surplus reality. That's a beautiful thing because you need spaces where you can prepare for the changes that you will have in real life. That's another thing that art can do: introduce a strange idea into the world so it becomes accepted.

Is humor important, and why?

Humor is an interesting mechanism because the fact that we laugh at something reveals that the subject is uncomfortable and that there's something problematic or stuck. If we laugh at it, we are somehow dealing with it. What I try to do with some of my workshops is to create punch lines, so that instead of [people] being faced with a traumatic ending, I try to push them to think of largely optimistic scenarios that are so ideal and optimistic that they still make you laugh—"oh, yeah, I wish that would happen." If you have to craft a joke in which you picture a desirable but extremely optimistic and utopian vision, then you have a certain direction to move in. If you have a desire for a vision, then you can imagine the necessary steps to move in that direction. That's the theory I have about humor.

Why is optimism so important?

Optimism is extremely important in order to break the cycle of complaint. When you're complaining, you're putting blame on someone else, and you're relieved from responsibility. I believe that's a very childish position. There is a belief that, through complaining, some change is produced. It's not. Nothing changes through complaining. I believe that there are too many artists and intellectuals complaining, which certainly can lead to critical mass, but creativity is most needed to imagine alternatives. Describing why things don't work is different than saying how things

can work. When you're trying to solve problems or heal a disease, you have to be readjusting all the time, and testing something, and doing it again; it's an active process. I believe that optimism is also a tactical approach that, at least, is trying to come up with solutions. Imagination is extremely important.

That seems to be the role of art.

Yeah, exactly. It's important to create visions of how would you like things to be, even if they're naïve. For instance, this piece is extremely naïve: turning a weapon into a musical instrument. I'm fed up with the open-endedness of art, with the idea that if you say something that is straightforward, you're being messianic or patronizing. I think that what artists do, often, is change the perception of things. At least that's a hope: that you can make the strange familiar and make the familiar strange.

I studied architecture; I wanted something that was more technical than art although I always wanted to be an artist. In architecture, you learn to solve problems, and you have to answer them through your designs. I think that has stuck with me—the issue of having to solve problems—to such a degree that often it's hard for me to think about artwork that is just art for art's sake.

You mentioned you wanted to be a mayor. Can you talk about that?

I don't know if I would love to, but I think that at some point, I would like to be a public servant, to try to produce change at that scale. Right now, I am doing shows, and it's hard to move away from that. But eventually, who knows?

Why does that appeal to you?

I'm interested in public policy because my hope is that my projects depart from the sphere of the art world and become public programs that could be replicated and continue to happen. I've been knocking [on doors] at governmental agencies, trying to get them to adopt these weapon-donation campaigns, in which the weapons are turned into instruments.

Mexico is a context where if you don't do it, no one else will. Your input is really important. You need to contribute to local development without waiting for authorities or companies to come and do it. I think that's been very healthy for the scene: everyone has had a space not only for their production but also where they can have other people engage in a dialogue.

Even if your undertaking only touches twenty people, for those who are participating, it is a transformative experience. That is ultimately the test we have to pass; that's where there is something that stays real.

Most of the work I do, I hope, is such that anyone who experiences it can understand it, regardless of whether they have an art education or know who Duchamp is. I don't think you need artistic literacy to understand most of the works I do, and I do that on purpose because I believe in art as a communication exercise. ∎

Experiences of War

Doris Salcedo discusses how people's experiences of war, displacement, and imprisonment form the foundation of her sculptures and ephemeral installations.

Interview by Susan Sollins at the artist's studio in Bogotá, Colombia, on September 2, 2008.

Art21—I'm curious how early on your political sensitivity was formed and when you connected that to the notion of being an artist. Looking back, when do you think you started to connect these things?

Salcedo—I always wanted to be an artist. I cannot name a date when that came to me; it has always been there. Living in Colombia, in a country at war, means that war does not give you the possibility of distance. War engulfs reality completely. In some cases, people can be killed or wounded at war, but in most cases war just distorts your life. It throws a shadow over your entire life. War creates a totality and you are embedded in it. It's like being engulfed in a reality. Political events are part of everyday life here, so art and politics came to me as a natural thing, something that has been very much present in my life from the start.

Explain a little bit more about war. I suspect that people living in the United States, think about war as being something where two countries are fighting each other, and war here in Colombia has a slightly different aspect.

I think war everywhere has a different aspect now, because I don't think war is waged between two nations any longer, or not the main war. I think war is waged at different levels. And those levels that are subtler are the ones that really destroy the life of a big section of the population. I believe war is the main event of our time. War is what defines our lives. And it creates its own laws. War forces us to generate some ethical codes in which we exclude a whole part of the population; once they do not fit into our ethical code, then we can attack them and destroy them because they are not seen as human. So it's a tool to expel people from humankind. I think that's the main event, and that's why it worries me so much. You see that there are civil wars going on everywhere on a daily basis. You are reading about these events and these events are really shaping the way in which we live. That's what I'm trying to show in my work—that war is part of or our everyday life.

How does this political thinking become embedded in a work of art?

Well, my work is based not on my experience but on somebody else's experience. I would like to reflect a little bit on the etymology of the word *experience*: it comes from the Latin word *experiri*, which means "to test" or "to prove," and from the Latin word *periri*, which means "peril" and "danger," and also from the Indo-European root *per*, which means "going across." So *experience* means "going across danger." So my work is about somebody else's experience, literally defined. That's where you get the connection with political violence, that's where you get the connection with war. And that's what really interests me.

I have focused all my work on political violence, on forceful displacement, on war, on all these events but not on the large event. I focus on the small, individual, particular experience of a human being. I'm trying to extract that and put it in the work. The memories of anonymous victims are always being obliterated. I'm trying to rescue that memory, if it could be possible. But of course I don't succeed.

My work lives at the point where the political aspect of these experiences is appearing and disappearing. We are forgetting these memories continuously. That's why my work does not represent something; it's simply a hint of something. It is trying to bring into our presence something that is no longer here, so it is subtle.

What kind of research are you doing now?

Well, I think I have been doing the same research for many years with small variations. For years I kept files on concentration camps, both historical ones and contemporary ones. What interests me is how it varies. It's always there, but it presents itself in different forms. I was amazed when Guantanamo was opened in Cuba, because Cuba was the first place that had a concentration camp. It was a Spanish invention. A Spanish general, Martinez Campos, thought it up in 1896. At that time they implemented it in Cuba. It's amazing to see how it has come full circle. Now you have Guantanamo again in Cuba. But of course the British had it at the end of the nineteenth century in South Africa. Then the Germans had it in West Africa. Then you have killing fields, forced labor camps, gulags—the list is endless.

I have come to the conclusion that the industrial prison system in the United States has many of these elements, where people, for really no reason, for possession of marijuana or things like that, are going to jail, where some minor crimes have become felonies. I'm really shocked by the sheer numbers of people being thrown into jails. And also I think it's amazing how this system, being in jail and then going out, has so many collateral effects that a fairly large portion of the population are not allowed to be alive.

The idea of having a large portion of the population excluded from civil rights, from many possibilities, implies that you have people who can almost be considered socially dead. What does it mean to be socially dead? What does it mean to be alive and

not able to participate? It's like being dead in life. That's what I am researching now, and that is the perspective I have been looking at events from for a long time.

Most of my pieces lately are related to this issue. There is *Neither* (2004), where I was thinking directly about Guantanamo, and *Abyss* (2005), where I had been thinking of what it means to be a contemporary slave, and this notion of confinement, to put people within an area where "everything is possible," as Hannah Arendt said. It's really my main focus of interest. But also what interests me is why we allow that to happen. What kind of society allows those events to take place and in such a consistent manner? That's what is really important: what is the political structure that allows that to happen, that we can do that to such a large portion of the population? That's what I think about while I'm doing my work.

In this research you're doing now, what kinds of things are you discovering? Talk a little bit more specifically about some of the discoveries you've made in your research, some of the factual information.

More than the factual information that I have discovered in this research, what I like to think about is, let's say, "we the people." What does it mean, "we the people"? Who is included in that "we the people"? We know that when the Constitution was written, slaves, poor people, women, and Native American Indians were not included. Now when somebody says, "we the

people," who are they thinking about?

There is a fragment of the population that is on the borders of life, on the edges of life, on the epicenter of catastrophe, and I would like to focus on them. How do they live? I would like to find out how they can live in such conditions without being able to find a job, without being able to vote, without losing their civil rights. So I try to make my work based on real testimonies of real people. I try to follow their steps and trajectories, know their family, know as much as I can to try to find and to build a complete life, in whatever situation. No matter how small the identity we try to impose on somebody else, I think that person will always be able to overcome that and be more than that identity.

When we're talking about the underclass, we have to know that that is a myth that is very useful to control a certain population. But at the same time, people who are under that horrible identity are able to be more. They can grow beyond the totality that is imposed on them. And I think art can do that—it can show the splendor of a complete life. I would like to show both sides: a complete life under whatever circumstances, and the circumstances and conditions in which we force some people to live. I would like to mix both things. I think art has the ability to connect everything; to connect both worlds and create an image that hopefully is richer than the stereotype or the myth.

I understand that part of your research involves talking with people; it's not just found in books or statistics.

For many years I've been talking to victims of violence. I used to travel to war zones in Colombia and interview people. After terrible events took place, I would go to the sites and interview people and gather objects. And my work was built based on the words that the witnesses told me. I used to think of myself as a secondary witness and I continued doing that. Nowadays, I try to interview people. The difference in the research that I'm currently doing is that I am no longer dealing with victims who are just victims, I'm dealing with victims who are perpetrators as well. So in that sense the research is more complex now. I guess it is essential to know that the artist is not making up things. I think as an artist I have a responsibility. I have to look at historical events and work with whatever material is given to me. I don't work based on imagination or fiction.

I believe my work is a collaboration with the witness, with the victims, because they give me their testimonies, they give me their words. They give me the very material I'm working with. I'm making a piece for them. Their existence gives meaning to my work. My cultural work could not be possible without their previous existence and experiences. It simply wouldn't exist. The primary collaboration I have is with them, and then the collaboration with my assistants, with the architects of my team, as well. But it is all, in essence, collaboration.

What do you mean by the material that they, the victims, give you?

The experiences they have gone through, the experiences that shape our world. I'm taking those, I'm working, and I'm trying to understand this reality, trying to make sense out of brutal acts, if that is possible. I know that seems vain but I try.

We know in the Third World that rationality does not fix every problem. In the Third World we see things in a different way. So you have to make your life out of chaos. You have to organize your life out of disorder and that's why I'm working on this chaos. I'm working on this pain. I'm making work out of war, out of the most chaotic and most extreme situations.

In something I read you talked about order or some aspect of order. Is there some, maybe subliminal, attempt to order this chaos?

My work is a vain attempt to bring some sense, to try and understand what is happening. I want to emphasize the word *vain* because I don't think art has the possibility of aesthetic redemption. But on the other hand, I think we have to try. Giorgio Agamben has a beautiful quote: "When the subject gives account of his own ruin, life subsists, maybe in the infamy in which it existed, but it subsists." I think that's our task, to make that subsist, not to allow that to be forgotten, to bring that to our present tense. ∎

Doris Salcedo

The Open Source

Stephanie Syjuco embraces the contradictions of the authentic and the inauthentic in artworks that play with ethnographic assumptions, such as what it means to be Filipino-American.

Interview by Christine Turner at the artist's studio in Richmond, California, on January 3, 2018.

Art21—How did you become involved in bootlegging and counterfeiting?

Syjuco—I got interested in bootlegs or counterfeits as extensions of the idea of the authentic. From a personal standpoint, I was curious about what it meant to be an authentic Filipino, an authentic ethnic Other. It's a personal construction of who I am, who you are, or who anyone is. There's also a lot of societal construction that we don't have any control over: how others position us or want to see us.

When one plays around with that, or counterfeits it, I think it destabilizes the idea of the fixed position. There's a lot of authority in being "real." Somehow, the authentic gets a lot of privilege. I was thinking about that, as a Filipino immigrant. The Philippines has a long history with the U.S., going on centuries. There's been mixing the whole time. Being a Filipino American is highly inauthentic in many ways because it's gone through so many permutations of culture and been hybridized in so many ways. I was thinking about what it means to be inauthentic as an immigrant. I have a tenuous connection with family in the Philippines; they see me as an outsider. So, I'm a kind of construct. It boils down to a lot of personal observations [of what is] manifesting in the world around me.

Can you talk about *Cargo Cults*?

A while ago, I started a project, *Cargo Cults*, in which I was thinking about historical ethnographic photography—specifically, images I'd seen taken in the Philippines. The Philippines itself is a kind of construction: more than seven thousand islands make up the country—numerous languages and types of folks form lots of different tribes throughout—and somehow it holds together as a country.

I was also thinking about the amalgamation of a country: what are the ways in which, when outsiders look into it, they create stories about different communities. *Cargo Cults* was a way for me to play with these markers of difference.

The Role of the Artist 183

I know it's a tried-and-true method; a lot of artists work with issues of fictional representation and re-look at ethnographic images.

But I was hoping to pair [this approach] with really jarring visual patterning: lots of zigzags and black-and-white, stark imagery. The whole series was made during a residency at the Bemis Center for Contemporary Art in Omaha, Nebraska, which I think is hilarious because the images appear to be exotic ethnographic photographs. I had gone to the shopping malls in Omaha and, using my credit card, purchased mass consumer goods from the stores, took them back to my studio, and styled them as costumes. [Using] these common, factory produced, mass-produced garments, I created these fictional identities. I later returned the clothes for full store credit. It was this way of thinking about this consumerist aspect of what we want to consume in those images—partaking in it but then denying it.

The black-and-white patterning in the images refer to the World War I painting technique called dazzle camouflage. American and British battleships were painted with crazy graphical patterns to confuse enemy aim. This was before radar, so they weren't trying to hide these ships; they were trying to make it really difficult to figure out their outlines. I'm hoping that, in the *Cargo Cults* images, it's also hard to see the shape of the figure. That kind of obfuscation makes viewers question what they're looking at.

What are some themes that unite your work?

One of the unifying factors of all the projects, even though they can appear really different, is materiality. Whether the concept is about digital networks, a database, or a communication structure, usually there's some form of evidence, like a processed object, installation, or collection of things. Somehow, I want to make the evidence of these larger ideas.

And I want to make sure that evidence has a kind of friction that may not be able to be said. I want things to be double-sided. I like for things to be read in different ways, depending on the person's perspective, and not be so open-ended that it's a meaningless mush that's open for interpretation. Look at the complexity of our contemporary culture, political moment, and lived realities; I want my work to be as complicated. There isn't just one way to look at it; literally depending on your perspective, you'll see it a different way.

I also want it to inhabit contradictions. If there is a positive element, you might be able to see a corresponding negative. In some of the installations, there is a literal double-sidedness. For example, you walk in and see a presentation delivered to you; when you walk around the back of it, you realize that the whole thing is a construct, a prop—and maybe you know someone had a stake in holding up this narrative and thought it

was so important that they're willing to show it to you this way.

Can you talk about the open-source work?

Collectively shared databases are open-source networks, a kind of a litmus test of the contributors. They are literally the results of the folks who have fed into those particular systems. When you analyze all the remnants, contributions, and motivations of those things, you start to [notice] this really odd picture of a group. That's an interesting kind of portrait: it's not definable by one particular entity but [rather] by a nameless group that has its biases, presumptions, and interests at stake.

Networks are really interesting, in that way. I've been searching for text PDFs that are available [for free] online. They show why it's important to scan a particular text (it could be a piece of literature, an academic paper, or a journal) and then upload it. You start to get a picture of why people would want to share something.

What kinds of work do you make?

I have a tendency to make large-scale installations, usually with thousands of objects that are produced. But in parallel, I also work with photography, social-practice projects that involve the public in some way, and digital and online networks. In some cases, they only exist in a virtual sphere or as propositions. It's this odd mix of things that, even though they might not seem related, I hope ties through in different ways to paint this larger portrait of how a visual artist today can work.

Can you tell us about the ways your work is playing out that go beyond your sculpture background?

As an exhibition designer, I've been pulled into discussions over the past number of years in the field of craft, everything from textiles to ceramics. What's interesting is that those disciplines have such a rich and deep history that, as a fine artist and sculptor, I can only begin to talk about, tap into, and use for my own projects.

I have a deep respect for the craft field because [it contains] a lot of technical and conceptual knowledge that I will never be able to tap into. But because my projects more recently have been involving textile production, invariably I get pulled into that conversation. And it's interesting to see who in the textile community takes to me—and who in the digital-network world and in the social-practice world takes to me. I'm not faithful to any discipline. I just have a sense that if you want sculpture to be as exciting as the world, then maybe some sculptures should look like things that are in the world. ∎

Studio as Laboratory

Addressing questions of how objects acquire value, **Sarah Sze** posits that being an artist is about giving yourself permission to make choices.

Interview by Susan Sollins at the artist's studio in New York City on June 11, 2011.

Art21—**What was the influence of science and architecture on your work?**

Sze—My father is an architect, so I grew up around models and plans, looking at construction sites with his eye, always talking about buildings and cities. That's definitely part of how I learned how to see the world.

Charlie Ray [once] asked me in an interview, "Do you know what was the first work of art you ever made?" It was maybe this: My dad had built a house, and there was a big mound of dirt that was left from digging the foundation, and my brother and I dug a hole through the bottom of it. We'd go inside the hole, and it was quite dangerous because it [seemed to be] floating; we couldn't see out. This experience of hiding, knowing that it could collapse on you—I feel like that, in some ways, was my first sculpture.

What early experience of artwork moved you?

I think that most artists are addicted to looking as much as they are to making art. From a very young age, I was making art. I was always thought of as the artist in the house, in whatever class I was in. The moment I realized that I was really going to become an artist was when I tried to stop making art and had the profound sense of loss and disorientation and the knowledge that looking at art had been such a sustenance and always will be. Those two things are married very closely: looking at art and making art. That's when I really started doing it, knowing that I wouldn't be able to not do it.

I grew up going to museums all the time. I grew up looking at buildings. I think my work became interesting when it related less to knowing about art than to thinking about experiences I had in the world that were completely unrelated to art.

I had a strong undergraduate education in art history, but that doesn't make you a good artist. Even when I went to graduate school, I think my work was very accomplished in certain ways but fundamentally not interesting. It wasn't until I figured out how to find a location—where information in my life and the rest of the world surprised me—that the work became interesting enough for an audience.

I was a painter and an architect, in the beginning. I started thinking

about how gravity is something that you don't have in painting. As a sculptor, I'm trying to make things that sit in between... I've been thinking a lot about traditional perspective in Asia and in the West: how those two meet, and where they don't meet, and how you can play with the two of them.

How did your experience of studying in Japan affect you?

Living in Japan was a profound experience because it showed me how aesthetics and art, and the way they can be integrated into your life, could be entirely different in another culture. The way that artworks are integrated into the everyday in Japan is so different from here. To see that shift—in the way people looked at beauty, aesthetics, the handmade, the machine-made, and valued those things—made me reconsider how our culture does it.

Can you talk about the use of ordinary, found materials in your work?

I was interested in value: How does an object acquire value? Why is it more valuable in the museum than in your house? How do things we own acquire value? How does a shirt that you know thousands of other people own become yours? How do you sense that an object is cared for or valued? [I wanted to] take things that had very little value—that were commonplace, mass-produced, easily accessible, easily replaced—and put them in a location, to craft and juxtapose them in a way that they seem to have value, so that there was a strong shift, and then back again to being nothing. That was something I wanted to play with.

Was this a spontaneous thing?

It's a balance; the spontaneity is always where it's the most interesting for the artist and for the viewer. You can spend a lot of time conceptualizing and thinking it over, and then it's usually in the process of making where there is something spontaneous that, after all that planning, you had no idea was going to happen. When that happens is when it's interesting.

Improvisation is crucial. That goes to this very old idea: How do you breathe life into a sculpture? When you look at a Bernini, you see how marble becomes an arm—how does an object that's inanimate come alive? I think that improvisation is crucial to the whole process, in that I want the work to be an experience of something live: a feeling that it was improvised, that you can see decisions happening on site, the way you see a live sports event or see live jazz and [know] that it happened and is never going to happen again. That feeling—of something happening in the moment—is crucial.

A lot of the works have this feeling, like going into a studio space or a laboratory. [This feeling] also has a relationship to intimacy: how a studio visit can be more interesting than a museum show or an Art21 interview can be more interesting than an [exhibition] catalogue. [It suggests] the idea that you're getting a backstory of evidence: you're going to an archaeological or forensic site, seeing what's behind a process and even a culture, and starting to understand behavior.

I think about how we read behavior through objects and space

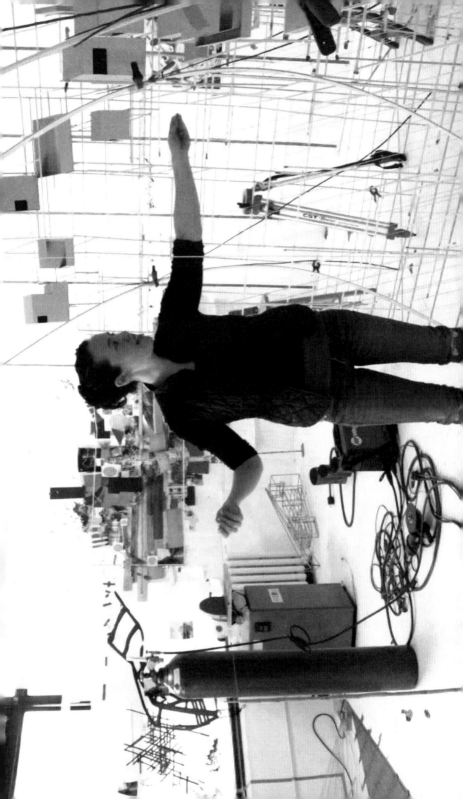

and how to develop an interest in the viewer. What behavior is happening here? How does a work become evidence of the behavior of an individual or of a culture?

Is there a sort of delight in making work for you?

In the process of making art, there's a window of real joy that happens in the studio, usually about three-quarters of the way through the process, for me. By the time I get past that, I'm thinking about the next project. Part of the way that I finish a project is by being on another project. I think part of being an artist is actually giving yourself permission to make choices and not judge them. There are ways that artists trick themselves into creating a mindset that allows for that kind of openness. One of my ways is that I think about another piece as I'm making a piece, so I can cut off the judgment that I think we all have, questioning an action before it actually happens.

That's the hardest thing about being an artist: being able to trust an action when it can be a completely absurd decision, to trust that the outcome might be quite fruitful. It might not be, and then you have to have the resilience to pick yourself up and try something else. You also have to have a way of cutting off the [internal] judging of what you're doing, so that you can see results and respond to them. The work makes the work, so you have to keep making the work, even when it's failing, and working through it

so that you can make progress.

What do you think about permanence and longevity, in relation to your work?

I think it is interesting to question the future of the work. I have this relationship with the work, where I think: How long did it take to make it? How long will it take to take it down? Where does it go? This is true of any painting or sculpture: how is this possible? I did my graduate thesis on the life of artwork over time and looked at how different artists took this on. One of the most interesting people is Félix González-Torres because he knew he was going to pass away, so he documented each work precisely but in a very idiosyncratic way. It was liberating to me to adopt his philosophy, which is that each piece needs a specific set of directions for [the future of] that piece. ∎

Sarah Sze in her studio, New York, 2012. Production still from the *Art in the Twenty-First Century* Season 6 episode, "Balance." © Art21, Inc. 2012.

On Process

Diana Al-Hadid
El Anatsui
Cai Guo-Qiang
Vija Celmins
Ellen Gallagher
Trenton Doyle Hancock
Mike Kelley
Liz Magor
Kerry James Marshall
Julie Mehretu
Bruce Nauman
Robert Ryman
Jack Whitten

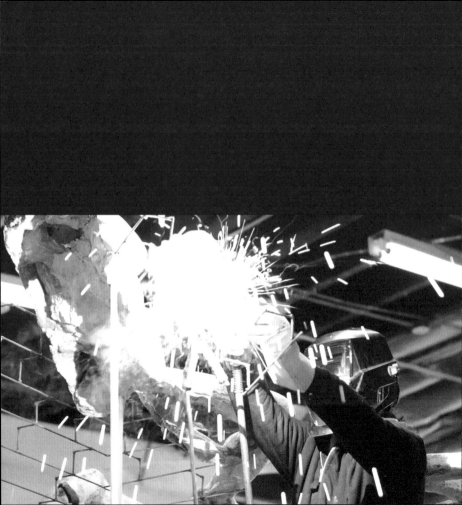

Scale, Mass, and Gravity

Known for pushing against the capacity of material, **Diana Al-Hadid** distinguishes between structure, skin, and scale in her paintings and sculpture.

Interview by Wesley Miller at The 1896 Studio in Brooklyn, New York, on April 29, 2012.

Art21—You have talked about learning how to draw as a child, from still life and from photographs, and that it didn't matter what the subject matter was, that you were trying to improve your technical ability. A lot of the starting points for your work are paintings, and it doesn't seem like the subject matters much now, either. Do you think there's similarity between your attitude then and now?

Al-Hadid—Then, I was trying to establish that I could draw, that I had some measurable ability. Now, I'm trying to learn something more about the nature of composition; it has something to do with volume and with scale. All these things are developed in paintings. There's something that these paintings can do in terms of scale and mass and especially gravity, levity, and illusion. I want to take some of that information and see if I can apply it to the sculptures.

Can you describe the paintings that achieve this?

A lot of Northern Renaissance or Mannerist paintings do this. I was looking at Pontormo a lot; his work is really strange. [In one painting], he has a figure in the foreground that looks like a very small boy, and it's almost the same size as a painted statue on a column in the background. The statue looks more naturalistic than the little boy that's supposed to be real. In the center of [another] painting, he put a cluster of faces, of figures, where you're supposed to pay the most attention, but your focus is elsewhere.

I'm dealing with actual space and gravity. [Those painters] get to do things that I wish I could make, but it's not possible. I'm trying to learn about composition and geometry. I've been inserting this invisible grid into my work for the past year; I'm imagining that everything has to snap to a six-inch grid. It's a way to organize some of the masses or forms into hard geometry because I've introduced the figure, which is an organic and indeterminate mass, in a way. Imposing this grid happened after these more nebulous forms (that were harder to outline) started leaking in; they seemed like they could shift quickly. The previous work that was more discretely

architectural had hard verticals and horizontals. But bodies move, and if one pauses at a strange moment, it looks unnatural. A lot of weird stuff can happen with an organic mass; it happens less with clean lines and geometry, like a building.

The sense of scale shifts in your work; there's a fractal quality to it. Can you talk about that?

My earliest work is about extreme scale shifts. I first got curious about fractal geometry when I realized that it was discovered by Mandelbrot, a French guy. He came to it when he asked the question: what's the length of the coastline of Britain? That's an unanswerable question because it depends on how far away you are from the coastline; you would have to zoom in or zoom out. Asking a good question produces really interesting answers or amazing discoveries. Of course, sculpture is inherently mathematical; it has to obey the laws of gravity, unfortunately. So, for me, scale in a sculpture is crucially important. And scale is different than size. People talk about the scale of my work. Yes, its scale relative to you is large, but scale strictly speaking is a measurement of two relative parts. You know that something is large only because something else is small. The whole sculpture can be large, but then there's everything that's handmade inside. Every little pencil mark and pixel that I applied was a building of layers and a developing of something larger.

I can see this scale in your work, _The Tower of Infinite Problems,_ because there's a large geometric shape, but

the pieces are built from tiny geometric shapes. Could you describe those two parts?

When I made _The Tower of Infinite Problems_, I started by laying out a map of a labyrinth on the floor, with tape. For the most part, I'd start with something flat, whether it was a map or printout of a painting. Then, I'd work from the ground up, as if something was extruded [from the flat image on the floor]. I slowly built each level up, like layers on a cake. I started to read about the way that bees behave. They have strange, alien minds; it's a group-think mentality, where you don't feel like any one bee knows any more than the sum total of bees. In much the same way, the workers of Babel had to be part of a larger system.

I imagine that bees helped me develop this work, but I made the little cells that look like they're made by bees. The labyrinth was, I believe, an octagon, so it was like trying to fit this square peg into a [round] hole. Sometimes I'm still doing that. My more recent work is more pyramidal, but it's sitting on a pedestal, so finding that transition is a little difficult.

Can you talk about gravity and suspension in your work?

I hate gravity. I want to do this thing that is irreconcilable with the laws of physics. I initially wanted _Tower_ to stand on its point. There's no gravity in your head; there, no one is saying, "This is going to need a triangle" or "This is going to need an I-beam." I don't fantasize in realistic terms, so I don't think, "I want to make this thing happen, but I'm going to need to put a right angle there." For me, to get a sculpture

Diana Al-Hadid

off the floor is the main event. It's the thing that I battle all the time. I don't want them to sit. It's easy to plop something on the ground. I think that the core of my sculptural gut is to get something off the floor. It's counterintuitive: to get it to not just do what it wants to do.

What are your thoughts about illusion versus reality? You go to great lengths to get things off the ground, but you work hard to conceal the effort. Are you pro-illusion?

There's a book written by this woman who had a stroke when she was 38. She lost the left side of her brain, which is the math, language, and time side; it's the side that understands sequencing. It's also the side that understands boundaries, like containers. But she retained the right side of her brain, and she's cultivated it. She's recovered fully but now has this greater sense of the difference between the two. I think it's the only time in recorded history that a brain scientist survived a stroke and had the mental awareness to piece together what was happening and to understand the difference between those two sides of her brain. I speculate about what side of my brain I am indulging.

When I'm on the floor in my studio and working, my focus is on these miniscule details: the nuts and bolts of how this thing comes apart, and which components of this sculpture I'm trying to make visible and palpable, and which parts are not important. But that's the skeleton; it's important; it's the thing that holds everything up. It's the most important thing structurally, but it's not important for me to explain to you the sequence of events, where something starts and where something ends, the math, or the hard logic of the piece. I know what material is compatible with another and what their limits are, more or less. Technical stuff would bore you, but that's what I labor with every day. What I want is not to burden the viewer with all of those mechanical details, not because I don't think they're important but because that's [for me to] worry about. The reason that my work looks so thin or has so many planes is because I've focused my attention on exploiting that capacity in that material. As much as it may seem like I'm weighing in more on illusion, I actually think it's a function of how realistic I'm being with the materials and how much I'm studying their limits and their capacities.

Can you talk about the drips in your work?

The drips came after a few years of noticing how I can pour something and reinforce it. I had to use years of accumulated knowledge about how different materials behave with one another, and I failed a number of times before I figured out. Many events happened before I got to that point with the drips. I didn't expect it; I thought I had figured out all I could with that material. A lot of my work starts with the material, with a careful study of what it can do or what it can't do. The skin of my work is the structure. In an effort to lose the object, I've laminated the surface and the structure as closely as possible.

During the process of filming, we talked about

some of the investigations that you were doing in your studio, and you referred to them as "trade secrets." Were you anxious about our presence there?

These things that I've figured out—it's okay for you to see them because they're mine now. Your interest comes as a result of the fact that I've developed them for so long. I think it's about coming to terms with the fact that it's not something everyone could do. There are things that I've figured out how to do, and I don't think anyone is interested in doing them. They're my weird things. I started with a pretty narrow knowledge about materials, and so I experimented a lot to see what would happen if I did this or that.

Everything I've made has been a new iteration of some material development that I did previously. Every sculpture piggybacks on some development from the previous work. [The process is] becoming more fine-tuned. I've been doing this quietly for what I feel like has been a long time, but it's not that long. ∎

Flexible Sculpture
El Anatsui explains the story behind his now-famous use of bottle caps.

Interview by Susan Sollins at Art21 in New York City on June 7, 2011. Some questions were conducted by Wellesley College students during a Q&A at the Davis Museum at Wellesley College on March 28, 2011.

Art21—How did you discover bottle caps and start to use them?

Anatsui—I was looking at what I call a "monument on a hillside," where potsherds and broken pots form a line, from the foot of the hill all the way to the top. I think it was done long ago because [the pots are] really old.

I used to visit there once in a while, and it was very inspiring: that art in the landscape. One time, I saw a curious bag, fairly big, lying by the roadside in a wood. I picked it up and saw that it was filled with these bottle caps. I thought, "Wow, this might be some material to work with." So, I put it in my [trunk] and took it to the studio.

It was in the studio for many months. Normally, I collect all kinds of material, and there are long periods of gestation before an idea of what to do with them comes [to me]. The idea came: these are individual bottle caps, but if you put them together, they might be able to do something more effective. So, the idea of opening them and stitching them together came about.

At that time, I was consciously thinking about a sculptural form that is very free and lends itself to many ways of manipulation and ways of configuring. I couldn't think about anything better than the sheet format, like cloth, which you can drape onto and into anything, spread on a floor... That's how the whole idea came about.

What made you decide to change materials, from wood to small little metal pieces?

I think change is something that human beings yearn for; you don't have to have a reason for it. I want to see something different. When I started working with wood again, I [used] wood that has been processed into slabs. But not too long after that I found out there was a lot of meaning in wood that had been put to human use, like doors and windows. That was the beginning of my fascination with objects that have been found or used or that have some history behind them.

Where do you go to collect all these materials?

I go to the distillers who recycle the bottles. They have people collecting them, and I obtain [the materials] from them.

Do you see yourself as recycling these materials?

I've always kicked against this idea of recycling because it's a politicized word. Recycling has to do

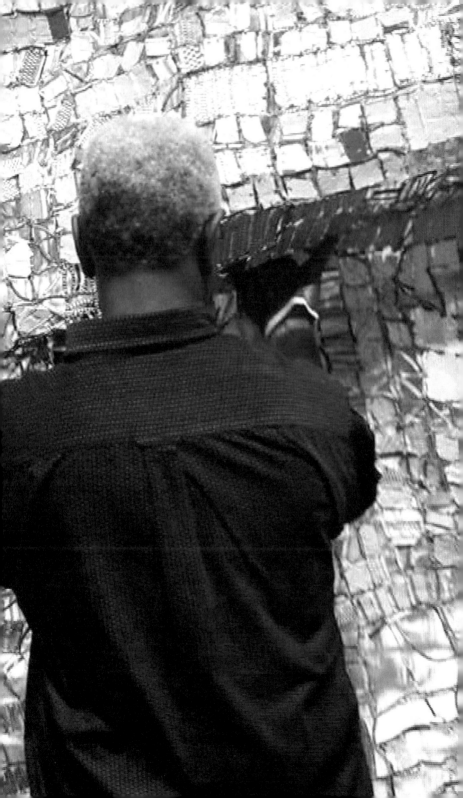

with the industrial process, and that's not what I do. I don't, for instance, return the bottle caps as mere bottle caps. Rather, they are sent into the work as something different. I think in America you call it *repurposing*.

Could you explain the process behind these pieces? How do you test ideas?

First, we make the units; we call them *blocks*. A block can consist of, maybe, two hundred and something bottle caps. The instructions I give [to my assistants] vary and give us many possibilities. If, for instance, you give them instructions to mix [the caps], some people put a lot of color in, and some don't. I think it's a way of harnessing the variety that you have when you are working with large numbers of people. If you make the instructions too strict, what comes out might be boring, too regular. I think the whole process and the end product all have to do with freedom and flexibility. Right from the instruction stage, you leave a lot of room for people to play around, and the resulting work tends to have that flexibility in it.

They do the blocks, and then I decide what the architecture is going to be like. I don't necessarily have to imagine things. I let things grow out of circumstances. You can have your assistants working on a series of units, and then at some point you can put them together in a bunch, and you try to see what it can suggest.

You lay all of them out, scatter them in the studio, and then start picking what you need for each portion of the work. If it's something you feel is interesting or effective, then perhaps you've found a new idea.

Do you think there are endless permutations?

Lots of permutations are available at each stage of the work. It's also possible to lasso—to cut out a portion and bring in a different portion. Maybe you are thinking about different textures; you think that this texture has run for too long, and it's no longer effective, and you want to introduce a break. You can cut portions from a different element altogether and bring it in.

Do you use leftovers or discards from different works? Do pieces from older works end up becoming parts of new works?

Over the years, you have to cut a corner, a middle [section], or an edge off the finished works or a work in process. We keep all these offcuts. And [eventually] you have a huge collection, and the idea comes that you can put them together in a way that speaks about their history. They are not things that are part of a continuum; they are offcuts, offshoots of bigger ideas.

The word *offcut* is from tailoring culture, when you are designing a suit or a shirt, and you have to cut some pieces of the fabric off. I think it's the same thing that I do because, when working on certain pieces, there are times that I have to cut [parts off]. We have stored these over time and discovered that we could work with them on their own. What I've done is introduce

irregular patterns made from the offcuts—combining these pieces with more regular patterns—and it brings in an element of contrast. The regular [patterns] might have elements running in one direction only, but with the offcuts you can introduce elements running in all directions. Once you're sure of the arrangement, you stitch it together and then test it, lifting and pulling to see if there are loose portions that need to be revisited. When you're satisfied, then it can be put to use.

How long does it take to make the larger pieces?

Quite some time. It's difficult to [calculate] because we are often working on several pieces at the same time. But I reckon that something like this, with twenty to thirty people working on it, would take about two to three weeks.

I have a question about the three-dimensionality and the volume in your works. I think a unifying theme is the fact that they take up space and exist beyond a flat plane. How do you conceive of these three-dimensional forms before you create them?

I work as a sculptor, so I always talk about volume. Volume was what led me to create this kind of form. I was looking for a form that is free, that you can shape and reshape, and the idea of the sheet came to me. It's like a piece of fabric that you can drape in so many ways, and I like the idea that you can contract it—fold or crease it into something small—or expand it, into a bigger size.

And, each time you hang it, it's a different cup of tea. I believe that artwork should be a reflection of life. Life is not something fixed; it is constantly in a state of flux. So, the artwork should be, too, and every time you meet it, it should be telling you something about what has happened to it, how it got there, and where it's been.

We were noticing how the light shines off the gold, and it has a luxurious effect to it. The appearance is very rich, yet it's made out of discarded materials. How do those two worlds come together, for you?

I think art is a way of transforming things. The moment the artist's hand touches something, it transforms it, whether it's a discarded thing or not. It gives it a certain value. It becomes something not thrown away: something that you contemplate. ∎

Spirituality and Chaos
Cai Guo-Qiang discusses the inspiration for his work and his methodology, which employs aspects of Taoism and Chinese medicine.

Interview by Susan Sollins at the artist's studio in New York City on March 8, 2005.

Art21—Can you talk about the El Greco poster that's hanging in your studio? Are his paintings an influence on your work?

Cai—Cultural exchange is very important. People are always asking, "What is it you're interested in art, historically? Who has influenced you the most in art history?" These are repeated questions that I have had to think about and kind of crystallize these ideas—who's important and why?

I've always, in my heart and spiritually, felt this affinity towards El Greco. During the Renaissance, dissecting a scene, having proper perspective was revered. But for El Greco, he saw beyond that already; he saw that these were only devices. His work has pride, spirituality, and his own compromises as well. What he has tried to express was beyond what these rational artists were doing at the time. This spirituality is what attracts me the most. This conversation is exchanged with the unseen forces and with the spiritual world.

We are working in an art that's called *visual art*. And by definition we are visually driven. In a way, we are bound by that, limited by this very fact. So, it's easy for us to depict things of this physical world, of the way we live now, but it's very difficult to depict things that are not seen but have a profound effect on us. It's very difficult to show life beyond death, life beyond this life. But there is something that he understood that these other Renaissance artists were depicting. Of course, a lot of this is religious imagery that is meant to evoke something that's eternal, that's very spiritual. But he knew that these were only subject matters, not necessarily what the works were representing in essence. While the subject matter is about spirituality, they were using man as a manifestation of that. So, it was very much based on man. Maybe El Greco inherited something of the past beyond the Renaissance.

Is that an analogy for your work as well?

Yes, it could be said as such. However, I live in a different time from El Greco. Our methodology and style are different. The way we approach art is different, so the representation may be different. Even though in thought, in spirituality, or in philosophy, there are some

links, our form is different.

I come from a background of alchemy and Taoism, and I've combined that with modern physics and a modern worldview. I know, for example, space could be totally engaged in a type of work that envelops the audience. The work could play out in time; there could be a time element in there. These issues broaden our representation, our way of working. They represent our time as well.

Can you talk about your working method a little more, your methodology?

It's very difficult to articulate exactly what that methodology is—even for myself. If I knew it all and understood it all, if I could clearly say it, then it would become a product on a shelf.

It's something I'm continuously exploring and trying to form. There are perhaps two ways of looking at that. One is a methodology in how you view the world, how you see and understand the world. I take a lot from the ancient philosophies, from Taoism. And then there is another side: how you specifically approach art or life, exactly how you live in this world, how you make art. One is more conceptual while the other is more practical. I also employ the basic philosophies of medicine—Chinese medicine or feng shui. These are very much infused in the more daily living and the art-making process.

I can be a little bit more specific about some of these ideas that I live by. For example, movement cultivates vitality. This is the idea of living within the chaos of time and space. Maybe not everything has to be resolved with a finite answer.

Rather, sometimes you can allow uncertainties to exist within the same space and situation. These are obviously ancient ideas from China. Because I'm Chinese, this is what I know. Some of these ideas are also found in the Western frame of mind as well, maybe in a slightly different perspective, but the principles are there. Perhaps during the Age of Reason, Enlightenment, and Industrial Revolution, some of these ideas were cast aside for more concrete analytical ways of approaching life. But since then, in postmodernism, some of these ideas have resurfaced, even in science. So, the chaos theory—it's technical—in Chinese, it translates as either "murky mathematics" or "chaos mathematics." In astrophysics and math, these are ideas that are employed by the most modern thinkers as well. I come from this perspective.

How does one work with chaos as a material for art— for example, fireworks and gunpowder?

With time, you start to get to know the material. You actually develop a way to know how it will behave, to a certain degree. First, you have to accept that it's uncontrollable and that there is an accidental element. You have to accept it and then work with it. I've worked with the material for so long that I've gained an understanding of how it works. Sometimes I can control it better than I realize, better than I expect. Then at that point it becomes stagnant. So, it's very important that there is always this uncontrollability that's a part of the work. My way of doing it is just to flow with the

material, go with the material, and let it take me where it wants me to go. So, I continuously want it to give me problems and obstacles to overcome.

What sort of obstacles?

If you follow that train of thought, it might get a little boring, so let me use another example. This whole process of making drawings is very much like lovemaking. From the very beginning, of laying down the paper, it's like laying down the sheets on the bed. First you lay down the sheets, and you have this idea of what you might want to do today, in form or in action—what you would like to accomplish. Then you bring in the materials, you lay them out, apply pressure here, but not too much pressure here. You know what kind of effect it might have. How much attention you should give to a certain area, how much material you should use, and how you should play off another balance are all things that you have to consider throughout.

It's a very long process. You keep going at it and always working towards a final goal. But it's a very prolonged process, and all the time there's this feeling that you just want it to explode, to finish. There's continuous control of pressure: you want to set this on fire, to explode it, but yet you are afraid that maybe it's too early, maybe it's not the best time yet, maybe you need to work on it a little more.

The explosion process obviously could be equated to the climax. Immediately afterwards, we're trying to clean it up, put out the flames, put out the sparks, clean up the pieces, clear it away, so you can see the work. Afterwards you have either great satisfaction or you have disappointment as to your entire performance. These play back and forth: the material, your idea, and what you're working on. It's actually quite a biological process; it's very visceral.

If we equate making art with making love you can see a different approach. You can talk all day about philosophy: ancient philosophies, modern philosophies, art history, criticism, theories. You can talk about subject matter, context, historical context, the contemporary, postmodernism. You can talk about form and representation. All these things can be discussed, but in the end, it's really how you do with this given situation. You can have all these ideas about lovemaking, but it's really the culmination of all these things. It's your physicality there, how you're involved in that moment.

Can you discuss the title of the piece, *Inopportune*, at MASS MoCA?

Ever since September 11th, the idea of terrorism is always on our minds. It's ever so present. And while car explosions have been around for a long time, they have a heightened sense of reality in our minds. *Inopportune* obviously has a direct reference to these conditions that we live in now. But making an installation that is so beautiful and mesmerizing that also borrows the image of the car bomb already has inappropriateness in it. Of course, there's a concept behind it, but never mind the concept—just the very fact is a difficult thing to overcome. It's difficult to resolve for some people. Whatever it is, it's a quite direct reference and commentary about some of these issues. So, maybe in

Cai Guo-Qiang

this way, it's kind of unfashionable or inappropriate, or inopportune.

Since the '80s, maybe the '90s, irony is such an important part of work now. There's less direct commentary or direct reference to certain social problems or phenomena in our world. Nowadays, artists tend to stay away from these kinds of ideas and take a more humorous approach, poking fun at society. All of my work is quite direct—for instance, the car bombs or the tigers. It's a quite direct reference and commentary about some of these issues.

In *Inopportune*, both the cars and the video installation loop, either metaphorically or literally. Can you talk about the notion of circularity in these works?

Just like the cars in the main gallery—as the first one takes off into the air, tumbling in a very dreamlike fashion, it lands back on its four wheels, safely, undamaged, unharmed. It repeats, going right back to the very first car again, suggesting that it's just one car. And like the video in Times Square—it happens, yet it looks right back into itself and it plays out again. This continuous loop suggests that something might or might not have happened—this illusion that we are seeing in front of us. The drawing may clarify it or crystallize this idea to put it in a more physical form of the circular shape.

How did you plan the work? How is it sited?

When I first saw the exhibition space—that elongated space, one hundred meters long and eighteen meters wide, for the work that became *Inopportune*—I felt that it was like a section of an avenue, a road that had been transported there with that concrete floor. The idea of doing a project having to do with car explosions had been on our minds for some time. But these kinds of conditions that are presented to you bring forward concrete ideas, so it seemed like a perfect opportunity to show this idea. And of course the physical manifestation was also inspired by the space itself.

And then while we were looking at how to lay out the entire exhibition, it wasn't just an avenue I was given— it was like a landscape. You travel upstairs, you come back down again, and then you go up these ramps or go into the adjacent space. I wanted to further that idea, and that's one of the reasons for having that stage prop that actually creates a little mountain where the tiger is sitting on top, in the tiger room. There was even a little staircase one could go up, symbolically. So, these elements were actually further extending the idea of this path or journey, and we can say that the entire exhibition is like a long scroll unfolding.

Can you talk about what's happening in the tiger room?

Entering the tiger room, you see the violent act—tigers with arrows pierced into their bodies—and there's a visceral response. Even though it's completely fake, the tigers are so realistically made that the audience feels pain when they see the them. The pain is not in the tigers, which obviously can't feel. The pain is really in the person who's viewing this. So, it's through the artwork, because it represents pain, that one feels this pain and has this very visceral

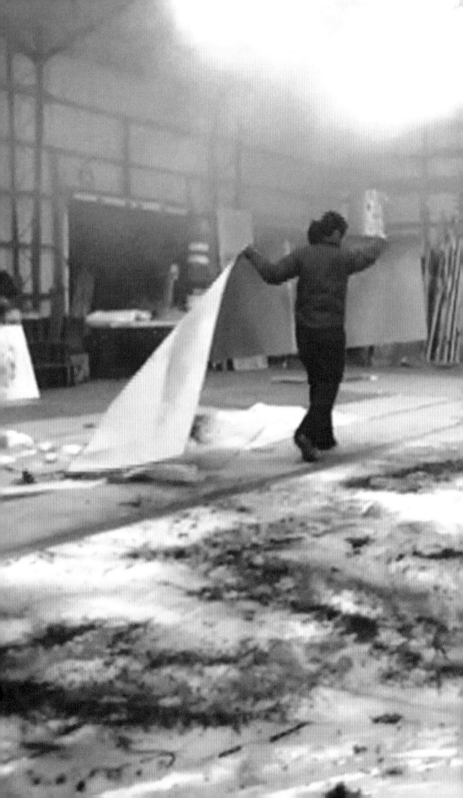

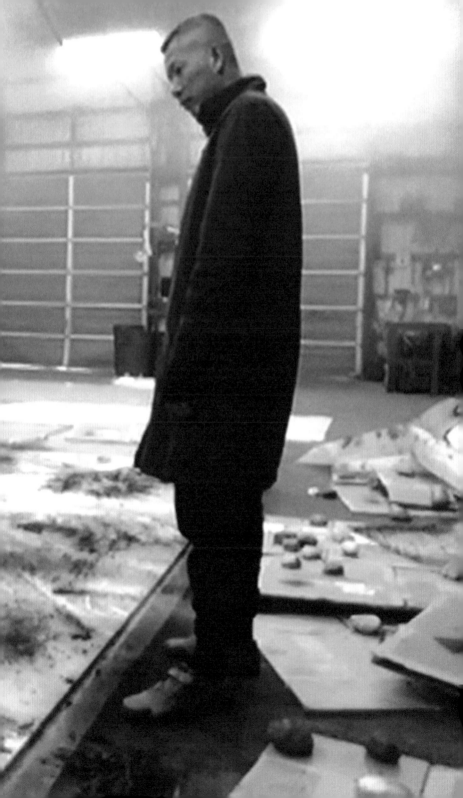

relationship or reaction to it.

There's a lot of talk about the content of my work, about the subject matter or the historical background. But there's not a real in-depth investigation into the visual impact. It's through visual impact that you transmit these ideas. And it's through visual impact that this pain is felt and you can elicit a direct response from the audience, a very strong response. But it's the treatment of all the elements that has the power to do this.

So, for you there is a connection between aesthetics and power?

Maybe my work is like the poppy flower. It's very beautiful, yet because of circumstances, it also represents a poison to society. So, from gunpowder, from its very essence, you can see so much of the power of the universe—how we came to be. You can express these grand ideas about the cosmos. But at the same time, we live in the world where explosions kill people, and then you have this other immediate context for the work. ∎

Building Surfaces
Vija Celmins discusses her methodology, inspiration, and the materiality of her work.

Interview by Susan Sollins at the artist's studio in New York City on March 27, 2003.

Art21—Is there a way to describe how your work led from one way of working into the next?

Celmins—Most of the changes in the work occur when I have had a little awakening experience—usually out in life, and I've forgotten all about it—and then somehow it creeps into the work. I think the night skies came out of pushing the pencil so hard and falling in love with the black. The ocean came from (maybe) walking my dog on the beach all the time and beginning to think of this giant surface. And thinking about my own surfaces on the work. The desert—I used to roam around.

They come out of life, you know; they come out of poking around my own life. Like, when I picked those set of rocks in New Mexico, it never even occurred to me. I had them in the back of the car, and I put them out on the table, and I just had this instinctive desire to make them myself, to see how close I could get, like a test or something, like a discipline. And then they became other things as I worked on them. I'm always picking up stuff—it's very sculptural stuff. Look at this. That's enough,

for goodness sake; you're making me, now, very self-conscious.

Explain why you're preparing the surface this way.

I start putting coats on the canvas to get to know it and to begin to fill the canvas, building a relationship with it. I kind of like the idea of laying a field out. Many times I begin working with an image already on it. This time I thought I would build more of a feel that begins to fill up some of the grain of the canvas itself, so that there's a semi-smooth, semi-rough surface. I put on a coat, and with each coat I try a slightly different color. Another layer. And I take it off because I don't really like strokes at this time. I have been into strokes in the past.

I put on an image, and I sand it lightly off to sort of push it back into nothingness, and I paint it again. This is a history of my working on this surface. It's childlike, maybe, or a little dopey. But it's a kind of a way of making the work dense by having many little layers on it. So, this is nothing; I'm just wiping this off, seeing what's coming out, knocking down the top ridges. Making a mess in my studio. Getting a little workout.

Will the paint sit differently?

Well, what happens is that the first layers of paint soak in and kind of become one with the material,

and now they're beginning to sit on top, like little ice forming on the surface. It's really bumpy. It makes a very frontal, flat kind of a field on which events can happen. And I tend to leave the edges kind of rough, so you have a feeling, so you really see the structure. You see the stretcher, the side of the stretcher, the work on the stretcher, the graininess of the material. And you see that it's been patted out and considered already from the beginning. Like, there's a little field that's been built up—not totally smooth but quite smooth. That's what I'm doing on this one.

For me, this part is interesting 'cause this is the part where I'm building the work from the get-go, from the beginning. I'm building a surface, a kind of a mass that's gonna sit there. I don't know—it does sound a little strange, but this is all part of the work. In fact, I often now talk about building a painting instead of painting a painting. Like, I'm making a structure that's a painting cause it's a two-dimensional object—it relates to the wall—but it also projects out. So, this is part of the beginning of the work.

Could you explain how you work with your source images—that the photograph is not an image that you're copying, but rather it's an image that you're using in some way to create the painting?

Well, I don't say *using*, either. I was trying to think of the word. I usually talk about it like I'm re-describing the image, through my body and through my sensibility—through everything I know, about how to make a painting. I'm making a painting. I'm not really copying an image. You know, when I did all the early still lifes—I looked at the lamp, I copied the image. But an image comes from a three-dimensional world.

For me, it focuses my activity but frees up something else; it's a touch that is then allowed to be. I was gonna say *gesture*, but I've kind of removed the gesture from the painting. But I still have a touch through which you can experience the work. It's hard for me to talk about the painting because I don't know that much about it. It isn't like I'm totally in control of everything. But I have this little area now that's beginning to work better on the painting, which makes me happier. But I still don't know whether I'm gonna be able to continue with this little color thing here. It's a little dull.

Something in what you're saying reminds me of Cézanne and what he was trying to do.

Cézanne has inspired so many painters. The thing that I think I got from Cézanne—which took me years—is a really gutsy relationship between the image and the plain flat object. He has such a wonderful way of pointing that out to you in every stroke. And also the fact—which I think was a great part of the twentieth century—that this is an invented thing. That it's not a copy of nature or a copy of a photograph. It's an invented thing that you have in front of you. I think I have that in me somewhere, this relationship.

Vija Celmins at work in her studio, New York, 2003. Production still from the *Art in the Twenty-First Century* Season 2 episode, "Time." © Art21, Inc. 2003.

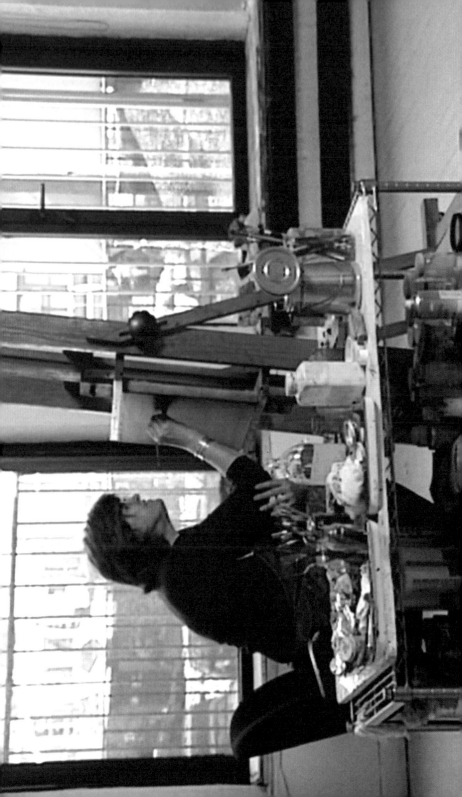

I think it shows up in different parts of my work, and sometimes I lose it a little bit, and sometimes it's more apparent. Cézanne lived in France. He had this fabulous country and light. I'm a very studio-oriented artist. Some artists now—the street is their subject; they love it. I love the street too, but my work is really studio-oriented. This is the place where everything is allowed to happen. I bring in things like my shells and rocks from the outside—always thinking that maybe I could somehow use some part of them—but it's very hard for me to work directly now. I work directly here, but it's very hard for me to look at something. Not hard in terms of that I can't do it, but intellectually it's hard for me to do. I see no reason for it. There are a lot of things that I don't think I can do.

I make a sort of a distant-and-close object that is a painting—that's how I think of it—and sometimes a very strange-looking painting. I think, for instance, that's a pretty strange-looking painting over there [*The River's Galaxy*]. It's kind of an enigmatic spatial painting I've been more interested in lately—meaning, the last two or three years—a more ambiguous space, flat: a space that's harder to place yourself in.

Is the darkness of the image an inherent quality of the flatness?

These dark paintings came out of me making those graphite drawings darker and darker—those drawings that I did in the late '80s. And I thought, "This pencil, which is graphite—they just can't hold anymore." I wanted more out of them, and I didn't think they [could]

carry more, so I just sort of slipped into this image. I do like kind of impossible images—I mean, images that are hard to pin down, that aren't like a tabletop and an apple, that are almost like mind images. Images that are space, but they're hard to grasp. But then, they're very graspable here. I make them accessible through another way, through manipulating the paint.

I did a whole series of black works—twenty, thirty works. I thought it was quite difficult to make a black painting work because it has such an incredibly strong silhouette. But it did a series of things. It invited you closer and closer to the work. I thought it was an interesting phenomena that happened. And at a certain point I thought I didn't want to do it. I'd done a reverse galaxy a long time ago, maybe twenty years ago in a print. And I thought I would turn the tables on the image and have the reverse image and lighten up the painting—a totally different kind of space. So, I did it, and I'm interested in it. I think this painting looks so strange, and it looks like a piece of concrete. And when you get very close to it, you begin to think you're hallucinating a little bit. It changes color and tone, depending on where it is. I began to think that those are interesting qualities.

So, I kept this painting. But I've been working on this thing for a year. I have to try to come to terms with it. I was doing all kinds of other things. But I like being back in the studio, working with this strange tedious surface.

What causes you to take a little of that dark turquoise or that ochre?

I follow my intuition. That's what I do. I have been putting quite a lot of cerulean in the black. It makes the black have a tiny bit more atmosphere. Makes it a little bit cooler, makes it a little bit chalkier.

Each one is a little bit different. Even though I've been sort of obsessed with this image that describes a space, I don't really have an agenda here, where I line them up and do it one way. Each one develops how it wants to develop.

Ugh. I just did the wrong thing. I just put in this little thing, and it makes this little pattern. This talking is too much. Now, look, I've ruined my painting. Or maybe not—eek! ■

Specificity is Undeniable
Ellen Gallagher discusses
her process and how she came to use collaged paper in her paintings.

Interview by Susan Sollins at Two Palms Press in New York City on January 10, 2005.

Art21—How did arrive at collaging paper into your paintings?

Gallagher—I didn't come from a fine-arts background although I certainly went to museums as a kid. I came from a carpentry background. And I worked building a bridge (a floating bridge that has since collapsed). I worked in the saw yard where we built the molds that the cement was poured into. Basically, I built a box over and over again for months. So, when I went to art school, that was what I knew how to do, and that's the way I built my canvases. I built a latticework grid and, over that, laid down very thin plywood and stretched the canvas over that. That way, I could sit on the canvas as I began gluing down sheets of penmanship paper, from top to bottom, left to right. Then I began drawing and painting into the pages, after they'd all been laid down in a skin. And they really became something that can be read both sheet-to-sheet and as an overall skin.

The lines of the penmanship paper sort of line up and, from a distance, almost form a seamless kind of horizon line. But up close, you see that it's a kind of striated, broken grid. So, there's this push and pull between the watery blue of the penmanship paper lines and the gestural marks made inside and around them. Penmanship paper is the found material that I always see as a reference to how you make your letters—what height, and where you dot your *i*—so, it's always been a sign of gesture for me.

It seems like there's a variation of this practice in the paintings from the "eXelento" show at Gagosian, especially in the use of the grid.

The large works at Gagosian are made in a way similar to the earlier penmanship paper works: they are built from found material. Now, the paper itself isn't something that's only a support, as it was in the earlier works. The paper is more readable, narrative. The characters exist within the support itself, the page.

I've collected archival material from Black photo journals from 1939 to 1972, looking at magazines like *Our World*, *Sepia*, and *Ebony*. Initially I was attracted to the magazines because the wig advertisements had a grid-like structure that interested me. But as I began looking through them, the wig ads themselves had such a language to them—so worldly—that referred to other countries, Leshiba, this sort of lost past. I started collecting the wig

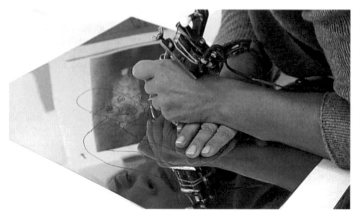

Ellen Gallagher at work at Two Palms Press, New York, 2004. Production still from the *Art in the Twenty-First Century* Season 3 episode, "Play." © Art21, Inc. 2005.

ads themselves. And then I realized that I also had a kind of longing for the other stories, the narratives—wanting to bring them back into the paintings and wanting the paintings to function through the characters of the ads, to function as a kind of chart or a map of this lost world...

How did they get conscripted?

My mind is also activated by the resistance of the material. The signs from a page of *Ebony* come with their own specificity and undeniable drag—their inability to be fully woven into my world. (Some model actually modeled these wigs in 1939!) The way they resist me—even before I manipulate them, or even after I blot out their original stylings with my Plasticine blobby wigs—is that I know I'm looking at someone who was eighteen in 1939, as opposed to somebody who was eighteen in 1970. And even though all the signs have been uniform—or they're now wearing my Plasticine form, and their eyes have been whited-out, and they are actually reproduced only in a kind of snapshot form and not the full advertisement itself—there's a way in which their specificity is undeniable. And I find that really moving. That was what I felt after painting *Double Natural* (2002). No matter what I did, this person's specificity was completely undeniable and unapologetic. I'm not only talking about this idea of capturing somebody in her youth from 1939. It's also the specificity of that moment and what it is about that—just in her face—that registers that precise moment.

The paper itself—it's not archival. It's archival in the sense of historical, but it's not a fine-art material. It will yellow and

darken with time, so no matter what, it resists me in that way. No matter how I may try to build it into forms, or arc it, or cut it, it will darken and yellow, which I like. It has its own relationship to time.

There's something poignant about figures stuck in time.

I am certainly moved by the idea. There used to be a store called A&S on 42nd Street where I would go, to collect these magazines, before 42nd Street got cleaned up. Among other magazines, there were *Our World*, *Sepia*, *Ebony*, and before about 1960, they're pretty radical. They're certainly not the *Ebony* magazine that I remember. There were interviews with Haile Selassie, a Richard Wright article next to a slasher text—they were dense. There was a necessity to them as a press, as a Black press. They were entertainment, but they had a kind of urgency and a necessity to them. Also a worldliness—articles about drag-queen balls in the Bronx, way before Jenny Livingston made *Paris is Burning*; nightclubs, like Lucky's, that were of mixed race. There was this sense of loss that I felt, reading them, but also it was exciting, this collection of data and information. They seem radical compared to what I'm reading today.

How exactly are the paintings made?

The material is archived. I make a disc, so it's digital, which means what you're looking at could be from an ad that was two inches or ten inches big—scale is really infinite and it can shift. The Plasticine is meant to allude to that idea of mutability and shifting, because Plasticine is used in Claymation. Much the same way that penmanship paper is not a fixed material, the Plasticine will always continue to be vulnerable. Next, I build a grid of these 396 pages with this idea of what will relate to what. Then the sheets are cut. The wigs are removed with a knife, and then the sheets are glued down to the canvas. At that point, I begin at the top left corner and work my way across and down, building these blobby Plasticine forms. And they're really built directly, wig to wig. There's a kind of improvisation that happens. I do about nine wigs a day or nine prosthetics a day. And they relate to each other over time. You can see shifts, which is also why I like to show more than one painting together, because they mark quite a long time period in making.

What excites you most about the process?

Using paper as support for printed material has always been central to my work, from the earliest penmanship paper works to *DeLuxe*, the print project at Two Palms Press, where I'm working in collaboration with printmakers and people building alongside of me.

What was exciting for me was that what happens as whimsy in the drawings or as a decision made with an improvisational spirit—for example, when I would make a choice to blindfold characters or obliterate names underneath characters—would have to be structured, so that it could be repeated twenty times. And it was exciting to see, repeated as a language, something that was usually a one-to-one experience. I would make these little squares, and they would then be hand-cut and traced, so each sort of whimsical obliteration or recovery would be

created into a kind of structure or language, back and forth. That was really exciting, in terms of looking at my work and my language and having it mean something even in its refusals to be completely readable. There's this call and response that you actually feel directly as you're working in this kind of collaboration.

I really get excited by this idea that a printed material can be so widely distributed. The Black press was widely distributed and there is a great American history of manifestos. I was always jealous of writers because their story could be in so many different hands—it didn't have to occur only in a gallery or a museum. There is a possibility for distribution and freedom.

Is there anything about your work that needs to be debunked?

What's seen as political in the work is a kind of one-to-one reading of the signs, as opposed to a more formal reading of the materials, how it's made, or what instances are made. I think people get overwhelmed by the super-signs of race when, in fact, my relationship to some of the more over-determined signs in the work is very tangential. What I think is more repeated than that, in the work, is a kind of mutability and moodiness to the signs. And that's more what I think the work is about than a one-to-one reading of the signs, however over-determined they may be. You may think that's what you're supposed to be translating. In fact, it's this other thing, which requires a kind of confidence that you have to enter that realm. And I think that's where you can talk about race in my work—that idea of the abstract "I"—what it means to look at somebody who was eighteen in 1939, whatever she was. That's specificity. It's impossible to know who that was. But try anyway to have some kind of imaginative space with that sign. I think that takes more balls than to just understand it as some kind of critique of Black hairstyles.

Talk about the elements of joy, pleasure, and beauty in your work.

I think it's hard for some people to look at a grid of wig advertisements or a group of women. They might be able to see the [*Some Girls*] album cover, but they don't have the depth that [the artist] had when he looked at that and thought those women were beautiful and altered them. Sometimes it's hard for people who don't make things to understand labor, joy, attention, and whimsy. But it's in the work—I don't think it's something I need to explain. ∎

Studio Floor
Trenton Doyle Hancock decodes his artistic lexicon and its related iconography.

Interview by Susan Sollins in Houston, Texas, on June 22, 2002.

Art21—When did you first start to make collages?

Hancock—When I was an undergraduate, I worked for the school paper, making cartoons. That was great for me to go through because I had to make images quickly. I had to come up with a story pretty much on the spot—maybe dealing with a story that was given to me that I used as a jumping-off point to make stories—but the drawings usually ended up being flat. I got bored making these flat drawings, so I started to experiment with collage and building up the surfaces of these drawings, sometimes very subtly—you wouldn't know that something had been collaged on unless you investigated further. When I learned how to do that, I wanted to put something on that was a little dumber, like something that you knew was collaged on. Eventually collage became part of the process.

[My work] went full circle, [beginning and ending with] something that was a pictorial space. The cartoons were about good design: you knew what was happening, it was a quick read, and you could go on. Then it became about not being able to read something so quickly. Now, it's morphed into a combination of the abstract things that I was doing and those cartoons that I wanted to do, as the cartoonist or the comic-book artist that I wanted to be when I was a kid. All these things are coming together to form this new thing for me. I wanted drawing to be a lot harder for myself; it seemed too easy to make a drawing. I wanted to remove the immediacy from the process. I think majoring in printmaking when I was an undergraduate helped me learn how to do that. It gave me patience. It helped me to see steps into the future, in terms of what a drawing could be or in terms of creating an image. It led to a richer kind of image, something that you can read from top to bottom, from back to front. Now, those issues are a given when I think about my work.

How does language factor into what you're doing now?

One of the bodies of work that I'm focused on at the moment is based on my studio floor. I have piles of little colorful scraps, remains of paintings that I cut up or set aside—some are made of felt, some have paint on them, and some are paper—that have been sitting around for about three years. I wanted to make a body

of work that dealt with the things I'm finding on my studio floor. I started to glue all those pieces onto big felt bands of different colors; they ended up looking like giant rugs. Furthering the theme of the studio floor, I took the words *studio floor* and made anagrams from those words. I came up with about fifty different anagrams, and all of them led back to the story. It was very strange; the word *loid* and the word *tofu* appeared. It was so weird; I thought, "Oh my goodness! Well, this is the next step." At the same time that I have giant, goofy, abstract things hanging on the wall, I have tight pencil drawings of characters in dialogue with each other, in a storyline. But everything coming out of their mouths will be those anagrams; they talk to each other in this baby talk, like, "Tofu rule" or "Tofu is drool."

When did you start to develop the story of the Mounds and the individual characters? How did they get their names?

The name of the Mounds came from a series of drawings that I did when I was an undergraduate. That was the name I would give to groups of things, like a mound of information. I had friends who also did drawings that related to the same kind of thing; I've always liked to group lots of things on one page. A mound is a way that I organize information and things. They pop up anywhere; these mounds seem to move with me. In my car, there's a pile of things: that's a mound. In my studio, there are piles of things all over the place, and I pick from these piles:

those are my traveling mounds.

Torpedo Boy has always been with me, more or less in the form that you see him now. He's a superhero; he can fly and lift things. I created him when I was in the fourth grade. He's now a lot more flawed, and his uniform is yellow (it used to be white). That's the only difference.

I've always been drawn to color, but it has to be necessary; it has to have some meaning if I'm going to use it. It's hard for me to choose a random color and use that as information because I feel disconnected from it. Lately in the work, every color appears for a specific reason. If there's no reason for color to be there, then the piece will probably end up being black-and-white, which I'm perfectly okay with. That's where [the character] Painter comes from.

Loid is this love that I have for both the lyrical nature of the spoken word and the way language looks when it's written. Loid operates in both a space where he can convey something that you fully understand or a totally abstract [space]. Language has the capability of either including or excluding you: that's what Loid is about.

You describe Torpedo Boy as an alter ego. What's your vision of yourself in your work? How do the characters relate to your identity?

I see each character as a separate part of me: I can put one aspect of my being in front of me and look at it. All of these things are inside me at once, battling each other. At certain points, one is dominant: at one point, I may be Torpedo Boy and have the biggest

ego ever; I could be one of the Mounds, a stationary [being] who's pathetic and a bit stubborn and kind of sad; I might be one of the Vegans, who's self-righteous and looks to make others like him. It's up to each of those other parts of myself to balance out the dominant side and make it come down in size.

While Torpedo Boy is your artistic persona, he also has a religious or mythical dimension. Are biblical narratives a big influence on your work?

I grew up in a very religious family. My stepfather is a Baptist minister. There were several ministers in my family. My mom, all of her sisters, and my grandmother are all very religious. We went to church at least two times a week. It was a sense of community. The church was filled with beautiful stories and great music, and it was a visceral type of experience. That spills over into how you live the rest of your life. Things were dealt with in old-fashioned terms. Punishment meant a different thing: if you don't feel the punishment, then it doesn't count. It was that kind of mentality. The idea of these beautiful stories—these archetypes of heroes going through toil and trouble and coming out better or teaching us a lesson not to go through, to take a different path—I wanted to incorporate that into the way that I tell stories.

A lot of it comes back to my mother. She is Painter and Loid, wrapped up into one. She is the smiling face and the color that you get from Painter, but at the same time she could be stern. When she put her foot down, when she spoke, you had to listen; if you didn't, she made sure that you listened the next time. So, she is also Loid. In a way, the mother and father energies in my universe are both my mother. ∎

Trenton Doyle Hancock at work in his
Core Residency Program studio at the
Glassell School of Art, The Museum of
Fine Arts, Houston, Texas, 2002.
Production still from the *Art in the
Twenty-First Century* Season 2 episode,
"Stories." © Art21, Inc. 2003.

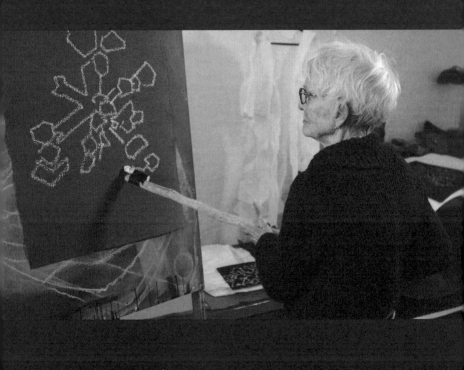

Joan Jonas at work in her studio, New York, 2013. Production still from the *Art in the Twenty-First Century* Season 7 episode, "Fiction." © Art21, Inc. 2014.

Performing for the Camera

Joan Jonas addresses the difference between her performance and video work, discussing the complexities in capturing an artist in a private moment.

Interview by Ian Forster at the artist's home and studio in New York City on February 17, 2014.

Art21—When you're working on a drawing, what's going through your mind? What are you thinking about?

Jonas—I'm trying to not think about anything. I'm thinking about you being there and the dog being there. I try not to think about those things; those are distractions. In the performance, I'm making the drawing, I'm thinking about what's on the video screen, what the music is. Here, there are a lot of diversions. You really have to take everything out of your mind and concentrate on these shapes.

But I don't have a vision of how the drawing's going to look, at the end. It will be related to that, but I don't have that kind of control over my drawing—that I know, "Okay, I'm going to make it exactly like this"—no.

In your performance piece, *Reanimation*, which we filmed in Sweden, you were drawing on stage as Jason Moran plays the piano. How is your drawing process different when it's public versus when you're alone in the studio?

When I'm alone here with my camera, it's very private. I've been doing it for years: I've been performing for my camera, making videos. That's a whole different situation because nobody else is there watching me; I'm totally free, alone. I put the camera on a tripod; I don't have a camera person, usually.

When I perform for the audience, I step into a situation in another mode, another world. In the performance, I'm performing. In a way, I'm performing here, but it's not the same. I don't think that you can ever really capture what it's like for an artist to be alone, working on their work in the studio. I don't think that's possible; it's always a setup. I mean, I got dressed in a certain way; I wanted it to look nice; I cleared up the mess. That's the way I approached it. So, it's a very different situation.

So there is an authentic, truthful experience that we simply won't be able to capture?

I don't care if you can't get it. I'm not interested in having my private moments truthfully represented at all, because I don't think it's possible. So, I don't think you can ever have

the truth. It's always not the truth.

Is there something about the artistic process that you think makes it especially difficult to capture?

If you're trying to capture it with a film crew, you'll get something, like, if somebody is just doing a job at a gallery. For instance, Richard Serra doing his lead pieces, throwing the lead in the corner: in a way, that's a performance, but it's also a task, a job that he has to do exactly the right way, technically. So, it can be recorded.

But that's not exactly what I'm doing here. I'm trying to make a drawing; I don't have control over whether this drawing is going to be good or bad. Why do you want to capture the artist in a private moment? It's just like you can never record a performance and experience it the same way [as seeing it live]. It's always going to be different. You just can't do it; those moments are gone.

Can you tell me about the music you were listening to as you were drawing? Why do you listen to music?

Basically, it's a matter of concentration, getting myself into a mode of concentrating. I like this Morton Feldman piece that I was playing, which I've been playing for many years. It's one of my favorites because it's very abstract. It has no drama to it. It's very calming; it's beautiful and mathematical. I like to have that, so it doesn't intrude upon me. And I like to have something else going on—not the television, because then you look at it—like sound or music to accompany me.

I put this on today because I thought that, since in my performances I always work with sound in relation to my actions, there should be sound. I listen to Morton Feldman all the time, so it's a normal situation in this room, to hear Morton Feldman.

Is this a typical setup for you, drawing on this easel?

No, I draw on the table a lot. And I draw on books, and I copy things. I like to draw on the wall, but I use the easel because it's a brick wall, and I don't have a surface to put something up against. I'll tell you what I do. I made these little tiny drawings. I like this drawing, for instance (but I don't think I would put it in the show), and I sort of like this drawing, because I did them very fast. Sometimes I make drawings to practice for other drawings. I made all these drawings because I was going to use them for another thing I'm doing. I do this kind of work a lot. And I make these very fast, so it's almost accidental if they turn out or not. Some of them I like. A few of them are good, and a few of them are not good.

It seems you're constantly working. Why?

I have work to do. Certain deadlines motivate me. When I'm starting a project, I always have things coming up in the future, and that's a big motivation.

What initially attracted you to working in film?

I was very interested in film and how to translate my work into another medium so that it would not disappear. I studied film, and I looked at films, continuously. So, I was interested in having my work in that medium.

**Speaking about what's
difficult to capture on film:
performance certainly poses
many challenges.**

In the beginning, I didn't record
my performances because it made
me so uncomfortable to see it. It
wasn't the same; it just doesn't have
the same feeling. But then, gradually,
the more I worked myself with the
camera, the more I wanted to record
everything. With a video camera, it
became very possible to do that. Then
I became interested in translating
the work into that medium. So, my
works are all translations of the
performances. They're not actually
the performances themselves.

Of course, I perform for
the camera. That's different than
recording a performance in a
gymnasium or a theater space. Now
I do that as much as possible. For
instance, I just did the performance
of the mirror piece that you saw
in Sweden. I really wanted to have
a recording of that, so we made a
recording. I've been doing that [piece]
for a long time, but I didn't have a
recording of the first mirror piece. ■

Mike Kelley on the set of "Final Procession"
from *Day Is Done* (2005), Valley Plaza
Recreation Center, North Hollywood,
2004. Production still from the *Art in the
Twenty-First Century* Season 3 episode,
"Memory." © Art21, Inc. 2005.

Day Is Done

Mike Kelley discusses *Day is Done*, a project planned to comprise 365 performance videos, one for every day of the year.

Interview by Susan Sollins at the artist's studio in Los Angeles on November 16, 2004.

Art21—Explain the concept behind your project, *Day is Done*.

Kelley—I'm making all these videos based on very common American performance types: school plays, children's performances, Halloween, dress-up day at work, things like that. But then I'm reconfiguring them through the tropes of history, like the avant-garde. In this one, this soundtrack lets you see the performance tropes more clearly because it de-contextualizes them, to a certain degree. By putting this wrong kind of music to it, you can see a performance type. So, I'm trying to play with popular or folk forms and reveal their performance structures.

And how does this relate to your earlier work?

Day is Done is built around the mythos that relates to *Educational Complex* and the history of a kind of Symbolist attempt at uniting all the arts. *Educational Complex* is a model of every school I ever went to, plus the home I grew up in, with all the parts I can't remember left blank. They're all combined into a new structure that looks like a modernist building. I started to think about this structure through the *gesamtkunstwerk*, the "total artwork" of Rudolf Steiner, where he tries to combine all the arts and develop a kind of rule system according to which every art form is related. So, the architecture relates to the dance relates to the music relates to the writing. But it's also a kind of religion. And so, my religion for this structure is repressed memory syndrome. The idea is that anything you can't remember, that you forget or block out, is the byproduct of abuse; all of these scenarios are supposed to be filling in the missing action in these blank sections in this building. It's a perverse reading of [Hans Hoffman's] push-pull theory.

What is your source material for *Day is Done*?

All the scenarios for *Day is Done* are based on images found in high-school yearbooks, in this particular case, though I've also made a whole collection of similar kinds of images from the newspaper of the town where I grew up. The particular categories had religious ritual overtones, outside of the church context. They all looked like they were done in public places, or they had gothic overtones. So I said, "Okay, I'm going to work with these particular

groups of images and develop a kind of pseudo-narrative flow." The rituals run the gamut from something like dress-up day at work to St. Patrick's Day or Halloween, to a community play or an awards ceremony. So, all I have is this image, and then I have to write a whole scenario for it, like a play, and then do the music and everything. Each one is just based on the look of the photograph that tells me what style it has to be done in.

Why use high-school yearbooks?

It's not because I have any interest in high school or high-school culture, but it's one of the few places where you can find photographs of these kinds of rituals. The only other place would be personal snapshots, which aren't accessible. So, really the only place I could get pictures of these kinds of common American folk rituals are in yearbooks and local newspapers.

It's almost like working as an anthropologist.

Yes, I think of it very much that way.

Will *Day is Done* be seen as video work?

My dream is to perform it live in a twenty-four-hour period. So, the day stands for the year. And at midnight, there would be a grand finale spectacle: a donkey basketball game. Because I think the donkey basketball game is one of the greatest examples of American carnival. It's all about inversions of power, which is very typical of folk forms that perform carnivalesque functions—where you get to break the mold of how you're supposed to act or look. In that sense, it's analogous to the traditional social

role of art in the avant-garde, but it's a very restrained one. I'm just trying to show that relationship between the traditional avant-garde and the carnivalesque social function of these folk rituals, as I guess you'd call them.

How do you expect viewers to respond to this work?

I know that people don't look at art like that, and I don't expect people to know any of this stuff. And I don't care if they do or don't, because you have to make an artwork so it can be enjoyed on the most superficial level. But I want for the more dedicated art viewer to be able to get the second and third levels of meaning. It has to operate on multiple levels: it has to be available to the laziest viewer and then on a more sophisticated level as well.

Can you say more about the overall structure of *Day is Done*—how the various scenes work together or compliment each other?

I was thinking of the Russian composer Scriabin who, at the time of his death, was working on a grand spectacle that would last for a week. And there was a different thing for each day, and that was linked to some kind of broader natural system. I'm using the year (a series of 365 tapes) just as a given system, the rationale tying it to this history of works that relate to natural cycles, like Symbolist artworks. But I don't expect to get to 365. I'd like to get to at least fifty of them. I would like to present one of these late-nineteenth or early-twentieth-century Symbolist works as a live theater work, like the mass spectacles of Meyerhold, or Rudolf Steiner, or even Wagner.

Or like a Passion play?

It's very much like a Passion play, yes. Passion plays can be folk drama, allegory, and social allegories; they can operate on multiple levels. The basic premise is that it's all based on trauma culture, and that's a contemporary motivation, a basic motivational idea. And I have to undermine that. I think having something be somewhat ridiculous is a way of undermining that notion—that life is just about trauma. This is also something that is embedded in a lot of modernist work—expressionism and existentialist artworks—that kind of heavy artist-as-sufferer... I have no interest in that.

Do you find this project humorous?

I think that's the joyfulness of it. But, it's a black humor; it's a mean humor, so it's a critical joy, it's negative joy. But that's art—for me, at least. That's what separates it from the folk art. I think the social function of art is that kind of negative aesthetic. Otherwise, there's no social function for it. You don't need art, then. Television can do the same thing.

And how does the idea of repressed memories syndrome come into play with *Day is Done*?

It's hard to differentiate between personal memory and cultural memory because, for example, a lot of what I use in writing is associative, and it comes from my experience. But it's very hard to, say, disentangle memories of films or books or cartoons or plays from real experience. It all gets mixed up. So in a way, I don't make such distinctions, and I see it all as a kind of fiction. And if you read a lot about the literature of repressed memory syndrome, the abuse scenarios are often standardized. It's a form of literature that's internalized and then voiced as reality. But it finds form in a variety of tropes. So, if you have a religious orientation, it comes through Satanic-cult abuse. If you don't, it might come through alien abduction. Or a more typical one is family incest scenarios. And yet the stories are all quite similar—it's just the social bracket that changes. I see this as almost a kind of overarching religion, in which the rationale for almost all behavior is the presumption of some kind of repressed abuse.

My own abuse was my training in Hans Hoffman's push-pull theory. All the formal qualities in the organization of these works are patterned on that kind of formalist visual-art training, which I see as a kind of visual indoctrination. So, I'm recovering from that. Another aspect of this—besides my video project of *Day is Done*—is paintings and drawings done in the manner of my student works. Hoffman-esque push-pull theory is also the organizational principle of the buildings in *Educational Complex* and even the sculptures that attend them. Everything else is a kind of social gloss added on top of that, taken from various cultural categories.

When did you first encounter Hoffman's theories?

When I went to undergraduate school, I studied to be a painter, and I was taught mostly by GI-bill artists who studied with Hoffman

or other modernists like Léger. But Hoffman was the primary theorist for compositional ideas in painting. That's what I was taught, but I always had this perverse version of it. And it was already kind of perversely being done by the early Pop people like Rauschenberg— obviously still painting in a Hoffman manner. I just replaced the blander everyday image that Rauschenberg used with more overtly perverse imagery because I was looking to the more sub-Pop Chicago School artists. I was more interested in the kind of popular material that they were working with, which was the lowest of the low, rather than New York Pop art, which tended to be more mainstream, like Warhol's Campbell Soup cans and standard Americana imagery. I was more interested in that [subculture] stuff.

You've always been interested in Marxism.

Very much so, yes. Always, my interest in popular forms was not to glorify them—because I really dislike popular culture in most cases. I think it's garbage, but that's the culture I live in, and that's the culture people speak. I'm an avant-gardist. We're living in the postmodern age, the death of the avant-garde. So, all I can really do now is work with this dominant culture and flay it, rip it apart, reconfigure it, expose it— because popular culture is invisible. People are visually illiterate. They learn to read in school, but they don't learn to decode images. They're not taught to look at films and recognize them as things that are put together. They see film as a kind of nature, like trees. They don't say, "Oh yeah, somebody made that;

somebody cut that." They don't think about visual things that way. So, visual culture just surrounds them, but people are oblivious to it. ■

Idea Generator

Liz Magor discusses how she approaches her sculptural practice, how we value objects, and her desire for a quiet studio.

Interview by Pamela Mason Wagner at the artist's studio in Vancouver, Canada, on September 6, 2015.

Art21—**Where do you begin, with a new piece?**

Magor—When I come to the studio, I'm usually working on one track. I try to focus on one work or a group within one idea or response, so that I'm not splitting my attention. Since I'm in the studio every day, the flow of works overlaps; as I'm finishing some work, the new work is already trying to start. The beginning of a work seems to be connected to the ending of another work. As I'm making a work, a variety of things might emerge that I want to pursue.

I wait and see if that desire to do that stays for even a day. I'm not too fussy. Sometimes a really interesting path comes from the most insignificant impulse. I'm not waiting for the big ideas or to be moved. I really don't like the word *passion*. I don't operate from passion; I operate from tiny, below-the-radar responses. I'm looking for latent emotions or responses, or not-quite-conscious or subconscious things: responses or things that get covered over by interests or more exciting events. I need a very quiet studio so that [I can notice] those ever-present-but-not-noisy operations that I'm doing as a human in the world. Those are the things I'm interested in. They're always there, but they're not always acknowledged.

A work begins with me acknowledging some thing or response like that: I sense or acknowledge the interest or the awareness. Then I look for the imagery, the form, that seems to match, represent, or have something to do with it, in some way. Then I'll bring that forward; sometimes that form or image is vague to me. It's like forgetting somebody's name but knowing it's a three-letter name that starts with D—and then you wait, and it comes up.

Sometimes I need to speed that [process] up. I can't wait for it, so I get on the bike and I go out, usually to Value Village, which is like a big mess, an archive that's not organized according to my system. As I go through it, the unpredictable always happens. Sometimes things that I see there trigger a sharper, better awareness of what I'm looking for. Value Village is a giant secondhand store. It's a business; it doesn't rely on donations from church members; it's not a charity. It takes and processes a lot of stuff. I'm not looking for special collectibles; the personal

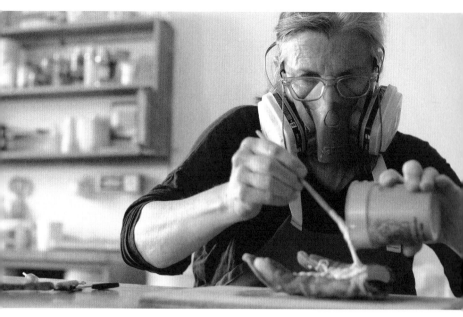

Liz Magor at work in her studio, Vancouver, 2015. Production still from *Art in the Twenty-First Century* Season 8 episode, "Vancouver." © Art21, Inc. 2016.

part of me has a few ideas about collectibles, but the art part is looking for what the world has dropped off. Everything there is from all cultures, all ages—many different generations of stuff, from the 1950s, the '40s, the '30s. It's like the beach at high tide, when all this flotsam comes up.

While beachcombing, you might find something that's floated over from Japan; you might find a surprise. You might find something that's not really special but is kind of beautiful, like a scrap from a boat. Value Village is like that. I use it as a generator, a trigger, or a vast archive.

Before I discovered Value Village, as the world in a capsule, I used to go to the library's picture files. The librarians don't do this anymore, but they would clip pictures. Then they would put them in files with categories, like "log cabins" or "horses" or "women with funny hairdos."

I would go to the library with a vague, unnamed interest. I'd follow this tiny scent, something to do with large noses, and there would be a file called "large noses." As I go through it, [I see] the variety of large noses is much greater than I could ever imagine, and then everything opens up, and a work begins there, in a way.

How important is the story or the history of the found object to your work?

To a degree, I look for found objects and include them in my work, but sometimes they're just models. If you're in a life-drawing class, you don't know the model's name; you're

not looking for the person there. You're looking for the shape of the body and the way the light reflects off the skin, and you're learning how to draw, or you're practicing looking and doing because that's a bit of a skill. Often, when I'm looking and bringing things back [to the studio], their provenance or their life story is not that important.

For example, with the paper-bag works, not any paper bag will work because some have a shiny surface that makes the mold shiny, and I don't like that. Sometimes the physical characteristics of something are determinate. These works on the wall are using found objects in a way that I haven't yet explored to this extent. In this case, I'm finding things, or people are giving me things, and again it's not about that thing; it's about the status of that thing at this point in time.

Most of [the things I use] are objects with some degree of specialness or uniqueness, or maybe there was only one because it was homemade or handmade. [About the stuffed] polar bear: it comes from the Inuit in the Arctic, who have tried various ways to produce objects that are for sale to the south. They're not quite for tourists; they're good cultural artifacts. The Cape Dorset prints were very successful exports but certainly not traditional; the Inuit did not know how to do lithographs before the White man went up there.

The polar bear is part of that [cottage] industry. It can be made at home—you can get fur (it's not polar-bear fur; it's probably rabbit fur or could even be cat fur)—and that polar bear is unique. The person who made it might make

one hundred in her lifetime, and they're sold at airports. Maybe they disappear to Germany. They're not museum objects; they might not even be memory objects. They might be symbols or signs of a lifestyle or conditions that someone admires.

[Visitors] think Canada is snow and freedom and nature, but if they're in Toronto or Montreal, it's dirty snow, there's no freedom, and there's no nature. When they go to the airport, they don't want to give up that original thing that they were seeking, and they take a polar bear home. I found a polar bear that was probably purchased for that reason; it's been used, it's a bit beaten up, and it's been cast away. But there's something about that polar bear: it doesn't go in the trash. A mass-produced Beanie Baby that's been overused goes in the trash, but that polar bear goes into a secondhand junk store—not a high-end collectibles store—and I find it there.

Its persistence is interesting to me, and it still has some of the qualities that help it survive, that help it persist. I keep that for some reason.

It was more an object in a category rather than a person tied to a story.
It's not personal. It's a condition, status, structure, or system. Objects flow through systems, and we use, waste, and wear them out. [Objects] also send stuff out as they're going through the system. There's a give and a take; every object gives something to us, and it takes wear and tear. Then it comes out the other end, called the waste stream. Even the waste stream doesn't quit; there's still somebody trying to sell something that's

completely worn out for a nickel. I'm interested in that: there's still some life left in the thing. It's a capitalistic life, a life in capitalism, that remains.

I pay for everything. Sometimes the little price ticket says, "50 cents"; then that's crossed out and it says, "25 cents," and that's crossed out, and it says, "free." The process that's really interesting is how we value things. For some works, I have found things on the ground, like a used cigarette butt. One year, I was focused on the [street] gutter, looking for crumpled-up cigarette packages, bottle tops—little bits of things that had come from intense experiences.

Cigarettes are very intense [objects] because usually [the person who used them is] addicted. An addiction is well served by the system: there's this perfect little box, it's affordable, and the government makes sure it's still affordable. You can feed your addiction in small increments, which are beautiful, too, because a cigarette—the tube, the length of the cigarette (if I'm talking industrial design)—is one of the most perfectly designed objects. If the tobacco doesn't have the paper, the tobacco is lost to the wind, and if the paper doesn't have the tobacco, the paper is [easily] crushable. Together they make a beautiful marriage.

I love the object of a cigarette. [It reveals] a relationship to humans, a system. I find it in its waste state, when that interest, passion, desire, and intensity is spent, and there's all this stuff. I bring these things into the studio and pay attention to them—which is my main talent, which I'm trying to foster—and through that effort I'll change their status. I'll resurrect them from the dead and bring them up into this quite-high-status activity that I'm involved in, turning them into a sculpture. And then they go out [to the world] again. ∎

History Painting

Kerry James Marshall talks about history painting and how his work addresses invisibility in that grand narrative tradition.

Interview by Susan Sollins at the Art Institute of Chicago on January 28, 2000.

Art21— How do you feel about this painting from 1994, *Many Mansions*, and about it being part of the Art Institute of Chicago's permanent collection? Are you satisfied with it as a work, after all the other works you've produced between then and now?

Marshall—Well, how I feel about the painting and how I feel about it being a part of the Art Institute's collection are two separate issues for me. Being in the Art Institute's collection is a great honor for me. It was something that I strove for, ever since I decided I wanted to be an artist. One of the reasons I became an artist was because I was impressed with some things by other painters that I had seen, or other artists that I had seen. And so, part of my ambition had always been to be included in the collection, alongside all these other artists that I admired, and which has so many things that I really love, things that I come to see all the time.

But how I feel about the painting is another thing. I mean, it's a painting that I like a lot. But when I come to look at my work in the museum, I come essentially to analyze it, to check and see if it still works or holds up the way I thought it held up when I finished it. So, I come to take a critical and analytical view of my work. I mean, when you look at a painting like *Many Mansions*, which I finished back in 1994, and consider where I am now, in 2000, I'm so much further ahead of where I was then. Obviously, when I look back on it, I have to take into account that it was made at a certain stage in my development, when I was interested in issues that I may have fully explored by now. But, I'm satisfied that it still seems as fresh to me now as it did when I completed it, six years ago.

Seeing it for the first time, something about the painting seems very familiar.

Well, the painting is built around what you could call a very Renaissance, architectural, or geometric structure. The most obvious thing you can see is this pyramidal, triangulated structure that the figures are fitted into. If you look at the painting, you can map out the grid on which all of those things hang, and then you look at the way the movement is created through these angles that cut across it. One

of the reasons I used that structure was because, when I started out, the artists and works that I really admired—like Géricault's *The Raft of the Medusa*—that whole genre of history painting, that grand narrative style of painting, was something that I really wanted to position my work in relation to. And so, in order to achieve a similar kind of authority that those paintings had, to fit them into a tradition of grandeur that those paintings represented, I had to adopt the similar structural format to develop my painting.

The subject matter seems in some ways less dramatic than the kinds of subjects represented in traditional history painting. But that's also a part of what the painting is about. It's about those figures being represented that way: the relationship between this representation of figures and the absence of those kinds of representations in that historical tradition of grand narrative history painting.

Why do you use such a flat black color when painting your figures?

I initially developed that unequivocally, emphatically black figure to function rhetorically in the painting. That kind of extreme is a rhetorical device that you go to when you want to emphasize or highlight a certain point. And one of the things that I had been thinking about when I started to develop that figure was the way in which the folk and folklore of Blackness always seemed to carry a derogatory connotation. So, you saw a lot of very negative stereotypical representations of Black people, especially in the nineteenth- and eighteenth-century images, and even

into the twentieth century. A part of what I was thinking to do with my image was to reclaim the image of Blackness as an emblem of power, instead of an image of derision.

It also dovetailed with some things I was reading at the time. One of the books I was reading when I started to develop that image was Ralph Ellison's book, *Invisible Man*, in which he describes the condition of invisibility as it related to Black people in America. The condition of invisibility that Ralph Ellison describes is not a kind of transparency, but it's a psychological invisibility. It's where the presence of Black people was often not wanted and was denied in the American mindset.

And so, what I set out to do was to develop a figure or a form that would represent that condition of invisibility, where you had an incredible presence, a way in which you could be seen and not seen at the same time. And I started with an image that was a black figure against a black ground, where there was only the slightest variation between the value of the figure and the value of the ground that it was painted against. The only distinction was that the temperature changed in the quality of the blacks. I'd paint a warm black figure against a cool black background. And that temperature change created enough of a perceptual difference that you can identify the figure at some angles, but at other angles

Kerry James Marshall viewing *Many Mansions* (1994) at the Art Institute of Chicago, 2000. Production still from the *Art in the Twenty-First Century* Season 1 episode, "Identity." © Art21, Inc. 2001.

it would completely disappear.

And it started with the first painting I did way back in 1980, a painting called *The Portrait of the Artist as a Shadow of His Former Self*. It was the first time I used this highly stylized, simplified representation of a black figure, in concert with all of these compositional and stylistic devices that I had learned from studying Renaissance painting. And it was the first painting I had ever done where I felt like I was completely conscious of and in control of all of the aspects of the painting I was assembling to make the representation. I understood the effect of all of the devices I was using on the overall concept of the painting. And so, that painting was one that established the black figure as a mode of operating for me. It was highly stylized and incredibly flat, then.

But over time, as my thinking about this became more complex, the representation needed a change and became more complex itself. It needed to start to be more than simply a two-dimensional kind of image; it started revealing a lot more subtlety and detail. And that's where I arrived when I did *Many Mansions*, where the figures still are unequivocally black. But there are highlights in the [paint] film that give you some variation and that reveal something of the individual identities of all of the figures represented there. You can't say that simply because they're painted with black paint that they all look alike.

A part of this was to challenge certain stereotypical assumptions or representations of Black people— that they can be represented by being called *Black* as a monolithic group, although I can't say that I believe for a minute that anybody really thought that, even though it's a convenient way of categorizing a population, singling them out for political and social discrimination. It's very convenient to think about people in blocks and in groups.

So, part of what I was doing was to challenge some of that by giving a very simplified reduction initially, but upon closer inspection you have to come to terms with the fact that there are incredible differences embedded inside this apparently simplified and stylized representation. Each one of those figures is based on somebody, some particular somebody—not a person that I want anybody to know, but what I do want you to know is that there is some difference between all of these representations, even as they seem to be simplified and reduced to what appears to be a stereotype. ∎

Layering Histories

Julie Mehretu discusses her process of layering and mark-making, and the different references embedded in her large-scale paintings.

Interview by Ian Forster at the artist's studio in Harlem, New York, on July 9, 2017.

Art21—For the project at the San Francisco Museum of Modern Art (SFMOMA), where did you begin, in terms of research? Did you research the specific site?

Mehretu—I went several times to visit the museum, and on maybe the second or third site visit, I was staring at two walls. There was no staircase [yet], just the plan for it, and there was this big empty space. I had seen architectural renderings of the plan for the lobby, and I started to think about how these two walls existed in this cavernous space of the construction site.

Being in San Francisco—in that majestic, beautiful, overwhelming landscape—I kept thinking about these spaces as being a type of sublime, mega space. [Looking at] this clean, cavernous, open space with these two walls, I saw a projection of this landscape. I started to think about the national parks—how there are vistas that you look across or toward— and representations of that. Immediately I started to think about representations of the landscape in American landscape painting.

When I came back [to New York], I was thinking about the Hudson River School painters who continued the westward nineteenth-century expansion, the American colonial project. But at first, my project wasn't about that concept; it was more about an attraction to these paintings that kept coming back to me.

I went to the Getty [Center], and I looked at all these [Carleton] Watkins photographs and [works by Albert] Bierstadt, Thomas Cole, [Frederic Edwin] Church, and others who were painting with this language. Although those paintings aren't very big, they encapsulate the idea of that project: the American awe and fear of that landscape, the place of an individual inside that context, and the [doctrine of] Manifest Destiny and limitless possibility in going westward.

Later, in studying [the period], talking to other people, and doing some more research, it became clear that this was happening at a tumultuous time in the U.S.—not just the effort of capturing the sublime in all its manifestations and the deep minuteness of the individual in that context but also the horrific, atrocious violence that

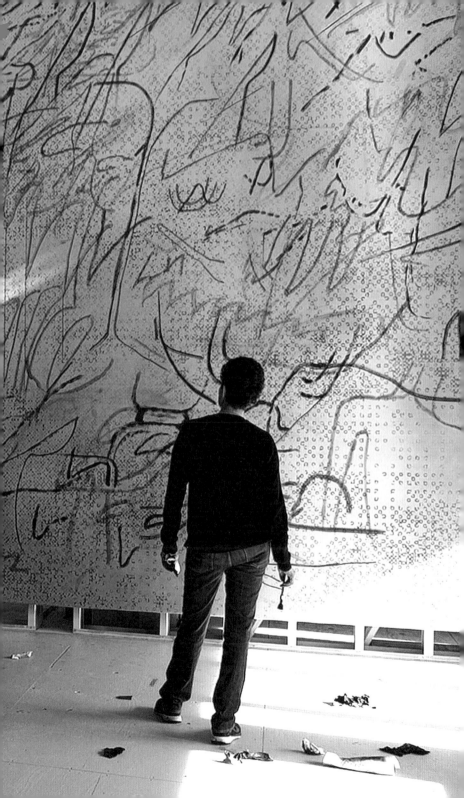

took place in that same landscape. In that moment, there were efforts to protect national parks, the effort to move toward emancipation and the Abolitionist Movement—all of these gestures taking place at the same time—and the Civil War was just before that. All of these social dynamics are part of that narrative, but we don't talk about them often, in regard to those paintings.

That came up as a point of departure. I kept thinking, as [people] climb the [SFMOMA] stairs, [they] would be on one platform looking across to another, and it reminded me of images of the Grand Canyon—although I've never been there—or when you drive [along] the Hudson and look across to the other side. I had an intuitive attraction to this rich context for these paintings.

San Francisco, then, as a site, became really important because it was the destiny, the [end] point. I was thinking about the history of San Francisco and [Eadweard] Muybridge and Leland Stanford and how that area started to develop and what it is now, as a tech center and what it offers in terms of that infrastructure, globally. [My project] in a sense offers another lens: it's the reversal of the nineteenth-century project of going out west, [developed from] thinking about those images and locating them in San Francisco, geographically.

I took several paintings that I was most attracted to and reduced them to 8-bit images in Photoshop

with the help of Damian Young, who worked closely with me in this process. I had an archive of images of race riots, [including] the 2014 London riots that exploded that same summer as the Gaza war and the many that took place in New York after various acts of police brutality and the explosion of the Black Lives Matter movement.

I wanted to find some way to immerse and change what these 8-bit renderings were for the paintings, as a sketch. I started to layer the blurred color images of these news photographs into these historic landscape paintings.

I created two of them, and they changed quite a bit, but they became the underpaintings. Each one has two different landscapes layered into it, as well as one part of an upside-down landscape, and they have all these different photographs and events. The color and light of those inform that landscape. The toxicity of the color, the intense oranges of the sirens and the flames, became infused [in these] images [and were] a place for me to start.

In a way, you're taking these two parts of American history—that we often think of as being separate—and compressing them.

[Focusing on] the cyclical dynamic of these narratives, for me, was a way to embed the paintings with some meaning—that didn't have to be read or identified by anyone else—a type of DNA or information inside the paintings, so that I could respond from a deeper place. I wanted to deal with this intense aspect—the violent part of this history—and put it

Julie Mehretu

into the paint, into that structure, [while] thinking about how you deal with those two realities, in this moment, and how these things come back, in cycles.

I had just read Colson Whitehead's *The Underground Railroad*, which also infused my thinking of the American landscape; I couldn't look at these paintings and not think about that narrative. I don't think it's possible for me to think about the American landscape, or the narrative of it, without thinking about the colonial history and the colonial violence of that narrative as well. So, those [ideas] were all brewing in the work.

While we were filming you working on the painting, you looked a couple of times at an image of a lynching. In the news today, there are so many images of Black deaths and brutality, and in seeing those images there's a fine line between being a witness to violence and being a voyeur. What's the role of abstraction in your process?

It's a complicated dynamic, and there are complex issues of representation and what it means to try to deal with that content. What I became interested in was how, in many ways, these images [contained] fragments of the body.

I started to think about that within a much bigger picture. In [remnants of] antiquity, there are disembodied parts, [like] the foot of the colossal [statue of] Constantine in Rome, or the hand or the knee or parts of the torso. These different aspects of antiquity were then represented in Venetian, fifteenth-century, Renaissance painting, and Caravaggio and others worked with this information as well, and they have evolved in [subsequent] representations.

I also looked at the history of American landscape painting, the depictions of that [time]. It's a horrific history. Some photographs of the massacre at Wounded Knee are horrific to see, but in many ways these are images of war, of terror and terrorism, of colonialism. That history has been a part of the archive that I've worked with for a long time.

But I don't tend to watch the videos of the [recent] shootings. There are certain moments that I will watch because I think it's my responsibility—our responsibility—to be a witness. But it is complicated. How do I construct or make images in ways that deal with things that we don't have proper language for?

What's happening politically in the United States—this reinforcement, reengagement, rekindling of that [expansionist] dynamic, for Trump to become president—is in many ways not only destabilizing but also affirming. Coming on the heels of brutal killings and executions of Black people in this country, there is something in all of that language: the discomfort is visceral, deep in the core of your being, when a person speaks so horrifically toward another. There's a loss in that, a feeling of being lost, like we don't have the language to deal with this political reality.

Trying to develop an aesthetic—a language, a way of making images, a way of being creative—in this moment feels

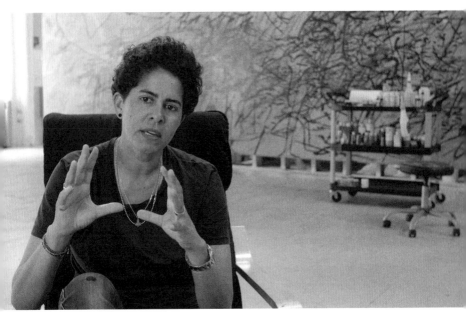

Mehretu interviewed at her Harlem studio, 2017. Production still from the Art21 *Extended Play* film, *Julie Mehretu: Politicized Landscapes.* © Art21, Inc. 2017.

really complex. I feel like these paintings, because of their scale, are dealing with that. They're not about perspectival space or the rationalism of Renaissance space or the space that happens on a screen. They're a mesh of those various types of spaces. They're not about reading a landscape or about gestural abstraction by itself. They're an enmeshment of different types of language. The paintings don't necessarily quote one artist or another, even though the DNA of those Bierstadt and Church paintings is part of the infrastructure. There are moments where you can think of a [Philip] Guston mark, or an Albert Oehlen element, or [Arshile] Gorky, Paul Klee, or whoever comes to mind; there are various artists that you can pull from, but they disappear quickly. It's like trying to invent a form of language, but you can't completely invent it in this language that we've been working with for thousands of years.

When language is not enough, what have you found the role of painting to be?

For me, painting has been where I feel most capable and creative, where I can access a place of invention, and where I feel most potent. I get excited about what a painting can do and how it can participate within this complex social, political, historical moment. How do you push the boundaries

of the gesture, the mark, and the history of what it means to make a mark or a trace? What else can it possibly be in this moment, and how else can we think about that?

While these [works] have a relationship to [Joachim] Richau or [Cy] Twombly or even [Jackson] Pollock and gestural mark-making, they're not about the expressive gesture. They're trying to do something else. They're not about writing even though sometimes [the marks] mimic writing or graffiti. There's a different trace: one that is quoting that language, sampling that, and then morphing it into something else.

There are moments when [the works] refer to Renaissance ascension paintings and other moments when they feel digitized; there's this different dynamic of what's happening in all that information. They're not graspable. The paintings break down into smaller paintings, but they're not—at least for me, yet—something I feel like I can holistically hold and give any full articulation of what's happening.

Erasure seems to be a huge part of the process. Can you tell me about the mark-making?

I try to work as intuitively as I can, so I spend a lot of time looking at the painting. When I'm working, usually I'll do a bunch of marks, and erase them, and do a bunch more, and erase them, and then eventually my head's immersed in what I'm trying to do. Those are the most exciting moments, and that's when I'm deeply engaged in working creatively.

That's the work I'm interested in.

Every mark that feels self-conscious is erased, usually. As much as I draw, I erase. I erase a lot more than what ends up in the painting. Sometimes, I'll erase [a mark] immediately; other times, I have to go back and sand it out. There are whole quadrants of these paintings that I've sanded back to the surface and then reworked. If a part of the painting feels like it's too self-consciously trying to do something, that's when I tend to pull it away. ∎

Setting a Good Corner
Bruce Nauman discusses the hard work and exactitude of *Setting a Good Corner.*

Interview by Susan Sollins in New Mexico on August 21, 2000.

Art21—You've made a number of works on video that have a built-in continuous loop. Like the video work from 1967, *The Artist is an Amazing Luminous Fountain*—the text, spoken and onscreen, seems to repeat endlessly. This is a curious use of video, especially when compared to the way that most things seen on television are narrative driven.

Nauman—When I was making that piece a lot of people were thinking about how to structure time. John Cage was making different kinds of ways of making music, and Merce [Cunningham] was structuring dance in different kinds of ways. And then [Andy] Warhol was making films that went on for a long period of time. And Steve Reich and La Monte Young were making music that was structured in a very different way. So, it was interesting for me to have a lot of ways to think about things.

And one of the things I liked about some of those people was that they thought of their works as ongoing. And so, you could come and go, and the work was there.

There wasn't a specific duration, so this thing can just repeat and you don't have to sit and watch the whole thing. You can watch for a while, leave and go have lunch or come back in a week, and it's still going on. I really liked that idea, of the thing just being there, so that it became almost like an object that you could go back and visit whenever you wanted to.

The video *Setting a Good Corner* seems to have a similar sense of duration, of something just being there and continuing along its own logic.

This is a completely different situation even though this is a new work, or a newish work, it comes from some thoughts about earlier work—where you could control the length of the film or videotape or activity by having a specific job. You began when the job started; and when the job was over, the film was over. And that became a way of structuring it without having to think about it, other than deciding what the job was that you were going to call the work.

What was the specific job in *Setting a Good Corner*?

In this case, we're building a corner to stretch a fence and hang a gate. It had a real purpose on the ranch here; I needed to do this. But at the same time, it made a beautiful

structure, and it also was one of these things: "Well, here's the job and..."

Is this where the text at the beginning and at the end of the video come in? The text at the beginning seems to describe what your activity is while the text at the end is more of a criticism of the project, of how well you made the corner.

I showed my partner Bill Riggins the tape, and he said, "Boy, you're going to get a lot of criticism on that because people have a lot of different ways of doing those things." And so, I put down some of the things that he said—about keeping your tools sharpened and not letting them lie on the ground, where they get hurt or get abused and dirty, and you can't find them. And some thoughts about how his father used to do things— how these things, if you grow up with them, you learn them in one way.

Was it the activity that you thought would make a good video, or was it the way in which you framed the shot or the colors—that sort of thing?

I don't know, and I wasn't sure when I finished it if anybody would take it seriously. It turned out to be kind of interesting to watch. I gave a certain amount of thought to how I set up the shot and then after that... That's not an uncommon way for artists to proceed. And then what makes the work interesting is if you choose the right questions. Then, as you proceed, the answers are what's interesting. If you choose the wrong questions and you proceed, you still get a result, but it's not interesting. And so, that's in there.

I think I learned some of that from Sol LeWitt, who does a lot of that. He builds a structure that you have to work with, and the work could come out different every time. But if you follow the structure, it's interesting—sometimes beautiful and sometimes just interesting.

How you determine the right questions in order to proceed?

Well, that's the art part, and that's what you don't know. That's the hard part. And sometimes the question that you pose or the project that you start turns into something else. But at least it gets you started. And sometimes you finish, and you look at it and say, "I got a bad result. I don't like what came out here." And so, you have to start over or change it somehow. We were having dinner with the Tuttles, Richard and Mamie. And I had said that about Sol [LeWitt]—that he was interested in finding these questions and setting them up and seeing what happened. And Richard said, "Well, that's the difference between us, because I already know the answers." I was driving home with Susan [Rothenberg] and I thought, "I forgot to ask him what they were." I was just so amazed.

So, when you were making the fence, even though you were filming it, you were mainly interested in doing the task well?

Yeah. I mean, if the fence is going to last, it has to be done well. And so, you want to do a good job. Other cowboys and ranchers are going to come around, and they'll see it and they'll say, "Well, that... that's a good one." Or, "That's not a

good one." It's when you go to work at somebody else's place, and the gates all work; or you have to get out of the truck, or off your horse, and drag them around and make a lot of extra work for yourself because nobody wants to spend the time to fix them up and make them work better. I have a lot of other things to do. So, if I'm going to do it, I'd like to get it right. So that, when I have to use it, it's just there and it's useful and useable, and I'm not wasting time with a lot of extra baling wire and stuff, patching it every once in a while.

Is there a meditative aspect to this kind of hard work?

You have to adjust yourself to it because it's hard work. And when I was digging that hole, the ground was extremely dry. The ground was very hard, like chipping limestone. And so, you adjust yourself to the task. And if you go out there and say, "Boy, I just hate doing this, and I got to get it done," you're probably not going to do a good job. And you might just forget, not even bother. But if you can find that spot—I suppose it's like running; I used to be a swimmer and swam laps—you just have to be there with what you're doing. Your mind could go a lot of other places, but your body has to be there with what you're doing. It's good discipline.

In the studio, I don't do a lot of work that requires repetitive activity. I spend a lot of time looking and thinking and then try to find the most efficient way to get what I want, whether it's making a drawing or a sculpture, or casting plaster or whatever. But part of the enjoyment I take in it is finding the most efficient way to do it—which doesn't mean corrections aren't made. I like to

have a feeling of the whole task before I start, even if it changes.

Is there anything you'd want a viewer to take away from this work?

It's probably the part that I can't say. It's the part that makes it art and not a "how to do it" tape. If you're an amateur artist, you can get it sometimes and not other times, and you can't tell, and you can't always do it over again. And the part about being a professional artist is that you can tell, and you can do it over again, even if you can't say how you got there exactly. You've done it enough, and you know how to get there. I don't have any specific steps to take because I don't start the same way every time. But there is a knowing when it's enough and you can leave it alone. You could go on and maybe make some changes. They could ruin it, and they aren't going to necessarily make it better. They're just going to be different. And that's what keeps me in the studio, the not-knowing part and always being surprised. ■

Color, Surface, and Seeing

Robert Ryman shares the reasoning behind his white squares and the viewing experience they incite.

Interview by Susan Sollins at the artist's studio in New York City on December 13, 2006.

Art21—**Can you talk about the way you use the color white in your paintings?**

Ryman—White has a tendency to make things visible. With white, you can see more nuances. If you spill coffee on a white shirt, you can see the coffee very clearly; if you spill it on a dark shirt, you don't see it as well. So, it wasn't a matter of the color white; I was not interested in that. I started to cover up colors with white in the 1950s. In 2004, I did a series of paintings in which I was painting the color white. Before that, I'd never really thought of white as being a color.

That's a long time to use a color in that particular way.

Until then, it was just that white could do things that other colors could not do. If I look at some white panels in my studio, I see the white, but I am not conscious of them being white. They react with the wood, the color, the light, and the wall. They become something other than just the color white. That's the way I think of it. It allows things to be done that ordinarily you couldn't see.

How?

If the panels were black or blue or red, they would become a different thing. You would see the color, and the panels would become more like objects themselves and more about that color. But white is such a neutral situation that, when you see it, you're not thinking "white." You're just able to see something as what it is.

How important is surface in your work?

Not working with illusion or narrative allows me the freedom to explore. The painting can be very thin, very close to the wall. Sometimes it can come away from the wall. I think it's important that it stay connected to the wall; I think it needs the wall to be complete. But it opens up many possibilities.

Is there any specific ideology or kind of thinking that could be connected with your work?

Existentialism. Years ago, I read a lot of it. I liked and agreed with it. But I don't know how much it has to do with my painting. It's kind of senseless to look back. I mean, I'm always involved with tomorrow and today, not yesterday. I'm always thinking about tomorrow.

Does that affect your painting?

In painting, you always have a structure. You have to have that in

order to go forward, to put things together. My painting is not limited at all. I have many possibilities, in terms of approach, because I'm not limited by a narrative that I want to get across. There's no symbolism or story that I need to tell or political project that I might want to do. I'm not limited by any of that. I don't have any of those things to stop me from experimenting and going forward.

So, you're constantly finding new ways to do things.

I like to do something that I don't exactly know how to do. I don't like to do things that I know I can do. If I take a certain approach to finish a problem in a painting, I don't have to go on with it. I'm more interested in finding what else I can do that's more of a challenge for me.

How did you arrive at painting mostly squares?

I began with the square in the 1950s. The square has always been an equal-sided space that I could work with. It's become so natural to me that I don't think of it any other way. It doesn't have the feeling of a landscape or some kind of window or doorway that we usually associate with rectangles. It's a neutral kind of space, and it feels right to me because of my approach to painting.

Do you think your work asks for a certain type of viewing situation?

In a sense, the paintings move outward aesthetically: they go into the space of the room. They're involved in that space, and they involve the wall. So, if you have something else next to the painting— for example, if the painting was on a brick wall—that would not be good. There would be a lot of visual activity going on, along the wall, and that would dilute the painting. A brightly colored wall would also change the painting—particularly some of those that are on translucent material or the ones with waxed paper or plastics. All of that changes the feeling of a painting. It needs to be on a neutral, smooth surface. Even though light is important, it doesn't have to be special light.

But the painting needs a certain reverent atmosphere to be complete. It has to be in a situation so it can reveal itself. What you are seeing is what it is, on its own; it's not representing anything else. It has to be in a certain visual situation because anything else will dilute or disturb it. The paintings do not signify anything other than how they work in the environment.

Some people say they look like clouds or that they look blank. But that's because they're looking at them as if they were pictures of something. So, of course they're going to see nothing, or they're going to see something that is white. I don't have any control over that.

Why are your series often produced in odd numbers?

It has to do with the way we see things. Aesthetically we see things in a certain way. I like odd numbers because there is always a center with an odd number. With an odd number, there is an expansive feeling, of things moving out from the sides. With an even number, the wall is the center, so it's more of an enclosed feeling; it doesn't move outward as much as the odd number does, which is okay. But certain things have different feelings, visually. If I have ten elements, the number is

not so crucial because I have enough that I don't really need a center. A triptych is ideal because there is a center. A diptych is always a problem; they never seem to work very well. It's just the way we see things.

How do you approach making a painting?

My approach tends to come from experiments. I need the challenge. If I know how to do something well, there's no need to do it all the time because it becomes a little monotonous. So, I like to find a challenge. Of course, all these things are rooted in the basics of painting. It's not that I do anything crazy; I tend to work within a structure and see what other possibilities there can be.

Sometimes, after I finish a group of paintings, I'm not sure what to do next. Maybe I have to wait a while, a month or two months. I don't worry about it. Slowly things fall into place, and I try a few things, and then I realize what else could be done and what interests me at the moment. And then it begins again.

What's the process?

These recent paintings that I haven't completed yet, for instance, involved some large canvases that I did in 1999 in Pennsylvania. At the time, I lost contact with them: I didn't like how they were going, and I rolled them up and put them away. Last year, I brought them here and unrolled them to see what they were. I tacked them up on the wall, and I thought, "Well, maybe I can do something with these."

I painted on the canvas, which is now attached to wooden panels. It's a very different approach. Whereas the ones [with wood] that I painted on reflect the light in that outward way, these canvases absorb the light. They're very soft, very quiet. And the others are soft too, in a way. It depends on how they work with the light.

Each one looks so different.

Yeah, the wood panels all have the same paint—the sizing and primer. But they will act very differently with different light sources. If they were in a daylight situation, you would probably never see them the same way: they would be changing constantly because of the way the light would act with the surfaces.

Light is very important to you.

I use real light; there's not an illusion of light. It's a real experience. The lines are real. You see real shadows. If the paintings are seen in a daylight situation, it's very important where that light comes from; it's a matter of direction. In many museums, you see paintings under the same electric light all the time. If you go in the morning, it looks just like it does in the afternoon. Sometimes that's the best that you can do. But if you can get daylight that comes from above or opposite a painting, that's better because it changes with the clouds and with the sun moving, so you always see the work differently. If the light comes obliquely from the left or the right, that's not good because you get a raking light across the work. And it's a distortion of the painting. The right

Robert Ryman installing *Philadelphia Prototype* (2002) at the Pennsylvania Academy of the Fine Arts, Philadelphia. Production still from the *Art in the Twenty-First Century* Season 4 episode, "Paradox." © Art21, Inc. 2007.

lighting situation is important for all painting but particularly for my work.

Where does this attention to light come from?

From seeing things and looking at everything, particularly painting. Of course, painting is a visual experience, so it only happens when we see light.

Is the light something you think a lot about, when you work?

Yes. I think about it when I'm working because I look at my paintings under different lights, like bright [incandescent] lights and daylight.

New York has amazing light.

When I first came to New York, I don't think I noticed much about the general light in the city. (The best light is right after it rains: that soft reflective light.) But I would hang around and look at the lights in Times Square. That was something I had never seen before. The electric lights were fascinating.

Did you come to New York knowing you wanted to be an artist?

When I came to New York from Nashville, music was the most important thing to me. I was studying and practicing. But I went to museums, and for the first time, I saw paintings that interested me not so much because of what was painted but [rather] how they were done. I thought it would be an interesting thing for me to look into: how the paint worked and what I could do with it. I looked at everything. I didn't know anything about art. I didn't even know any artists. I accepted everything; I had no prejudice. If

[something] was in a museum, it was a good thing. When I got a job in a museum, it was ideal for me. That was a fantastic education.

Is music an influence on your work?

I came from music. I think that the type of music I was involved with—jazz, bebop—had an influence on my approach to painting. We played tunes. No one uses that term anymore; it's all songs now, telling stories—very similar to representational painting, where you tell a story with paint and symbols. But bebop is a more advanced development of swing. It's like Bach: you have a chord structure, and you can develop that in many ways. You can play written compositions and improvise off of those. So, you learn your instrument, and then you play within a structure. It seemed logical to begin painting that way. I wasn't interested in painting a narrative or telling a story with a painting. Right from the beginning, I felt that I could do that if I wanted to but that it wouldn't be of much interest to me. Music is an abstract medium, and I thought painting should also just be what it's about and not about other things—not about stories or symbolism.

You don't think of meaning in the work?

There is a lot of meaning but not what we usually think of as meaning. It's similar to the meaning of listening to a symphony: you don't know the meaning, and you can't explain it to anyone else who didn't hear it. The painting has to be seen; there is no meaning outside of what it is.

So, meaning is closer to an emotional reaction?

I think the real purpose of painting is to give pleasure. There can be a story; there can be a lot of history behind it. But you don't have to know all of those things to receive pleasure from a painting. It's like listening to music: you don't have to know the score of a symphony in order to appreciate the symphony. You can just listen to the sounds.

Do you think of your work as abstract?

I don't think of my painting as abstract because I don't abstract from anything. It's involved with real, visual aspects of what you are looking at, whether wood, paint, or metal: how it's put together, and how it looks on the wall and works with the light. The wall is involved with the painting. Of course, realism can be confused with representation. And abstract painting—if it's not abstracting from representation—is involved mostly with symbolism. It is about something we know or about some symbolic situation. I don't make a big deal about it. It just seems that what I do is not abstract. I am involved with real space—the room itself—real light, and real surface.

There's a challenge to the concept of objectivity in your work.

Well, I'm certainly not the only painter working this way. The Guggenheim Museum used to be called the Museum of Non-Objective Painting.

How does your work fit into the contemporary-art world?

I don't think of myself as being part of anything. I'm involved with painting, but I look at it as solving problems and working on the visual experience. I'm not involved with any art movement. And I'm not a scholar. I'm not a historian. I don't want to get into that kind of thing because it would interfere with my approach. So, it's better that I not think of that. ∎

Compressing Complexities

Defining his move into abstraction, **Jack Whitten** discusses his "slab paintings" and the impetus for the *Black Monolith* series.

Interview by Ian Forster at the artist's studio in Queens, New York, on October 25, 2017.

Art21—**What caused you to shift away from abstract expressionism at the end of the '60s?**

Whitten—In the 1960s, I started to develop what I call my autobiographical paintings: Jack Whitten putting Jack Whitten on the couch and picking my brain about all kinds of different symbols—sexual, spiritual—we have to do that. I spent ten years doing these autobiographical paintings.

It wasn't until the end of the '60s that I made a drastic change toward more conceptual ideas that dealt with the materiality of paint. I removed all the spectrum color from the studio, stopped working in oil, made a big move to acrylic, and restructured the studio and my thinking about painting. I explained it by changing the verb *to paint* to the verb *to make*—a big difference on how a painting is approached.

My background is one of process and materiality. It was 1970 when I made a big move toward process. I built a big tool, twelve feet wide, that I called "the developer." With that tool, I could move large bodies of acrylic paint across the surface of the canvas. The first of those were what I call "slab paintings" because that's what the acrylic became: a slab. It reminded me of when I used to go to the steel mills and saw slabs of hot molded steel coming out of the furnaces. My father was a coal miner, but when the miners were on strike or he didn't have work, he often got part-time work at the sawmills. Things that influenced my thinking on the slab paintings were a slab of hot rolled steel and a slab of pine, freshly cut at the sawmill.

The slab became the basis of everything that I do. I'm still working with that slab. The only difference today is that the slab has been deconstructed. I work with some concepts that are so complex that I have divided them into three separate processes: I speak of them as construction, deconstruction, and reconstruction. Through those three processes, I can deal with the complexity of it.

The slab led me to the tesserae. The tessera is a cube of acrylic paint that the painting is constructed from. I've traveled a lot in the Mediterranean area. I have lived in Greece, on the island of Crete, since 1969. Visiting the sites of ancient mosaics in Europe and in Egypt has influenced me a lot. All of that connected with African

art, early Greek Cycladic art, Minoan art—it's all had an effect on me.

How do you begin the process of taking all those various ideas and influences and starting a new work?

The key word is *compression*. These complexities are compressed, and that allows me to go directly to the subject. I do a lot of reading in science. Particle physics and astrophysics excite me. The ancient people knew about animist beliefs; they claimed that all matter had a life force in it. When we study particle physics and the workings of quantum mechanics, [we find] this stuff is active: science tells us that all the aspects of matter can be broken down into these little bits, and they're not static. I think there's something within that, which connects to what we need today, in terms of a worldview.

How can art help along those lines?

We [artists] are not scientists. I mention science because that's what excites me. Artists have to have something to fire up their imagination, and different artists have different things. My excitement is what's happening in science. I believe that art should reflect the period in which it's made. It's more and more obvious to me that it's evolution. As a painter, I think of painting as being organic; therefore, painting evolves. It evolves like other organic structures.

Another thing I like about quantum mechanics is that it breaks down the distinction between organic and inorganic, not only in a physical sense but also from a philosophical point of view. Racially, you're Black or you're White. Or sexually, you're

this or you're that. I prefer more of a fluid situation. I use *neither/nor*. I find it much more fluid, and it has more rhythm to it. The spirit does not have a chance to flourish in the kinds of environments we have today. People are exhausted, so they fall back upon old-fashioned, out-of-date symbols because it's easy; it doesn't require any thought or effort.

There was a book that became my bible in the late '70s: *The Dancing Wu Li Masters* by [Gary] Zukav. He knew of these complexities. The whole essence of the book is that once you realize the complexity of the world, your survival depends upon your dancing with it.

What's kept you going through the decades?

It's this life force—of wanting something that exists outside of dualities. That's what keeps me going.

How are the ideas in your sculptures different from the ideas in your paintings?

The sculptures began as what I like to call "research into identity." Instinctually I knew there was something in African sculpture that I had to learn. After reading a lot of books and visiting museums, I wasn't getting all the information I wanted. That's why I started carving wood; it started as an investigation into African sculpture.

How important is speed in your process, comparing the past to now? I was reading about how you invented certain tools and strategies to make fast marks. And your current process is much slower. Could you talk about that evolution, from working quickly to working slowly?

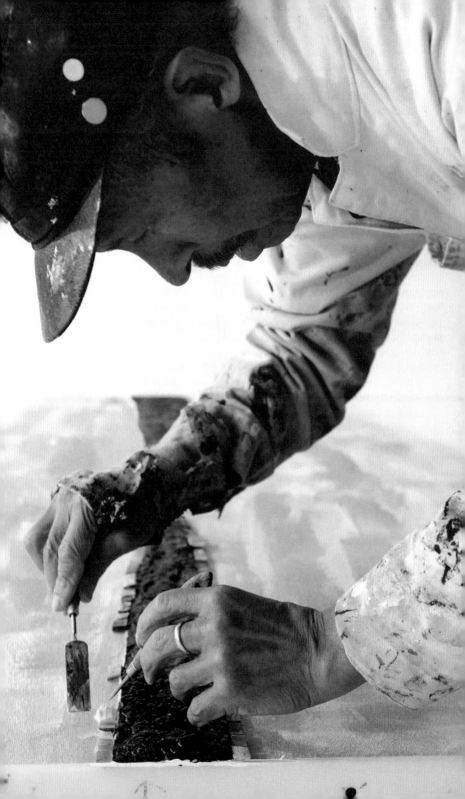

When you're younger, you don't think twice about doing something fast. You act. But there's another side of it conceptually. Photography has been the greatest influence on painting, more than anything. In 1964, I wrote on my studio wall, "The image is photographic; therefore, I must photograph my thoughts." I didn't know what it meant. It took me years of trying to understand what that was about. I got a lot of help from the scientific community about the nature of light, photons, "molecules" of light...

The other side of the speed factor was my hanging out with Bill de Kooning, as a young painter. I had to get away from being under his thumbs—I knew I had to go faster than the motherfucker. With de Kooning, we always speak of incredible speed, but it wasn't fast enough for me. It was still relational: one mark in relation to another mark. So, I came up with the bright idea of a non-relational mark. I wanted a painting to exist as a single line, as one gesture. That's why I built the developer. I don't think there's anybody in the history of painting who has done a painting faster than Jack Whitten: one gesture, three, four seconds at the most, one single movement. Speed is something that we can use to overcome gravity. That's what our rocket ships do, right? We can overcome gravity, but we need speed, thrust, and power to do that.

With the slab, I discovered that paint could be used as collage, and that led me to the discovery of the tessera. It's a bit of information; I can build anything I want with it. It's slow, but it separates me from a lot of the shit that's going on. I'm finding, as I get older, it serves as meditation. The slowness is a salvation: I sit there, and I do my thing. I don't want to make thirty paintings. If it's slow, we just have to wait.

Often people ask me, when I'm doing this, "How do you know where to put each tessera?" I'm reacting to what painters call the density of light, to every color as a density. I'm applying pressure that directs the light where I want it to go. These are not put in [one] flat [plane]; they are put in such a way to direct the light. This is why I speak of different dimensions.

Where did the term *Black Monolith* come from?

From the back porch at my house in Greece, I can see a huge rock, up in the mountains. It's a monolith. It comes up out of the earth, and that damn thing has really inspired me over the years. That's where it started, back in the early '80s. The idea came out of that rock; it's massive.

Each *Black Monolith* begins with a Black person who has contributed a lot to society: scientists, musicians, sports figures, writers. It's something that I plan to do for the rest of my life because in the Black community, we have people who have contributed. I know it's not advertised a lot, but we have creative, successful people who've given back to society tremendously. These are not simplistic narrative paintings. The story's in the paint. ∎

Jack Whitten at work in his studio, Queens, New York, 2017. Production still from the *Extended Play* film, *Jack Whitten: An Artist's Life*. © Art21, Inc. 2018.

Biographies of the Artists

Diana Al-Hadid

Diana Al-Hadid was born in 1981 in Aleppo, Syria. She was raised in Cleveland, Ohio, and lives and works in New York. Al-Hadid's large-scale sculptures and wall hangings are the outcome of process-based investigations into materials, including fiberglass, polymer, steel, and plaster.

Exploiting the innate tension between mass and gravity, Al-Hadid is particularly interested in the point at which her works are fixed to the ground, often seeking to create what she describes as "something that seems improbable." Having made drawings since her adolescent years, Al-Hadid creates meticulous renderings driven by a fascination with the depiction of space and perspective. While critics often cite Al-Hadid's Syrian background as influential to her ornate works, the artist is just as likely to make references in her work to ancient Rome, the Renaissance, or Mannerist painting.

El Anatsui

El Anatsui was born in Anyako, Ghana, in 1944. Anatsui lives and works between Nigeria and Ghana. Many of Anatsui's sculptures are mutable in form, conceived to be so free and flexible that they can be shaped in any way and altered in appearance for each installation. Working with wood, clay, metal, and the discarded metal caps of liquor bottles, Anatsui breaks with sculpture's traditional adherence to forms of fixed shape while visually referencing the history of abstraction in African and European art.

The colorful and densely patterned fields of the works assembled from discarded liquor-bottle caps also trace a broader story of colonial and postcolonial economic and cultural exchange in Africa, told in the history of cast-off materials. The sculptures in wood and ceramics introduce ideas about the function of objects in everyday life—their destruction, transformation, and regeneration—and the role of language in deciphering visual symbols.

Ida Applebroog

Ida Applebroog was born in the Bronx, New York, in 1929 and lives and works in New York. Applebroog has been making pointed social commentary in the form of beguiling comic-like images for nearly half a century. Anonymous "everyman" figures, anthropomorphized animals, and characters that are half-human/half-creature are featured players in the uncanny theater of her work. She sometimes employs curt texts to skew otherwise banal images of everyday urban and domestic scenes into anxious scenarios infused with irony and dark humor. Strong themes in her work include gender and sexual identity, power struggles both political and personal, and the pernicious role of mass media in desensitizing the public to violence.

Applebroog propels her paintings and drawings into the realm of installation by arranging and stacking canvases, exploding the frame-by-frame narrative logic of comic books and films into three-dimensional environments. In addition to paintings, Applebroog has also created sculptures, artist books, several films (including a collaboration with her daughter, the artist Beth B), and animated shorts that appeared on the side of a moving truck and on a giant screen in Times Square.

John Baldessari

John Baldessari was born in National City, California, in 1931 and lives and works in Venice, California. Synthesizing photomontage, painting, and language, Baldessari's deadpan visual juxtapositions equate images with words and illuminate, confound, and challenge meanings. He upends commonly held expectations of how images function, often by drawing the viewer's attention to minor details, absences, or the spaces between things. By placing colorful dots over faces, obscuring portions of scenes, or juxtaposing stock photographs with quixotic phrases, he injects humor and dissonance into vernacular imagery.

For most of his career, Baldessari has also been a teacher. While some of the strategies he deploys in his work—experimentation, rule-based systems, and working within and against arbitrarily imposed limits to find new solutions to problems—share similarities with pedagogical methods, they are also intrinsic to his particular worldview.

Mark Bradford

Mark Bradford was born in 1961 in Los Angeles, where he lives and works. Bradford transforms materials scavenged from the street into wall-size collages and installations that respond to the impromptu networks—underground economies, migrant communities, or popular appropriation of abandoned public space—that emerge within a city.

Drawing from the diverse cultural and geographic makeup of his southern Californian community, Bradford's work is as informed by his personal background as a third-generation merchant there as it is by the tradition of abstract painting developed worldwide in the twentieth century. Bradford's videos and map-like, multilayered paper collages refer not only to the organization of streets and buildings in downtown Los Angeles but also to images of crowds, ranging from civil-rights demonstrations of the 1960s to contemporary protests concerning immigration issues.

Tania Bruguera

Tania Bruguera was born in 1968 in Havana, Cuba, and lives and works between Havana and New York. Bruguera, a politically motivated performance artist, explores the relationships between art, activism, and social change in works that examine the social effects of political and economic power. She defines herself as an initiator rather than an author, often collaborating with multiple institutions and individuals toward the full realization of her artwork:

when others adopt, adapt, and perpetuate her proposals and aesthetic models.

Bruguera expands the definition and range of performance art, sometimes performing solo but more often staging participatory events and interactions built from her observations, experiences, and interpretations of political repression and control. Advancing the concept of Arte Util (literally, "useful art"; art as a benefit and a tool), she proposes solutions to sociopolitical problems through the implementation of art. She has developed long-term projects that include a community center and a political party for immigrants and a school for what she calls "behavior art."

Cai Guo-Qiang

Cai Guo-Qiang was born in 1957 in Quanzhou City, Fujian Province, China, and lives and works in New York. His work is both scholarly and politically charged. For his work, Cai draws on a wide variety of symbols, narratives, and traditions: elements of feng shui, Chinese medicine and philosophy, images of dragons and tigers, roller coasters, computers, and vending machines.

Cai began using gunpowder in his work in the 1980s to foster spontaneity and confront the controlled artistic tradition and social climate in China. While living in Japan from 1986 to 1995, he explored the properties of gunpowder in his drawings, leading to the development of his signature explosion events. Poetic and ambitious, these explosion projects aim to establish an exchange between viewers and the larger universe. Since the September 11 tragedy, he has reflected upon his use of explosives both as metaphor and material: "It is important to make these violent explosions beautiful because the artist, like an alchemist, has the ability to transform certain energies, using poison against poison, using dirt and getting gold."

Nick Cave

Nick Cave was born in Fulton, Missouri, in 1959 and lives and works in Chicago. His *Soundsuits*—surreally majestic objects blending fashion and sculpture—originated as metaphorical suits of armor, in response to the Rodney King beating, and have evolved into vehicles for empowerment. Fully concealing the body, a Soundsuit serves as an alien second skin that obscures race, gender, and class, allowing viewers to look without bias toward the wearer. Dazzling in movement, the Soundsuits are crafted in collaboration with artisans, from an array of materials including beads, raffia, buttons, sequins, twigs, fur, and fabric. Cave regularly performs in the sculptures, dancing before the public or the camera, activating their full potential as costumes, musical instruments, and living icons. The artist also works with choreographers, dancers, and amateur performers to produce lavish community celebrations in untraditional venues for art.

The Soundsuits are often displayed in exhibitions as static sculptures, arranged as groups of figures in formation that are striking in their diversity and powerful stance. Cave's sculptures also include non-figurative assemblages, intricate accumulations of found objects that project from walls, and installations enveloping entire rooms.

Vija Celmins

Vija Celmins was born in Riga, Latvia, in 1938 and lives and works in New York. Celmins immigrated to the United States with her family when she was ten years old, settling in Indiana. Celmins received international attention early on for her renditions of natural scenes, which were often copied from photographs that lack a point of reference, horizon, or discernable depth of field.

Armed with a nuanced palette of blacks and grays, Celmins renders these limitless spaces—seascapes, night skies, and the barren desert floor—with an uncanny accuracy, working for months on a single image. Celmins has an attuned sense for organic detail and the elegance of imperfection. One series of works take as their subject delicate spider webs: in works like Web #2, Celmins renders the translucent quality of the web, lending the image a sense of discovery and wonder. A master of several mediums, including oil painting, charcoal, and multiple printmaking processes, Celmins matches a tangible sense of space with sensuous detail in each work.

Latoya Ruby Frazier

LaToya Ruby Frazier was born in 1982 in Braddock, Pennsylvania, and lives and works in Chicago. She formerly lived in New York. An artist and activist, Frazier uses photography, video, and performance to document personal and social histories of midwestern America.

Having grown up in the shadow of the steel industry, Frazier has chronicled the health and environmental crisis facing her family and her hometown since she was a teenager. Realizing at a young age that media depictions of people like herself did not accurately represent her life, she employs a radical black-and-white documentary approach that captures the complexity, injustice, and hope within America. Her 2016 body of work, *Flint is Family*, traces the lives of three generations of women living through the water crisis in Flint, Michigan.

Ellen Gallagher

Ellen Gallagher was born in Providence, Rhode Island, in 1965 and lives and works in New York and Rotterdam, The Netherlands. In her earlier works, Gallagher glued pages of penmanship paper onto stretched canvas and then drew and painted on it. Repetition and revision are central to Gallagher's treatment of advertisements that she appropriates from popular magazines like Ebony, Our World, and Sepia and uses in works like *eXelento* (2004) and *DeLuxe* (2004–05).

Although her work has often been interpreted strictly as an examination of race, Gallagher also suggests a more formal reading with respect to materials, processes, and insistences. From afar, the work appears abstract and minimalist; upon closer inspection, googly eyes, reconfigured wigs, tongues, and lips of minstrel caricatures multiply in detail. Gallagher has been influenced by the sublime aesthetics of Agnes Martin's paintings as well the subtle shifts and repetitions of Gertrude Stein's writing.

Theaster Gates

Theaster Gates was born in 1973 in Chicago, where he still lives and works. He first encountered creativity in the music of Black churches on his journey to becoming an urban planner, potter, and artist. Gates creates sculptures with clay, tar, and renovated buildings, transforming the raw material of urban neighborhoods into radically reimagined vessels of opportunity for the community. Establishing a virtuous circle between fine art and social progress, Gates strips dilapidated buildings of their components, transforming those elements into sculptures that act as bonds or investments, the proceeds of which are used to finance the rehabilitation of entire city blocks.

Gates's non-profit Rebuild Foundation manages projects in Chicago—including the Stony Island Arts Bank, Black Cinema House, Dorchester Art and Housing Collaborative, Archive House, and Listening House—while extending its support to cities throughout the Midwest. Many of the artist's works evoke his African American identity and the broader struggle for civil rights, from sculptures incorporating fire hoses to events organized around soul food and choral performances by the experimental musical ensemble, Black Monks of Mississippi, led by Gates himself.

Katharina Grosse

Katharina Grosse was born in 1961 in Freiburg/Breisgau, Germany, and lives and works in Berlin. Grosse is a painter who often employs electrifying sprayed acrylic colors to create large-scale sculptural environments and smaller wall works. Interested in the shifts of scale between "imagining big" while being small in relationship to one's surroundings, she explores the dynamic interplay between observing the world and simply being in it.

By uniting a fluid perception of landscape with the ordered hierarchy of painting, Grosse treats both architecture and the natural world as armatures for expressive compositions of dreamy abandon, humorous juxtaposition, and futuristic flair. Her evocatively titled projects often suggest complex narratives through the inclusion of everyday objects and psychedelic vistas. With layers of color built up with expressive immediacy, her work becomes a material record of its making and, perhaps, an inscription of her thoughts. But, Grosse says, "I am the painting trickster. Don't believe me!"

Trenton Doyle Hancock

Trenton Doyle Hancock was born in 1974 in Oklahoma City, Oklahoma, and lives and works in Houston, Texas. Hancock's prints, drawings, and collaged-felt paintings work together to tell the story of the Mounds—a group of mythical creatures that are the tragic protagonists of the artist's unfolding narrative. Each new work by Hancock is a contribution to the saga of the Mounds, portraying the birth, life, death, afterlife, and even dream states of these half-animal/half-plant creatures.

Influenced by the history of painting, especially Abstract Expressionism, Hancock transforms traditionally formal decisions—such as the use of color, language, and pattern—into opportunities to create new characters,

develop sub-plots, and convey symbolic meanings. Hancock's paintings often rework biblical stories that the artist learned as a child from his family and local church community. Balancing moral dilemmas with wit and a musical sense of language and color, Hancock's works create a painterly space of psychological dimensions.

Jenny Holzer

Jenny Holzer was born in Gallipolis, Ohio, in 1950 and lives and works in Hoosick Falls, New York. Whether questioning consumerist impulses, describing torture, or lamenting death and disease, Holzer's use of language provokes a response in the viewer.

While her subversive work often blends in among advertisements in public space, its arresting content violates expectations. Holzer's texts—such as the aphorisms "Abuse of power comes as no surprise" and "Protect me from what I want"—have appeared on posters and condoms and as electronic LED signs and projections of xenon light. Holzer's use of text ranges from silk-screened paintings of declassified government memoranda detailing prisoner abuse to poetry and prose in a sixty-five-foot-wide wall of light in the lobby of 7 World Trade Center, New York.

Rashid Johnson

Rashid Johnson was born in 1977 in Chicago, and lives and works in New York. Johnson, who got his start as a photographer, works across media—including video, sculpture, painting, and installation—using a wide variety of materials to address issues of African American identity and history.

Invested in the artistic practices of conceptualism and abstraction, Johnson is influenced by literary figures such as Ralph Ellison, Zora Neale Hurston, and Richard Wright as well as artists such as Norman Lewis, Sam Gilliam, and Alma Thomas. Johnson's installations frequently include shea butter and black soap, materials that were present throughout his childhood and that carry a particular significance within Afrocentric communities.

Joan Jonas

Joan Jonas was born in New York in 1936 and lives between New York and Nova Scotia, Canada. A pioneer of performance and video art, Jonas works in video, installation, sculpture, and drawing, often collaborating with musicians and dancers to realize improvisational works that are equally at home in the museum gallery and on the theatrical stage. Drawing on mythic stories from various cultures, Jonas invests texts from the past with the politics of the present.

By wearing masks in some works and drawing while performing on stage in others, Jonas disrupts the conventions of theatrical storytelling to emphasize potent symbols and critical self-awareness. From masquerading in disguise before the camera to turning mirrors on the audience, she turns doubling and reflection into metaphors for the tenuous divide between subjective and objective vision and for the loss of fixed identities.

Mike Kelley

Mike Kelley was born in Detroit, Michigan, in 1954. Kelley's work questions the legitimacy of normative values and systems of authority and attacks the sanctity of cultural attitudes toward family, religion, sexuality, art history, and education. His work ranges from highly symbolic and ritualistic performance pieces to arrangements of stuffed-animal sculptures, wall-size drawings, multi-room installations that restage institutional environments (schools, offices, zoos), and extended collaborations with artists such as Paul McCarthy, Tony Oursler, and the band Sonic Youth. A critic and curator, Kelley wrote for art and music journals and organized numerous exhibitions incorporating his work, fellow artists' work, and non-art objects that exemplify aspects of nostalgia, the grotesque, and the uncanny.

Kelley also commented on and undermined the legitimacy of the concept of victim or trauma culture, which posits that almost all behaviors result from repressed abuse. Kelley's pseudo-autobiographical project, *Extracurricular Activity Projective Reconstruction*, begun in 1995, was inspired by mundane yearbook photos and an examination of his selective amnesia. Kelley's aesthetic mines the rich and often overlooked history of vernacular art in America, and his practice borrows heavily from the confrontational, politically conscious, "by any means possible" attitude of punk music.

Kelley lived and worked in Los Angeles, where he passed away in January 2012.

William Kentridge

William Kentridge was born in 1955 in Johannesburg, South Africa, where he still lives and works. Having witnessed first-hand one of the twentieth century's most contentious struggles—the dissolution of apartheid—Kentridge brings the ambiguity and subtlety of personal experience to public subjects that are often framed in narrowly defined terms.

Using film, drawing, sculpture, animation, and performance, Kentridge transmutes sobering political events into powerful poetic allegories. Using a now-signature technique, he photographs his charcoal drawings and paper collages over time, recording scenes as they evolve. Working without a script or storyboard, he plots out each animated film, preserving every addition and erasure. Aware of myriad ways in which we construct the world by looking, Kentridge uses stereoscopic viewers and creates optical illusions with anamorphic projection, to extend his drawings-in-time into three dimensions.

Kimsooja

Kimsooja was born in 1957 in Daegu, South Korea, and lives and works between New York and Seoul, South Korea. Kimsooja's videos and installations blur the boundary between aesthetic and transcendent experience and refer to meditative practices through their use of repetitive actions and serial forms. In many of her pieces, everyday actions—such as sewing or doing laundry—are presented as two- and three-dimensional works, actively performed. Central to her work is the bottari, a traditional Korean

bed cover used to wrap and protect personal belongings, which Kimsooja transforms into a metaphor for structure and connection.

In videos that feature Kimsooja in various personas (*Needle Woman*, *Beggar Woman*, *Homeless Woman*), she leads viewers to reflect on the human condition, offering open-ended perspectives through which she presents and questions reality. With her body faced away from the camera, she becomes a void; we see and respond through her. While Kimsooja's works are striking for their vibrant color and dense imagery, they emphasize metaphysical changes within the artist-as-performer as well as the viewer.

Jeff Koons

Jeff Koons was born in 1955 in York, Pennsylvania, and lives and works in New York. Koons's works employ images and objects plucked from popular culture, framing questions about taste and pleasure. His works' spectacularly engineered surfaces transform banal items into sumptuous icons, with a contextual sleight-of-hand that presents subliminal meanings through dramatic shifts in scale and allegories that feature animals, humans, and anthropomorphized objects.

The subject of art history is a constant undercurrent in Koons's work, whether he elevates kitsch to the level of classical art, produces photos in the manner of Baroque paintings, or develops public works that borrow techniques and elements of seventeenth-century French garden design. Organizing his studio production in a manner that rivals a Renaissance workshop, Koons makes computer-assisted, handcrafted works noted for their meticulous attention to detail.

Barbara Kruger

Barbara Kruger was born in Newark, New Jersey, in 1945 and lives and works between New York and Los Angeles. In the early 1970s, Kruger worked as a graphic designer and picture editor at Condé Nast Publications for magazines such as *Mademoiselle*, *Vogue*, *House and Garden*, and *Aperture*—a background that is evident in the work for which she is now internationally renowned. In addition to appearing in museums and galleries worldwide, Kruger's work has been presented on billboards, buscards, posters, a public park, a train-station platform in Strasbourg, France, and in other public commissions.

Kruger layers found photographs from existing sources with pithy and aggressive texts that address the viewer as having a role in the struggle for power and control that the texts convey. With instantly recognizable white letters against slashes of red, her trademark slogans include: "I shop, therefore I am," and "Your body is a battleground." Most of her texts—questioning concepts of feminism, classicism, consumerism, and individual autonomy and desire—are positioned over black-and-white images that, culled from mainstream magazines, promote the very ideas that she disputes.

Glenn Ligon

Glenn Ligon was born in the Bronx, New York, in 1960 and lives and works in New York. Ligon's paintings and sculptures examine cultural and social identity through found sources—literature, Afrocentric coloring books, photographs—to reveal the ways in which the history of slavery, the civil-rights movement, and sexual politics inform our understanding of American society. Ligon appropriates texts from a variety of writers, including Walt Whitman, Zora Neal Hurston, Gertrude Stein, James Baldwin, and Ralph Ellison, and from more popular sources, such as the comedian Richard Pryor.

In Ligon's paintings, the instability of his medium—oil crayon applied through letter stencils—transforms the texts he quotes, making them visually abstract, difficult to read, and layered in meaning, much like the subject matter that he appropriates. In other works that feature silkscreen, neon, and photography, Ligon threads his autobiography and image into symbols that speak to collective experiences: "It's not about me," he says, "It's about we."

Maya Lin

Maya Lin was born in Athens, Ohio, in 1959 and lives and works in New York and Colorado. Lin catapulted into the public eye when, as a senior at Yale University, she submitted the winning design in a national competition for a Vietnam Veterans Memorial to be built in Washington, D.C. She was trained as an artist and architect, and her sculptures, parks, monuments, and architectural projects are linked by her ideal of making a place for individuals within the landscape.

Lin draws inspiration for her sculpture and architecture from culturally diverse sources, including Japanese gardens, Hopewell Indian earthen mounds, and works by American earthworks artists of the 1960s and 1970s. Her most recognizable work, the Vietnam Veterans Memorial, allows the names of those lost in combat to speak for themselves, connecting a tragedy that happened on foreign soil with the soil of America's capital city, where it stands.

Liz Magor

Liz Magor was born in Winnipeg, Manitoba, Canada, in 1948 and lives and works in Vancouver, British Columbia, Canada. She makes uncannily realistic casts of humble objects—garments, cardboard boxes, ashtrays—that speak of mortality and local histories. Magor's delicate copies are often combined with found ephemera, such as tiny vices (like cigarettes, candy, and alcohol), stuffed dead birds, and plush toy dogs. In Magor's works, social narratives of how things in the world are created, enter our lives, and depart in a vast waste stream are folded together with personal anxieties and small worries, such as the desire to afford nice things, to mend what's broken, and to preserve order against inevitable entropy.

The visual doubletake in Magor's work—of things appearing one way but being quite another—is on dramatic display in the artist's large-scale public projects, where an architectural column resembles a towering Douglas fir tree

and a rickety clapboard shack from a bygone era is carefully remade in cast aluminum. Resurrecting neglected items and moments from the recent past, Magor creates artworks that function like fossils: exacting copies that preserve whispers of existence.

Kerry James Marshall

Kerry James Marshall was born in 1955 in Birmingham, Alabama, and lives and works in Chicago. The subject matter of his paintings, installations, and public projects is often drawn from African American popular culture and is rooted in the geography of his upbringing: moving to Watts in 1963 and growing up near the Black Panthers in South-Central, Los Angeles. In his *Souvenir* series, he pays tribute to the civil-rights movement, with sculptures featuring slogans of the era ("Black Power!") and paintings populated by the ghosts of heroes of the 1960s. In *Rythm Mastr*, Marshall creates a comic book for the twenty-first century: ancient African sculptures that have come to life are pitted against a cyberspace elite that risks losing touch with traditional culture.

Marshall's beautiful, formally rigorous, and socially engaged work is based on a broad range of art-historical references, from Renaissance painting to Black folk art, from El Greco to Charles White. A striking aspect of Marshall's paintings is the emphatically black skin tone of his figures, which emerged from his investigation into the invisibility of Blacks in this country and the unnecessarily negative connotations associated with darkness.

Julie Mehretu

Julie Mehretu was born in 1970 in Addis Ababa, Ethiopia, and lives and works in New York. Mehretu's paintings and drawings refer to elements of maps and architecture, achieving a calligraphic complexity that resembles turbulent atmospheres and dense social networks. Architectural renderings and aerial views of urban grids enter the work as fragments, losing their real-world specificity and challenging narrow geographic and cultural readings. The paintings' formal qualities of light and space are made more complex by Mehretu's delicate depictions of fire, explosions, and perspectives in two and three dimensions. Her works refer to the history of nonobjective art, from Constructivism to Futurism, and pose questions about the relationship between utopian impulses and abstraction.

Recently, Mehretu has employed "underpaintings" of abstracted images of war, abolition, and social unrest on her canvases, as in her 2017 commission for the San Francisco Museum of Modern Art. Over these, Mehretu applies her gestural, calligraphic brushstrokes in a process of continual marking and erasure, creating layers that address America's complex political history.

Zanele Muholi

Zanele Muholi was born in Umlazi, a township southwest of Durban, South Africa, in 1972 and lives and works in Johannesburg, South Africa. Muholi creates work that asserts the presence of South Africa's marginalized LGBTI community. Both joyful and courageous, she refers to herself as a

visual activist, driven by a dedication to owning her voice, identity, and history and providing space for others in her community to do the same.

In her self-portrait series, *Somnyama Ngonyama (Hail the Dark Lioness)*, Muholi exaggerates the darkness of her skin tone and presents herself as different characters to experiment with South Africa's layered history and cultures and to record her existence as a queer Zulu woman. For the ongoing project, *Faces and Phases*, Muholi creates arresting portraits of Black lesbian and transgender individuals. The project documents the presence of this overlooked community, in the hopes of eradicating the discrimination, stigma, and violence that has affected it. In the *Brave Beauties* series, Muholi focuses her camera on transgender women who participate in beauty pageants, powerfully expressing and claiming their femininity.

Bruce Nauman

Bruce Nauman was born in 1941 in Fort Wayne, Indiana, and lives and works in New Mexico. Nauman has been recognized since the early 1970s as one of the most innovative and provocative of America's contemporary artists. His diverse output communicates alternately political, prosaic, spiritual, and crass personae to map the arc between life and death.

Soon after leaving school, Nauman realized that, for an artist, whatever was done in the studio must be art. Working in the mediums of sculpture, video, film, printmaking, performance, and installation, Nauman concentrates less on the development of a characteristic style and more on the way in which a process or activity can transform or become a work of art. The subtext of an early neon work that proclaims, "The true artist helps the world by revealing mystic truths," is that the audience, the artist, and the larger culture are involved in determining the significance of any work of art.

Catherine Opie

Catherine Opie was born in Sandusky, Ohio, in 1961 and lives and works in Los Angeles. Opie investigates the ways in which photographs document and give voice to social phenomena in America, registering people's attitudes and relationships between themselves and others and how they occupy the landscape. Many of her works capture the expression of individual identity through groups (couples, teams, crowds) and reveal aspects of her biography vis-à-vis her subjects.

Influenced by art history, Opie's work conveys formal ideas regarding "the way things should look." Working between conceptual and documentary approaches to image making, she examines familiar genres—portraiture, landscape, and studio photography—through surprising serial images, unexpected compositions, and diverse subject matter. Whether documenting political movements, queer subcultures, or urban transformation, Opie's images compose a portrait of contemporary America.

Raymond Pettibon

Raymond Pettibon was born in Tucson, Arizona, in 1957 and lives and works in Hermosa Beach, California. After graduating from college with a degree in economics, Pettibon worked briefly as a high-school math teacher but soon launched a career as a professional artist. A cult figure among underground-music devotees for his early work associated with the Los Angeles punk-rock scene, Pettibon has acquired an international reputation as one of the foremost contemporary American artists working with drawing, text, and artist books. In the 1990s, he extended his work beyond the printed page, creating wall-size drawings and collages.

Pettibon is as likely to explore the subject of surfing as of typography; themes from art history and nineteenth-century literature appear alongside 1960s American politics and contemporary pop culture. His 1998 anthology, *Raymond Pettibon: A Reader*, presents a number of the artist's muses, including Henry James, Mickey Spillane, Marcel Proust, William Blake, and Samuel Beckett.

Lari Pittman

Lari Pittman was born in 1952 in Los Angeles, where he still lives and works. Inspired by commercial advertising, folk art, and decorative traditions, his meticulous paintings transform signage and anthropomorphic depictions of furniture, weapons, and animals into luxurious scenes full of pattern and complexity, to convey themes of romantic love, violence, and mortality.

Both visually gripping and psychologically strange, Pittman's hallucinatory works refer to a broad range of aesthetic styles, from Victorian silhouettes to social-realist murals to Mexican retablos. His paintings and drawings are a personal rebellion against rigid, puritanical dichotomies. Pittman's deployment of simultaneously occurring narratives and opulent imagery reflects the rich heterogeneity of American society, the artist's Colombian heritage, and the distorting effects of hyper-capitalism on everyday life.

Pedro Reyes

Pedro Reyes was born in 1972 in Mexico City, where he still lives and works. He designs ongoing projects that propose playful solutions to social problems. From turning guns into musical instruments to hosting a People's United Nations in order to address pressing concerns, to offering ecologically friendly grasshopper burgers from a food cart, Reyes transforms existing problems into ideas for a better world. In the artist's hands, complex subjects like political and economic philosophies are reframed in ways that are easy to understand, such as a puppet play featuring Karl Marx and Adam Smith fighting over how to share cookies.

When encountering a project by Reyes, viewers are often enlisted as participants through one-on-one conversations, therapeutic acts, or as creators of objects in collaborative workshops. Originally trained as an architect, Reyes is acutely aware of how people interact with the built

environment, and many of the artist's works take the form of enclosures. Reyes's home, featuring an extensive library that he draws from for inspiration, is itself a work of art that is continually adapted by the artist and his family.

Robert Ryman

Robert Ryman was born in Nashville, Tennessee, in 1930 and lives and works between New York and Pennsylvania. Ryman's work explodes the distinctions between art as object and as surface—between sculpture and painting, between structure and ornament—emphasizing instead the role that perception and context play in creating an aesthetic experience.

Ryman isolates the most basic components of an artwork (material, scale, and support), enforcing limitations that allow the viewer to focus on the physical presence of the work in space. Since the 1950s, Ryman has used primarily white paint on a square surface—canvas, paper, metal, plastic, or wood—to harness the nuanced effects of light and shadow that animate his work. In Ryman's oeuvre, wall fasteners and tape serve both practical and aesthetic purposes. Neither abstract nor entirely monochromatic, Ryman's paintings are paradoxically "realist," according to the artist's lexicon.

Doris Salcedo

Doris Salcedo was born in 1958 in Bogotá, Colombia, where she still lives and works. Salcedo's understated sculptures and installations embody the silenced lives of the marginalized, from individual victims of violence to the disempowered of the Third World. Although elegiac in tone, her works are not memorials: Salcedo concretizes absence, oppression, and the gap between the powerful and the powerless.

While abstract in form and open to interpretation, her works serve as testimonies on behalf of both victims and perpetrators. Even when monumental in scale, her installations achieve a degree of imperceptibility: receding into a wall, burrowed into the ground, or present for only a short time. Salcedo's work reflects a collective effort and close collaboration with a team of architects, engineers, and assistants—and, as Salcedo says, "with the victims of the senseless and brutal acts" to which her work refers.

Kiki Smith

Kiki Smith was born in 1954 in Nuremberg, Germany, and lives and works in New York. The daughter of the American sculptor, Tony Smith, Kiki Smith grew up in New Jersey. As a young girl, Smith helped to make cardboard models for her father's geometric sculptures. This training in formalist systems, combined with her upbringing in the Catholic Church, would later resurface in her evocative sculptures, drawings, and prints.

The recurrent subject matter in Smith's work has been the body as a receptacle for knowledge, belief, and storytelling. In the 1980s, she turned the notion of figurative sculpture inside out, creating objects and drawings based on organs, cellular forms, and the human nervous system. This body of work evolved to incorporate animals, domestic objects, and narrative tropes from

classical mythology and folk tales. Life, death, and resurrection are thematic signposts in many of Smith's installations and sculptures.

Stephanie Syjuco

Stephanie Syjuco was born in Manila, the Philippines, in 1974 and lives and works in Oakland, California. Syjuco works in photography, sculpture, and installation, moving from handmade and craft-inspired mediums to digital editing. Her work explores the tension between the authentic and the counterfeit, challenging deep-seated assumptions about history, race, and labor.

Syjuco's installations frequently invite viewers to be active participants—from crocheting counterfeit designer handbags to purchasing items at an alternative gift shop within a museum—in order to investigate global consumer capitalism and its effects. Through photographic portraits composed in the studio, Syjuco further explores economies of labor and value, with a political dimension inspired by colonialist ethnographic photography, her identity as an immigrant, and media-filtered protest imagery.

Sarah Sze

Sarah Sze was born in Boston, Massachusetts, in 1969 and lives and works in New York. Sze builds her installations and intricate sculptures from the minutiae of everyday life, imbuing mundane materials, marks, and processes with surprising significance. Combining domestic detritus and office supplies into fantastical miniatures, she generates her works, fractal-like, on an architectural scale.

Often incorporating electric lights and fans, water systems, and houseplants, Sze's installations balance whimsy with ecological themes of interconnectivity and sustainability. Whether adapting to a venue or altering the urban fabric, Sze's patchwork compositions seem to mirror the improvisational qualities of cities, labor, and everyday living. Playing on the edge between life and art, her work is vibrant with potential mutability.

James Turrell

James Turrell was born in Los Angeles in 1943 and lives and works in Arizona. Turrell's work involves explorations in light and space that affect the viewer's eye, body, and mind with the force of a spiritual awakening. Informed by his studies in perceptual psychology and optical illusions, his work allows viewers to witness their process of seeing. Whether harnessing the light at sunset, converting the glow of a television set into a fluctuating portal, or transforming an extinct volcano into a celestial observatory, Turrell's art places viewers in a realm of pure experience.

Turrell's fascination with the phenomena of light is ultimately connected to a very personal, inward search for humanity's place in the universe. Influenced by his Quaker faith, which he characterizes as having a "straightforward, strict presentation of the sublime," Turrell's art prompts greater self-awareness through a similar discipline of silent contemplation, patience, and meditation.

Ursula Von Rydingsvard

Ursula von Rydingsvard was born in Deensen, Germany, in 1942 and lives and works in New York. Von Rydingsvard's massive sculptures reveal the trace of the human hand and resemble wooden bowls, tools, and walls that seem to echo the artist's family heritage in pre-industrial Poland, before World War II.

The artist spent her childhood in camps for Nazi slave laborers and postwar refugees, and her earliest recollections—of displacement and subsistence through humble means—infuse her work with emotional potency. Von Rydingsvard builds towering cedar structures, composed of a network of individual beams glued together and shaped by sharp and lyrical cuts to form intricate, sensuous, puzzle-like surfaces. While von Rydingsvard's work is abstract at its core, it takes visual cues from the landscape, the human body, and utilitarian objects—such as the artist's collection of household vessels—and points toward where culture meets nature.

Kara Walker

Kara Walker was born in Stockton, California, in 1969 and lives and works in New York. Walker is best known for exploring the raw intersections of race, gender, and sexuality through her iconic, silhouetted figures. She unleashes the traditionally modest Victorian medium of the silhouette directly onto the gallery walls, creating a theatrical space in which her unruly cut-paper characters fornicate and inflict violence on each other. With one foot in the historical reality of slavery and the other in the fantastical world of the romance novel, Walker's nightmarish fictions simultaneously seduce and implicate the audience.

In Walker's work, *Darkytown Rebellion* (2000), overhead projectors throw colored light onto the ceiling, walls, and floor of the exhibition space; the lights cast a shadow of the viewer's body onto the walls, where it mingles with the artist's black-paper figures and landscapes. In 2014, Walker made her first large-scale public installation, *A Subtlety, or the Marvelous Sugar Baby* (2014), which was presented in the decommissioned Domino Sugar Factory in Brooklyn, New York.

Carrie Mae Weems

Carrie Mae Weems was born in Portland, Oregon, in 1953 and lives and works in Syracuse, New York. With the pitch and timbre of an accomplished storyteller, Weems uses colloquial forms—such as jokes, songs, and rebukes—in photographic series that scrutinize subjectivity and expose pernicious stereotypes.

Weems's vibrant explorations of photography, video, and verse breathe new life into traditional narrative forms: social documentary, tableaux vivants, self-portraiture, and oral history. Conveying epic contexts through individually framed moments, she debunks racist and sexist labels, examines the relationship between power and aesthetics, and uses personal biography to articulate broader truths. Whether adapting or appropriating archival

images, restaging famous news photographs, or creating new scenes, Weems traces an indirect history of the depiction of African Americans over more than a century.

Jack Whitten

Jack Whitten was born in Bessemer, Alabama, in 1939. He attended Tuskegee University as a pre-medical student and ROTC cadet but later transferred to Southern University in Baton Rouge, Louisiana, to study art. There, he became involved in the American civil-rights movement and took part in the spring 1960 student demonstrations, staging sit-ins and a shutdown of the university.

While Whitten's early work combined figuration and abstraction, he later made a significant conceptual and stylistic shift, moving from oil paint to acrylic to focus on the process and materiality of painting. Whitten's "developer"—a twelve-foot-long wooden rake invented by the artist to move large amounts of acrylic paint in a single gesture—resulted in his "slab" paintings, large color fields defined by a single movement. Whitten's proclivity for invention was also manifested in his signature tesserae: small cubes cut from slabs of acrylic paint and adhered to the canvas, angled to catch and reflect light. Investigating the notion of paint as a collage element, Whitten used the tesserae as a vehicle to explore his passion for science and technology; he thought of the tesserae as individual bytes of information.
For more than four decades, Whitten utilized the tesserae to develop his Black Monolith paintings, a series of abstracted tributes to Black artists, musicians, and public figures, such as Ralph Ellison, Chuck Berry, and W.E.B. Du Bois.

Whitten was one of the most influential abstract and conceptual painters of his generation. He lived in New York City, where he passed away in January 2018.

Index

Page numbers in italics refer
to illustrations.

Abstract Expressionists, 44
Agamben, Giorgio, 182
Al-Hadid, Diana, 194–98
 biography, 262
 on composition in paintings as influence
 on, 195–96
 on drips in her works, 197
 on gravity and suspension, 196–97
 on illusion versus reality, 197
 on processes she invented, 198
 on scale in sculpture, 196
 in studio (*New York Close Up* film *Diana Al-
 Hadid's Studio Bloom*), 194
 on *Tower of Infinite Problems*, 196
AMERICA retrospective (Ligon), 158
El Anatsui, 199–203
 architecture of pieces, determining, 202
 art as way of transforming things, 203
 biography, 262
 blocks, making on, 202
 on collecting materials for future use, 199
 on discovery and use of bottle caps, 199
 installing When I Last Wrote to You About
 Africa at Blanton Museum of Art (*Art
 in the Twenty-First Century*, Season 6
 episode, "Change"), 200–201
 offcuts, use of, 202–3
 on repurposing, 199–202
 on volume, 203
Anderson, Laurie, 136
 "anyway" principle, 106–8
Applebroog, Ida, 16–19
 on being a female artist, 18
 biography, 262–63
 on feminism and art, 18–19
 on first making art, 17
 on labels, 18, 19
 on politics, 19
 on power, 17–18
 on structures and stagings, 17
 in studio (*Art in the Twenty-First Century*,
 Season 3 episode "Power"), 16
 on violence, 19

Arendt, Hannah, 181
artist, role of
 Bruguera on, 132–35
 Kelley on, 142–47
 Koons on, 148–52
 Ligon on, 153–58
 Marshall on, 159–62
 Muholi on, 163–67
 Pettibon on, 168–72
 Reyes on, 173–77
 Salcedo on, 178–82
 Syjuco on, 183–87
 Sze on, 188–91
Artist is an Amazing Luminous Fountain
 (Nauman), 249
Asphalt Pour (Smithson), 122
Aycock, Alice, 123

Baldessari, John, 20–24
 on art as play, 23
 biography, 263
 on communication, 24
 conceptualism and, 21–22
 on interchangeability of images and words,
 21
 on labels, 21–22
 on language as art, 21
 on making art as a choice, 22
 on misconceptions about his work, 22
 on small town life, 22
 in studio (*Art in the Twenty-First Century*,
 Season 5 episode "Systems"), 20
 on teaching, 23–24
Barthes, Roland, 162
beauty
 Kelley on, 146–47
 Marshall on, 160–62
 Weems on, 96–97
becoming an artist
 Applebroog on, 16–19
 Baldessari on, 20–24
 Bradford on, 25–29
 Cave on, 30–33
 Celmins on, 34–37
 Frazier on, 38–41
 Grosse on, 42–45

Johnson on, 46–50
Kentridge on, 51–54
Kimsooja on, 55–59
Opie on, 60–65
Pittman on, 66–69
Smith on, 70–75
Turrell on, 76–83
Von Rydingsvard on, 84–87
Walker on, 88–93
Weems on, 94–97
Benjamin, Walter, 119
Beuys, Joseph, 173
Bierstadt, Albert, 241, 246
Black Monolith series (Whitten), 261
Bona, Charlottesville (Muholi), 167
bottari, 57
Bourgeois Bust—Jeff and Ilona (Koons), 151–52
Bradbury, Ray, 162
Bradford, Mark, 25–29, 100–103
 biography, 263
 childhood and family influences in
 development as artist, 28
 on community fluidity and
 change, 101
 goal in filming, 102
 on graffiti, 103
 LA riots of 1992 and, 102
 Market>Place, 100, 101, 102
 merchant background of, as influence, 101–2
 on palimpsest, 103
 on politics, 25
 posters used in work of, 102–3
 on process in creating collages, 25–28
 on relationship between public and private,
 103
 shift from making to being an artist, 28
 in studio (*Art in the Twenty-First Century*,
 Season 4 episode "Paradox"), 26–27, 29
 on taking independence, 28–29
Brave Beauties (Muholi), 164–65
Bruguera, Tania, 132–35
 on Arte Útil, 133
 biography, 263–64
 defines artist, 133
 on definition of "art," 135
 on difference between artists and other
 social activists, 133–34
 at *Immigrant Movement International Project*
 (*Art in the Twenty-First Century*, Season 7
 episode "Legacy")*, 132
 on Immigrant Movement International
 project, 134

Burton, Scott, 123
Butler, Hiram, 77
Butler, Octavia, 63

Cage, John, 56, 249
Cai Guo-Qiang, 104–8, 204–10
 on "anyway" principle, 106–8
 biography, 264
 on circularity, 206
 influences of, 204
 on *Inopportune*, 206–7
 Japanese history as influence, 104–5
 on Kuan Yin statuary, 105–6
 local community involvement and, 105
 on luck, 108
 methodology of, 205
 on overcoming obstacles in working with
 materials, 206
 on process, 204–10
 on *Reflection*, 104–6, 107
 Taoism and Chinese medicine employed in
 art-making process of, 205
 on tiger room and visual impact to transmit
 ideas, 207–10
 at work (*Art in the Twenty-First Century*,
 Season 3 episode "Power"), 208–9
 on working with chaos as material for
 art, 205–6
Campos, Martinez, 180
Cargo Cults (Syjuco), 183–86
Cartier-Bresson, Henri, 95
Cave, Nick, 30–33
 biography, 264
 childhood of, 30–31
 at Cranberry Academy of Art, 31
 creation of Soundsuits, 31–33
 intricacy in work of, 33
 on juxtaposition of images in work of, 33
 on process in creating sculptures, 33
 race and, 31–32
 in studio (*Art in the Twenty-First Century*,
 Season 8 episode "Chicago")*, 32
Celmins, Vija, 34–37, 67, 211–15
 at art school, 37
 biography, 265
 on building a painting, 211–12
 on Cézanne, 212–14
 childhood of, 35–37
 on dark paintings, 214–15
 early visual inspirations, 37
 on early works, 34–35
 on preparing canvas, 35, 211

Index 279

on process, 211–15
stillness in work of, 35
timelessness in work of, 35
at work (*Art in the Twenty-First Century*,
 Season 2 episode "Time"), *36, 213*
on working with source images, 212
Cézanne, Paul, 212
childhood/family life
Bradford on, 28
Cave on, 30–31
Celmins on, 35–37
Frazier on, 38
Gates on, 109–11
Kentridge on, 51
Kimsooja and, 55, 56
Smith on, 72–73
Von Rydingsvard on, 85–87
Church, Frederic Edwin, 241, 246
circularity, 206
Cole, Henri, 113
Cole, Thomas, 241
collage
Bradford's, 25–28
Gallagher and, 216
Hancock's, 220–23
color
Marshall on flat black color for his
 figures, 238–40
Ryman on use of color white in his
 paintings, 252
Turrell on, 82–83
communication, 24
conceptualism
Baldessari and, 21–22
Grosse on, 43
consumerism, 119
Courbet, Gustave, 43
Cunningham, Merce, 249

Damski Czepek (Von Rydingsvard), 125–26, 128
Dancing Wu Li Masters, The (Zukav), 259
Day Is Done (Kelley), *144, 145,* 229–32
dazzle camouflage, 186
De Kooning, Willem, 261
death, 74
DeCarava, Roy, 95, 96
décollage, 25–28
Dickens, Charles, 158
Disarm (Reyes), 173–74
Double Natural (Gallagher), 217

Educational Complex (Kelley), 229, 231

El Greco, 204
elitism, 68–69
Elkins, Leslie, 77
Ellison, Ralph, 238
Equivalents (Stieglitz), 48
Evans, Walker, 95, 96

Faces and Phrases (Muholi), 164–65
Fahrenheit 451 (Bradbury), 162
feminism
Applebroog on, 18–19
Kimsooja on, 57–58
Kruger on, 117
Ferenczi, Sándor, 142
Football Landscape #16 (Opie), 65
For 7 World Trade Center (Holzer), 113
Fox, George, 78
Frank, Robert, 62, 95
Frazier, LaToya Ruby, 38–41
on art as 24/7 job, 41
biography, 265
childhood and family life of, 38
installation view of video *Momme Portrait
 Series (Heads)* (from *New York Close Up*
 film *LaToya Ruby Frazier Makes Moving
 Pictures*), 39
in performance (from New York Close
 Up film LaToya Ruby Frazier Takes on
 Levi's), 40
on relation between domestic sphere and
 public place, 40–41
schedule of, 41
socioeconomic climate of Braddock, Pa.
 and, 38–40, 41
Freud, Sigmund, 142
Friedan, Betty, 18

Gallagher, Ellen, 216–19
biography, 265
on collage in paintings of, 216
on Double Natural, 217
methodology of, 218
on misconceptions about her work, 219
on use of grid, 216–17
what she finds exciting in process of
 creating her works, 218–19
at work (*Art in the Twenty-First Century*,
 Season 3 episode "Play"), 217
on working with archival materials, 216–18
Gates, Theaster, 109–12, 136–41
on artist's role, 136–41
biography, 266

Chicago childhood and upbringing of, 109–11

on city planner/artist role of, 111–12

on object- versus engagement-based art, 136–37

on relation between materials and discarded communities, 137–40

on revitalizing communities, 140–41

in studio (*Art in the Twenty-First Century*, Season 8 episode "Chicago"), *110, 138–39*

gender

Applebroog on being a female artist, 18

Kimsooja on women's roles and feminism, 57–58

Kruger on intersectionality of race and class and gender, 117–18

See also feminism

Géricault, Théodore, 238

gestural painting, 44

Goldblatt, David, 164

Gonzalez-Torres, Felix, 191

Gorky, Arshile, 246

graffiti, 103

Grosse, Katharina, 42–45

Abstract Expressionists and, 44

biography, 266

on conceptualism, 43

early influences of, 42–43

on role of, and being an artist, 42

in studio (*Art in the Twenty-First Century*, Season 7 episode "Fiction"), 45

on theoretical training, 43

three-dimensional forms and, 43–44

Groundswell (Lin), 121–23

Guston, Philip, 246

Hancock, Trenton Doyle, 220–23

on biblical narratives as influence on, 222

biography, 266–67

on characters in Mounds story, 221–22

on development of Mounds story, 221

on first creating collages, 220

language as factor in work of, 220–21

at work (*Art in the Twenty-First Century*, Season 2 episode "Stories"), *223*

Hoffman, Hans, 231–32

Holzer, Jenny, 113–16

biography, 267

on clichés, 116

on filling space with text and programming electronics, 114–15

first person texts, use of, 115

on handprint paintings, 116

Inflammatory Essays, 115

politically based texts, obtaining, 116

reasons for stopping writing, 115

selecting text for *For 7 World Trade Center*, 113

Truisms, 115

at work (*Art in the Twenty-First Century*, Season 4 episode "Protest"), 114

working with text of others, 113–14

humor

Kelley on humor in *Day is Done*, 231

Pettibon on, 169–71

Reyes on, 175

Immigrant Movement International project (Bruguera), 134

In Praise of Shadows (Tanizaki), 96

In Protest to Sex Offenders (Opie), 65

Inauguration (Opie), 63–64

Inflammatory Essays (Holzer), 115

Informel, 42

Inopportune (Cai Guo-Qiang), 206–7

Insurrection! Our Tools Were Rudimentary, Yet We Pressed On (Walker), 88–89, 90–92, *92*

Invisible Man, The (Ellison), 238

Jodorowsky, Alejandro, 173–74

Johns, Jasper, 157, 158

Johnson, Rashid, 46–50

on additive process in creating photographs, 49

artists studio as context for seeing art, 47

biography, 267

early influences of, 47–48

first gallery show of, 48

shea butter and other materials used by, 49–50

in studio (*New York Close Up* film *Rashid Johnson Keeps His Cool*), *46*

Jonas, Joan, 225–27

biography, 267

on concentration on shapes when painting, 225

difference between public performance versus work in studio, 225

on interviewer capturing truth of artistic process, 225–26

on listening to music while working, 226

on recording performances, 227

at work (*Art in the Twenty-First Century*, Season 7 episode "Fiction"), 224

on working in film, 226

Kelley, Mike, 142–47, 228–32
 on beauty, 146–47
 biography, 268
 on critics understanding of his
 work, 146
 Day is Done, 144, 145, 229–32
 on Educational Complex (Kelley), 229, 231
 on his books, 145–46
 humor in *Day is Done*, 231
 influences on early writing of, 145
 interests in Marxism of, 232
 on own writing, 145
 on process, 228–32
 psychological theories in work of, 142–45
 relation of *Day is Done* to earlier works, 229
 on repressed memory syndrome in
 Day is Done, 231
 on set (*Art in the Twenty-First Century*,
 Season 3 episode "Memory"), 143, 228
 source material for *Day is Done*, 229–30
 on structure of *Day is Done*, 230–31
 in studio (*Art in the Twenty-First Century*,
 Season 3 episode "Memory"), 144
 on the sublime, 146–47
 on titles of projects, 146
 on Uncanny, 142, 145
 on viewer response to *Day is Done*, 229–30
Kentridge, William, 51–54
 biography, 268
 deciding to be, and working as an artist, 51–52
 early artistic experiences of, 51
 film work of, 54
 political history of family of, 52–53
 on South African versus American
 histories, 53–54
 in studio (from *Extended Play* film *William
 Kentridge: Meaning*), 53
Kimsooja, 55–59
 in art school, 56–57
 biography, 268–69
 bottari's role in work of, 57
 To Breathe—A Mirror Woman, 58, 58–59
 childhood and family life of, 55, 56
 on Crystal Palace installation, 58–59
 earliest creative experiences of, 55–59
 early influences of, 56–57
 on feminism, 57–58
 installation view at Crystal Palace, Madrid
 (*Art in the Twenty-First Century*, Season 5
 episode, "Systems"), 58
 installation view at Rotunda at Galerie
 Ravenstein, Brussels (*Art in the

 Twenty-First Century, Season 5 episode,
 "Systems"), 59
 Lotus: Zone of Zero, 59
 philosophy and art melding in work of, 55–56
 transition from sewing needle to video, 58
 on women's role, 57
Klee, Paul, 246
Klein, Melanie, 145
Koons, Jeff, 148–52
 biography, 269
 on Château de Versailles works, 150–52
 on gesture, 149–50
 installation view at Château de Versailles,
 France (*Art in the Twenty-First Century*,
 Season 5 episode "Fantasy"), 148
 on notions perpetuated about his work, 152
 on personal iconography, 149–50
 on relationship with art, 149
Kruger, Barbara, 117–19
 biography, 269
 on consumerism, 119
 on feminism, 117
 on intersectionality of race and class and
 gender, 117–18
 media sources watched by, 118
 on power and potential of art, 118
 on street photography and
 photojournalism, 118–19
 on *Untitled,* 117, 119

LA riots of 1992, 102
labels
 Applebroog on, 18, 19
 Baldessari on, 21–22
Levitt, Helen, 62
LeWitt, Sol, 250
Lichtenstein, Roy, 22
light
 Ryman on, 254–56
 Turrell on, 78–79, 82–83
 Weems on, 95–96
Ligon, Glenn, 153–58
 on *AMERICA* retrospective, 158
 biography, 270
 eschews self-expression in use of text, 153
 influences on and antecedents to work of,
 157–58
 on letter by letter stenciling, 157
 on literature and text in work of, 153
 on misconceptions about his work, 158
 on painting, 153–56
 on struggle in creating ideal painting, 156

on text paintings, 156–57
at work (Art in the Twenty-First *Century*,
 Season 6 episode "History"), *154–55*
Lin, Maya, 120–24
art and architecture, distinction
 between, 123
biography, 270
on Groundswell, 121–23
on monuments versus memorials, 122–23
on process, 122
on Stones and furniture design for
 Knoll, 123–24
in studio *(Art in the Twenty-First Century,*
 Season 1 episode "Identity"), *120*
Live Oak Friends Meeting House (Turrell), *80–81*
Lobster (Koons), 151
Longitude (Lin), 124
Lotus: Zone of Zero (Kimsooja), 59
Lowe, Rick, 136

Magor, Liz, 233–36
on beginning a new work, 233–34
biography, 270–71
on flow of objects, 235–36
on found objects in work of, 234–36
in studio *(Art in the Twenty-First Century,*
 Season 8 episode "Vancouver"), *234*
Mandelbrot, Benoit, 196
Many Mansions (Marshall), 237–38, 240
Market>Place (Bradford), *100, 101*, 102
Marshall, Kerry James, 159–62, 237–40
author viewing Many Mansions *(Art in the*
 Twenty-First Century, Season 1 episode
 "Identity"), 239
on beauty, 160–62
biography, 271
on creating black superheroes in
 comics, 159–60
on developing own comic strip, 159–60
on *Many Mansions*, 237–38, 240
on phenomenological existence, 161–62
on *Portrait of the Artist as a Shadow of His*
 Former Self, 240
on process, 237–40
Martin, Agnes, 18–19
Mehretu, Julie, 241–47
biography, 271
erasure as element in process of, 247
on researching and creating San Francisco
 MOMA project, 241–46
role of abstraction in process of, 244–46
on role of painting, 246–47

on violence, 244–45
at work (from *Extended Play* film, *Julie*
 Mehretu: Politicized Landscapes), *242–43*
Mies van der Rohe, 124
Mockus, Antanas, 173, 174
Momme Portrait Series *(Heads)* (Frazier), 39
Moreno, Jacob L., 175
Moscow Diary (Benjamin), 119
Muholi, Zanele, 163–67
biography, 271–72
on Bona, Charlottesville, 167
on Brave Beauties, 164–65
collaboration and community in works of,
 164–65
on Faces and Phases, 165
on gaze and eye contact in images of, 163–64
on portraiture in South Africa, 163
on process of taking self-portraits, 165–66
on Somnyama Ngonyama, 166–67
on term artist, 167
at work (Art in the Twenty-First Century,
 Season 9 episode "Johannesburg"), *166*
Murray, Elizabeth, 67
Muybridge, Eadweard, 244

Nauman, Bruce, 248–51
on *Artist is an Amazing Luminous Fountain*,
 248–51, *249*
on being there with task you're
 doing, 251
biography, 272
on choosing right questions to answer, 250
job depicted in *Setting a Good Corner*, 249–51
on *Setting a Good Corner*, 249–51
watching Setting a Good Corner in studio
 (Art in the Twenty-First Century, Season 1
 episode "Identity"), *248*
Needle Woman (Kimsooja), 58
Neither (Salcedo), 181

objects
Gates on object- versus engagement-based
 art, 136–37
Magor on found objects in her work, 234–36
Smith on domestic objects, 70–72
Sze on how an object acquires value, 189
Oehlen, Albert, 246
Oldenberg, Claes, 22
Ona (Von Rydingsvard), *127*
Opie, Catherine, 60–65, 119
on *In and Around Home*, 64–65
at art school, 61–62

biography, 272

documentary photography influences of, 61–62

early Western painting's influence on, 61

on Inauguration, 63–64

observational photography, relation to and expansion from, 62–63

on religion, 65

utopian notions reflected in work of, 63

at work *(Art in the Twenty-First Century,* Season 6 episode "Change"), *60, 64*

optimism, 175–76

Palas por Pistolas (Reyes), 173–74

Pan Pacific Horizon (Cai), 105

Papageorge, Tod, 95

Pettibon, Raymond, 168–72

anger and social criticism in work of, 168–69

biography, 273

depiction of women by, 171–72

failure and longing in work of, 172

humor, use of, 169–71

on Patty Hearst and the SLA, 171

on political issues and artists, 169

sadness in work of, 172

in studio *(Art in the Twenty-First Century,* Season 2 episode "Humor"), *169, 170*

Pittman, Lari, 66–69

art education of, 67

audience of, 68

biography, 273

influences of, 67

on Los Angeles' influence on work, 69

mannerism and, 68

on Orientalism in his work, 67–68

on populism versus elitism, 68–69

at work *(Art in the Twenty-First Century,* Season 4 episode "Romance"), *66*

politics

Applebroog on, 19

Bradford on, 25

Holzer's work and, 116

Kentridge and, 52–53

Pettibon on, 169

Salcedo on, 179–80

Pollock, Jackson, 247

Pontormo, 195

populism, 68–69

Portrait of the Artist as a Shadow of His Former Self (Marshall), 240

power, 17–18

process

Al-Hadid on, 194–98

El Anatsui on, 199–203

Bradford on, 25–28

Cai Guo-Qiang on, 204–10

Cave on, 33

Celmins on, 211–15

Gallagher on, 216–19

Hancock on, 220–23

Jonas on, 225–27

Kelley on, 228–32

Lin on, 122

Magor on, 233–36

Marshall on, 237–40

Mehretu on, 241–47

Muholi on, 165–66

Nauman on, 248–51

Ryman on, 252–57

Whitten on, 258–61

Project for Extraterrestrials (Cai), 105

public space

Bradford and, 100–103

Cai and, 104–8

Gates and, 109–12

Holzer and, 113–16

Kruger and, 117–20

Lin and, 120–24

Von Rydingsvard and, 125–29

pUN: People's United Nations project (Reyes), 174, 175

Puppy (Koons), 150

push-pull theory, 231

Rabbit (Koons), 151

race

Cave's work and, 31–32

Kruger on intersectionality of race and class and gender, 117–18

Muholi on, 166–67

Walker's work and, 88–90

Weems' work and, 97

Raft of the Medusa (Géricault), 238

Rauschenberg, Robert, 25, 232

Ray, Charlie, 188

Reflection (Cai), 104–6, *107*

Reich, Steve, 249

religion/spirituality

Opie on, 65

Turrell on, 83

repressed memory syndrome, 231

A Requiem (Weems), 97

Reyes, Pedro, 173–77

biography, 273–74

on creating a space for violence, 174
on desire to be a public servant, 176
at home and studio (*Art in the Twenty-First Century*, Season 8 episode, "Mexico City"), 177
on humor, 175
library and studio of, 174
on making art, 173
on optimism, 175–76
on *Palas por Pistolas*, 173–74
on problem solving and art, 176
on *pUN: People's United Nations* project, 174, 175
role playing in work of, 174–75
surplus reality, use of, 175
Richau, Joachim, 247
Ridin' Dirty (Bradford), 25
Roden Crater (Turrell), 76, 79–82
Rogers, Sara, 121
Roma, Tom, 95
Ruthenbeck, Reiner, 43
Ryman, Robert, 252–57
 approach to painting of, 253–54
biography, 274
doesn't consider his work abstract, 257
influence of music on work of, 256
installing *Philadelphia Prototype* at Pennsylvania Academy of Fine Arts (*Art in the Twenty-First Century*, Season 4 episode "Paradox"), 255
on light, 254–56
 on meaning in works of art, 256–57
place in contemporary art world of, 257
on producing odd numbered series, 253–54
on proper visual situation for viewing his pictures, 253
on scope of possibilities and ability to experiment in his paintings, 252–53
on surface of work, 252
on use of color white in paintings of, 252
on use of squares, 253

Salcedo, Doris, 178–82
biography, 274
current research of, 180–81
interviews with victims of violence, 182
 on politics, 179–80
on populations excluded from civil rights, 180–81
on war, 179–80
at work (*Art in the Twenty-First Century*, Season 5 episode, "Compassion"), 178
Schumacher, Emil, 42

Scriabin, Alexander, 230
Self Portrait (Koons), 151–52
Serra, Richard, 226
Setting a Good Corner (Nauman), 249–51
shea butter, 49–50
Sign on a Truck (Holzer), 113
small town life
Baldessari on, 22
Cave on, 30
Smith, Kiki, 70–75
on art as means of protecting oneself, 74–75
biography, 274–75
on childhood and helping father's work, 72–73
on death, 74
on domestic objects, 70–72
on printmaking and sculpture, 72
on storytelling, 74–75
at work (from Art21 *Extended Play* film *Kiki Smith: Printmaking*), 71
Smithson, Robert, 122
Something to Put Something On (Weiner), 50
Somnyama Ngonyama (Muholi), 166–67
Soundsuit (Cave), 31–33
spirituality. *See* religion/spirituality
Split Rocker (Koons), 150
Stanford, Leland, 244
Steiner, Rudolph, 229
Stern, Larry, 47
Stieglitz, Alfred, 48
Stones (Lin), 123–24
storytelling
Hancock on characters in Mounds story, 221–22
Smith on, 74–75
surplus reality, 175
Syjuco, Stephanie, 183–87
on authentic/inauthentic and immigrants, 183
biography, 275
on *Cargo Cults*, 183–86
on crafts fields, 187
installing exhibit *Citizens* at Ryan Lee gallery (*Art in the Twenty-First Century*, Season 9 episode "San Francisco Bay Area"), 184–85
interest in bootlegging and counterfeiting, 183
on open-source work, 187
themes in work of, 186–87
Sze, Sarah, 188–91
biography, 275
early experiences of art, 188–89

This book was made possible by the generous support
of the Juliet Lea Hillman Simonds Foundation.

art21 21 years

Published by Art21

Art21
231 West 29th Street, Suite 706,
New York, NY 10001, United States
art21.org

ISBN 978-0-692-09673-4

Editor: Tina Kukielski
Interviewer: Susan Sollins, et al.
Curatorial and Editorial Assistant: Danielle Brock
Image and Caption Editor: Lindsey Davis
Catalogue Designer: Adam Squires, CHIPS
Copy Editor: Deanna Lee
Printer: The Prolific Group, 150 Wyatt Road,
Winnipeg, Manitoba Canada R2X 2X6
Indexer: Rich Genova

Available through Artbook, LLC
Distributed Art Publishers
155 Sixth Avenue, 2nd Floor, New York, NY 10013
artbook.com

on future of works, 191
on how an object acquires value, 189
on joy in creating art, 191
science and architectural influences on
 work of, 188
on spontaneity and improvisation, 189–91
on studying in Japan, 189
at work *(Art in the Twenty-First Century,
 Season 6 episode "Balance"), 190*

Tadeusz, Norbert, 43
A Tale of Two Cities (Dickens), 158
To Breathe—A Mirror Woman (Kimsooja),
 58, 58–59
Topologies (Lin), 123
Tower of Infinite Problems (Al-Hadid), 196
Truisms (Holzer), 115
Turrell, James, 76–83
 biography, 275
 on color, 82–83
 on designing Quaker meetinghouse, 77–78
 on light, 78–79, 82–83
 Live Oak Friends Meeting House, 80–81
 Meetings attended as a child, 78
 relation of light to Quaker tradition, 78
 on *Roden Crater,* 79–82
 at Roden Crater *(Art in the Twenty-First
 Century,* Season 1 episode "Spirituality"), 76
 on spirituality in works of art, 83
Tuttle, Richard, 70
Twombly, Cy, 158, 247

Uncanny (Kelley), 142, 145
Underground Railroad, The (Whitehead), 245
Untitled (Kruger), 117, 119

violence
 Applebroog on, 19
 Mehretu on, 244–45
 Reyes on, 174
 Salcedo on, 182
Von Rydingsvard, Ursula, 84–87, 125–29
 biography, 276
 comes to America, 85–86
 on *Damski Czepek,* 125–26
 on future projects, 129
 influences of, 128–29
 Madison Square Park project, 125–26
 on making public art, 126
 Ona, creation of (from Art 21 *Extended Play*
 episode: *Ursula von Rydingsvard: Ona*), 127
 on parents seeing her work, 126–28

in Polish camps, post World War II, 86–87
in studio *(Art in the Twenty-First Century,
 Season 4 episode "Ecology"), 84*
on working with wood, 87

Walker, Kara, 88–93
 biography, 276
 on *Insurrection! Our Tools Were Rudimentary,
 Yet We Pressed On,* 88–89, 90–92, 92
 overhead projectors, use of, 88, 90–91
 on projections, 91
 representation of self as artist, 89–90
 self-discovery and, 91–93
 at work *(Art in the Twenty-First Century,
 Season 2 episode "Stories"), 89*
war, 179–80
Warhol, Andy, 249
Watkins, Carleton, 241
Wave Field, The (Lin), 123
Weems, Carrie Mae, 94–97
 on beauty, 96–97
 biography, 276–77
 on constructing an image, 97
 on light, 95–96
 photographic influences of, 95–96
 on *A Requiem,* 97
 at work (from *Extended Play* film *Carrie
 Mae Weems: "Grace Notes: Reflections for
 Now"*), 94
Weiner, Lawrence, 50
Wheatley, Phillis, 90
Whitehead, Colson, 245
Whitman, Matthew, 51
Whitten, Jack, 258–61
 biography, 277
 on *Black Monolith,* 261
 on evolution from working quickly to more
 slowly, 259–61
 on ideas in sculptures versus paintings, 259
 on move away from abstract
 expressionism, 258
 on science, 259
 on slab paintings, 258–59, 261
 on tessera, 258, 261
 at work (from *Extended Play* film: *Jack
 Whitten: An Artists Life*), 260
Winogrand, Garry, 95

Young, Damian, 244
Young, La Monte, 249

Zukav, Gary, 259